The World's Top Photographers

Wildlife

A RotoVision book
Published and distributed by RotoVision SA
Route de Suisse 9
CH—12 95 Mies
Switzerland

RotoVision SA, Sales & Production Office
Sheridan House, 112/116 A Western Road
Hove, East Sussex BN3 1DD, UK

Telephone +44 (0) 1273 72 72 68
Facsimile +44 (0) 1273 72 72 69
Email sales@rotovision.com
Website www.rotovision.com

ISBN 2–88046–689–X

Written by Terry Hope. Contact terry@terryhope.com
Designed by Dan Moscrop
Cover image by Heather Angel

Production and separations in Singapore by ProVision Pte. Ltd.
Telephone +65 6334 7720
Facsimile +65 6334 7721

The World's Top Photographers

and the stories behind their greatest images

Wildlife

Contents

Introduction

Welcome to the *Wildlife* book in The World's Top Photographers series, a collection of some of the greatest wildlife and natural history images from an international selection of photographers, all of whom are acknowledged as contemporary "greats" in their field. Along with the pictures are the stories behind each photographer's rise to prominence, and something of the philosophy that lies behind their work. It's striking to learn from these stories how much passion and sheer back-breaking hard work lies behind the fashioning of a reputation.

Without exception, each photographer has developed an affinity with their subject, and the pictures that you see here are a result of a deep understanding and love of nature. It's clear that there is no other way to approach this subject; this is not an area of photography that anyone enters with a mind to finding fame and making a fortune. For a fortunate few, that might be the end result, but for the majority, the attraction is the chance to get out into the field and to experience wildlife face to face in a way that most of us could only dream about, and to share for a few moments the lives that these animals lead.

Because of the passion of these dedicated few, those of us who might never have had the chance to visit remote wilderness areas, or who haven't the patience or the inclination to sit and wait for hours for a creature to make an appearance, can take a privileged front-row seat and look in wonder at what nature has to offer.

The role of the wildlife photographer has assumed more importance than ever over the past few decades, as humanity has continued its destructive onslaught on the natural world and many of the most remarkable species on the planet have had their very existence threatened. Now the pictures that we're presented with are not only offered up to give us pleasure, but also serve to remind us of what we stand to lose if we continue to ignore the environment and the wellbeing of the creatures that share our planet.

Perhaps the best chance that some of the most endangered species have is that photographers will highlight their plight and force some action to be taken. This gives a thought-provoking subtext to many of the stunning wildlife pictures being taken today, and the realisation of this awesome responsibility is a theme running through the biographies presented throughout this book.

So sit back and enjoy this wonderful collection of work; read the stories that these accoladed photographers have to tell; and bear in mind the sobering thought that, without a worldwide change of attitude, this generation may be the last to experience the extraordinary diversity of life that inhabits our planet. These pictures, and others like them, may be the key to making sure that such a scenario does not happen. Such a thought guarantees that, along with being stimulating and evocative, these photographs have an added dimension to offer. **Terry Hope**

Cherry Alexander UK

Auster penguin colony, Antarctica
Alexander was able to approach these emperor penguin chicks very closely as they waited for their parents to return with food.

Canon EOS 1N, 17-35mm zoom (at 20mm), Fujifilm Provia

Cherry Alexander, who together with her husband Bryan, runs a thriving picture library devoted to the polar regions, feels that the wildlife photographer tag she has acquired is something of a misnomer, since she has always strived to cover a far wider range of subjects. There's no denying, however, that her understanding of arctic wildlife subjects is second to none and this, combined with the intimate local knowledge that she has acquired through her experience of working in this demanding environment, has led to the steady output of the high-quality photographs that have established her reputation.

Her peers acknowledged her skill in this area in 1995, when her picture of penguins on a blue iceberg won her the overall title of Wildlife Photographer of the Year, one of the ultimate accolades for anyone working in the wildlife arena. It was the latest highlight in a career that, initially at least, had developed in almost ad hoc style following the completion of a vocational course in photography at the London College of Printing in the late 1960s.

"Bryan and I were on the same course," says Cherry, "and we spent three years hugely enjoying the access to equipment and to other people who loved photography as much as we did. But when we left in 1971 we really had no idea of how we were going to make a living. We were given a direction when, in that year, Bryan won a travel bursary and used the money to go to Greenland. He decided there and then that the polar regions were for him, and in the next few years we travelled north on a regular basis, building up the photographic stock that we held on the region. We just decided that we loved the light, the people and the environment."

For a full ten years, however, it was impossible for the couple to make enough money from their photography to enable them to make a living, and Cherry undertook jobs ranging from working in the darkroom at the Ministry of Defence to waiting on tables in a casino. Temporary work was the order of the day, filling in between expeditions and helping to raise enough money to keep everything ticking over.

Finally, in 1981, a book contract from Time Life gave the couple enough security to make the move into full-time photography, and since then they've worked hard to establish themselves as experts in a specialised field. "When we were starting out people used to say that, to really be accepted as a wildlife photographer, you had to travel to Africa and spend time working in the big game parks there," says Cherry. "The polar regions weren't seen in the same way, but that seems to have changed now, and they are attracting a lot more interest. From our point of view, we just feel that it pays to have a speciality and to do that you have to really get to know an area and, just as importantly, that area has to get to know you."

Some of Cherry's best-known pictures have featured polar bears, and her collection has been built up through a series of five trips to the renowned bear habitat of Cape Churchill in Canada. "When we started out photographers would be taken out to Cape Churchill in tundra buggies that would also serve as sleeping accommodation. These had huge windows and sometimes you would be woken at night by the vehicle shaking, and you could see a large male bear outside, rocking us around just because he could. The windows also offered a fantastic view of the aurora."

Cherry decided a few years ago to make the switch to autofocus and invested in Canon EOS 1N cameras, keeping an F1 body to hand as a back-up in case of equipment failure. "So far I've never needed to use it," she says. "Most of the trips I've undertaken have been in conditions that haven't dipped below minus 20 degrees, and I tuck the camera body down my jacket when it freezes and keep a supply of batteries in my pocket so that I'm well covered.

"I normally travel with four lenses and three of them are zooms because the quality of optics on the Canon autofocus zooms is so high. Zooms are also invaluable in polar regions because they don't require to be changed as often as fixed lenses do, and that prevents the problem of driving snow getting into the camera once the lens has been detached from the body.

"The zooms I use are a 17-35mm, a 28-70mm and an 80-200mm, and they all feature a maximum f-stop of f/2.8. I also have a very portable 300mm f/4 image-stabilised lens that goes everywhere with me. Carrying all of these plus a tripod, film and flash in a backpack can be very tiring, especially since I'm only five feet four inches and the wrong side of 50, but I seem to manage."

Cherry uses a variety of film speeds, among them the latest Fujifilm ISO 400 materials that feature particularly fine grain. "The quality is certainly up to the standard that is required by a picture library," she says. "I wouldn't use it during the day because it's not necessary, but at dawn and dusk, or for emergency use, it can mean that photography can take place at times that would not have been possible with slower materials.

"And when I'm on a trip to Antarctica and photographing from one of the icebreakers that take you around down there the combination of ISO 400 film and my image-stabilising lens allows me to take pictures from the deck when it would have been totally impossible to use a tripod."

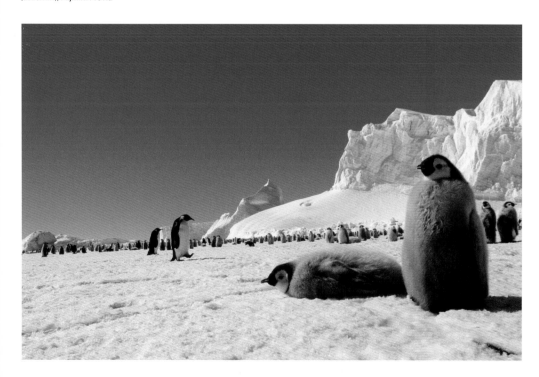

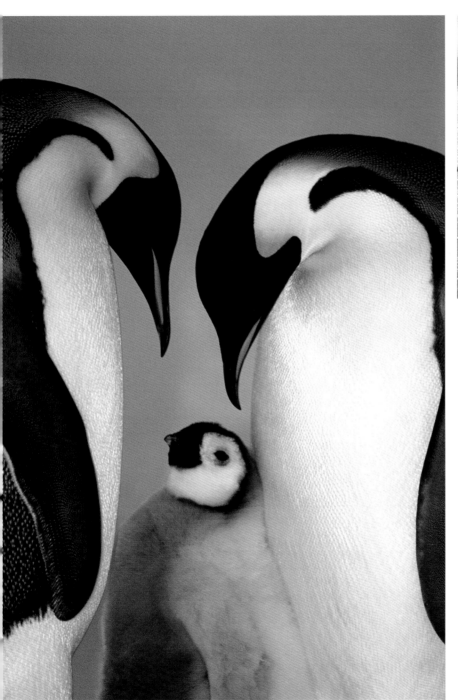

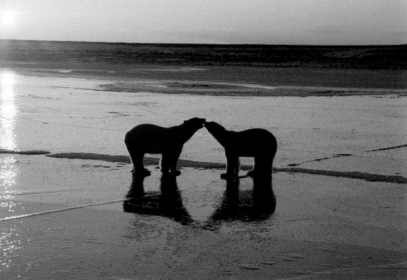

Emperor penguins, Weddell Sea
Emperor penguins bend their heads over a chick as part of a ritual greeting. It's also the way they locate their own chick to feed, from among the thousands in the colony. This shot was taken in Atka Bay, on Antarctica's Weddell Sea.

Canon EOS 1N, 300mm f/4 IS lens, Fujifilm Provia, fill flash

Polar bears, Cape Churchill
Adult polar bears greet each other on the ice of a tundra pond near Cape Churchill in Manitoba, Canada, as they wait for the sea ice to freeze so that they can go out on it and hunt seals.

Canon F1, 300mm f/2.8 lens, Kodachrome 64

Cherry Alexander

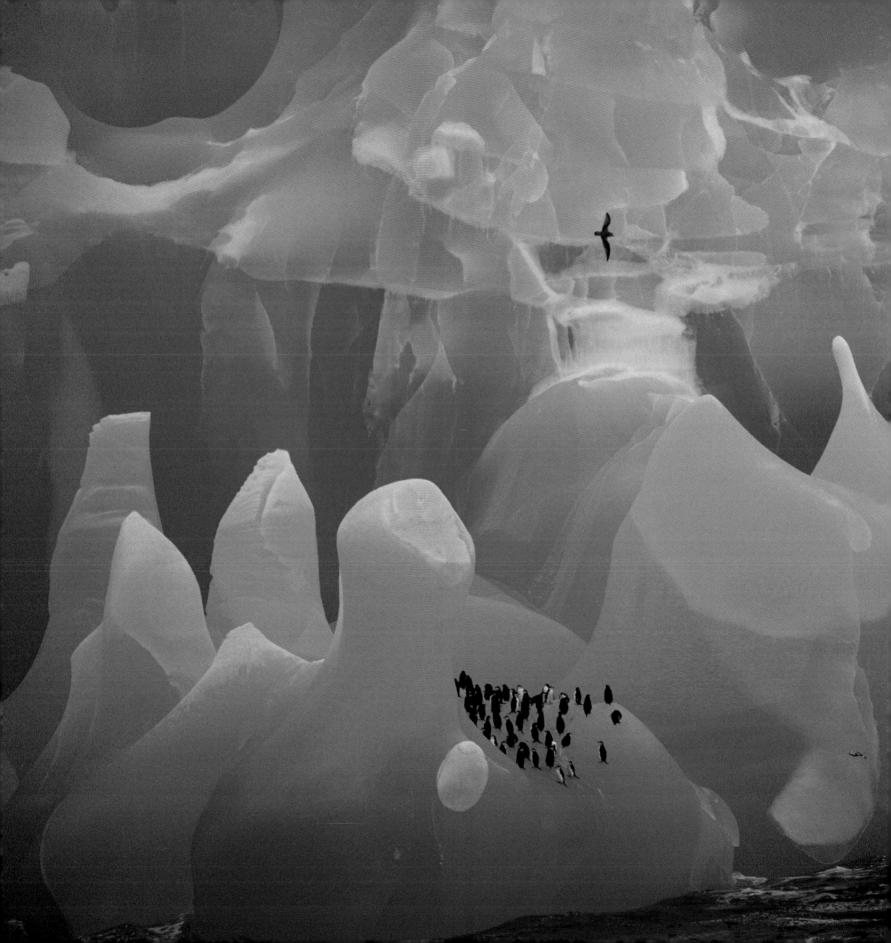

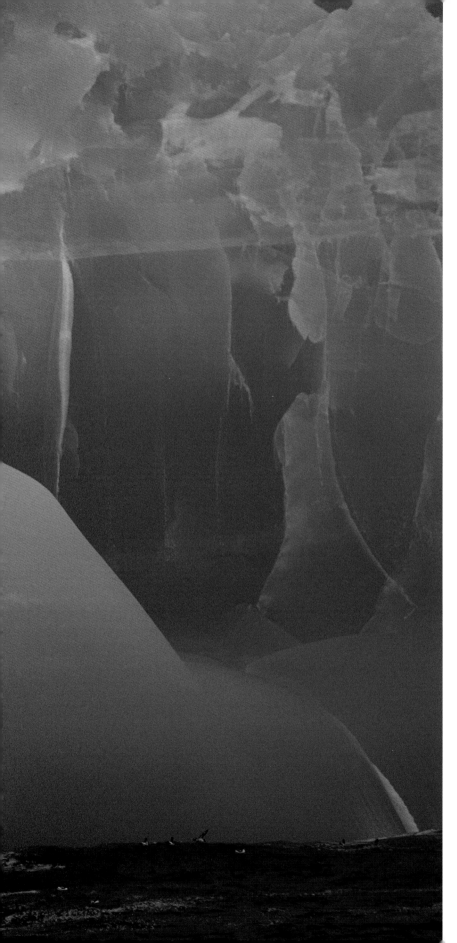

Blue iceberg

This is the picture that won Cherry Alexander the title of Wildlife Photographer of the Year in 1995. It was taken from the deck of a Russian icebreaker in the region of the South Sandwich Islands in Antarctica. "The icebreakers are the only ships that venture into this region," says Cherry, "and there's probably only around two of those a year, so there are always photographers on board hoping to produce some pictures of this inhospitable area. I was with a group of six that included Frans Lanting, and we had earlier been photographing a smaller iceberg and had achieved what we thought were really strong pictures of that. Frans, however, said that he thought it was nearly perfect but not quite: we asked him what he meant and he said that there were no penguins on it.

"Shortly afterwards we saw this iceberg on the horizon, a lump of bright blue on a grey day. When we got closer it turned out to be about 250 feet long and some 70 feet tall at the centre and, as we approached, we realised with excitement that this one really was perfect, and that there were penguins and other seabirds around it.

"The reason that the iceberg is blue is because it is extremely ancient, compressed ice from the Antarctic Continental Ice Sheet, probably formed around two miles down, and all the white ice that was originally around it has melted. The amazing form of this one was sculpted by the seawater when the top side had originally been underwater — icebergs roll in the water just like ice cubes in your glass — and just out of frame on the left of the picture was an ice arch that waves were washing into.

"Wildlife is attracted to icebergs because the cold water from thawing ice sinks into the sea and causes an upwelling of warmer water that carries with it micro-organisms, which serve as food for penguins and other seabirds. The iceberg also makes a good place to sit, safe from leopard seals.

"I decided to crop the picture to exclude the sky — which was grey and rather uninspiring — and also the ice arch, which was proving to be a little distracting. The picture was taken with a Canon T90 and I framed this view through the short end of an 80-200mm zoom. As a final touch, a seabird flew into the frame just as I pressed the shutter, and this helped to complete the image."

Canon T90, 80-200mm zoom, Kodachrome 64

Cherry Alexander

Heather Angel UK

Heather Angel is one of the most prolific and successful nature photographers in the UK. To date her pictures have appeared in more than 5,000 books — nearly 50 of which feature her work exclusively — as well as innumerable magazines and calendars. She also manages a stock library of around 350,000 images, covering a huge range of subjects, from wildlife in a wide variety of shapes and forms, through to plants and gardens.

It's all a far cry from her early ambitions, which didn't extend to photography at all. Following on from an education that was received at a multitude of places, due to the fact that her father was a serving officer in the RAF — she attended 14 different schools in the UK and New Zealand — she went on the achieve a BSc Honours degree in Zoology and a MSc for her thesis in Marine Ecology at Bristol University.

Throughout the majority of this period, however, she had never taken a picture, and it wasn't until she was given a camera as a gift for her 21st birthday that things started to fall into place. "I didn't even know how to load a film at the time," she says, "but, being an inquisitive scientist, I just asked lots of questions." Angel quickly became hooked on photography, using it initially to document marine life and then turning to look at the wider world of nature. It soon became clear to her that she had found her true vocation in life.

Accordingly, Angel decided to move over to photography full time. She turned freelance in the early 1970s, working as an extramural university lecturer and using her earnings to finance her photographic trips. Her first book on nature photography was published in 1972, and she soon began to build a reputation for herself through her deep understanding of her subject and her sensitive eye for an image.

Since that time, Angel has worked in locations all over the world, including the Arctic and Antarctic, East and South Africa, China, India, Japan, North America, Europe and Australasia, and she's used her expertise as a basis for teaching others about the intricacies of photography and the need to develop an understanding of the natural world before it can be properly documented.

She's tutored since 1963, and is now one of the most respected authorities in her field, undertaking numerous workshops throughout a typical year. She also served as the President of the Royal Photographic Society between 1984 and 1986, only the second woman to hold that role in the Society's 150-year history. In 1994, Nottingham University made her a Special Professor; making her the first British wildlife photographer to be so honoured. Her work is also regularly exhibited, her biggest show to date being *Natural Visions*, which brought together a huge variety of images that demonstrated the full range of her work.

Being self-taught, Angel's way of working has evolved through experience, and she's been extremely loyal to her equipment, believing that the thorough understanding of her gear has allowed her to work more instinctively. "The cameras I use are Nikon F4s and F5s," she says. "The F5 features a superb accurate metering system, but I can't bring myself to say goodbye to the F4s, because they have been such good friends to me over the years."

The lenses she chooses to take on an assignment will vary depending on the demands that each particular trip will impose. When she's likely to be shooting some distance from her subjects, she uses a 500mm f/4, which can be extended by using a teleconverter, and a 300mm f/4. The latter is much lighter than the 500mm and so can be handheld for photographing whales from boats, or birds hovering overhead.

"For groups of animals, such as herds of game, I'll use an 80-200mm zoom, which has a maximum aperture of f/2.8 throughout its range," says Angel. "Its speed makes it extremely versatile, and it's capable of excellent results in low light. I like what I can achieve with this lens, because I've always been keen to avoid overfilling the frame with a subject. I prefer to give it space and to show something of the environment as well."

Because of the variety of her work, which covers everything from bugs through to big game, Angel sometimes works with a 105mm Micro-Nikkor, which is one of her favourite optics. Her film choice is more standardised: usually she'll shoot on Kodak Ektachrome 100 VS, opting for a relatively slow emulsion to ensure that the grain quality she achieves is up to the rigours of reproduction.

Another consideration in quality terms is the need for sharp images even when a slow shutter speed is being used, and Angel uses Benbo tripods. "It's very well suited to wildlife photography," she says, "because any one of its legs can be moved through 360 degrees, so it can be set up on the most uneven of terrains.

"If I'm shooting from an open safari vehicle in Botswana, I can still use the Benbo and shoot in any direction through 360 degrees. For closed vehicles, however, I'll use a beanbag, draped over the window frame, so I can rest the camera and lens directly on it.

"For shooting from my own or hire car I use a neat window clamp, topped with a ball and socket head, which can be fastened in a matter of moments and is capable of supporting anything up to a 500mm lens."

Angel is fortunate in that she has found a way of combining her interests, and she's aware how privileged she is to have achieved that. "I never lose the thrill of taking pictures," she says. "I just love being out there with my cameras. Unfortunately, when I return, I then have the chore of having to caption the transparencies before I can sell them, so that I can afford to set off on my next trip. That, I'm afraid, is the tedious part of wildlife photography!"

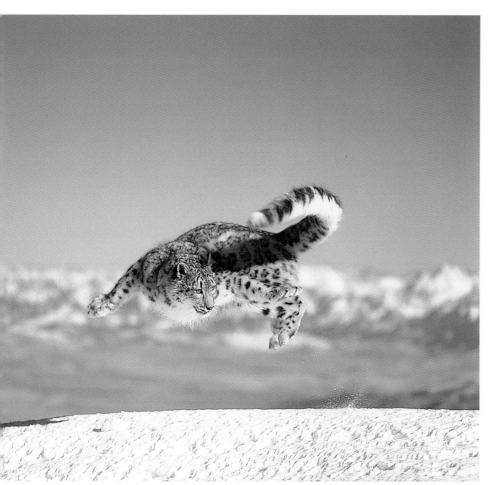

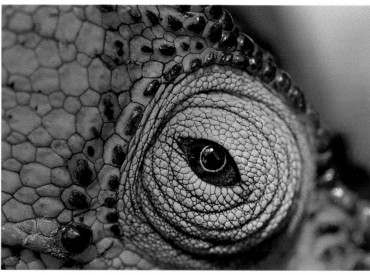

Parson's chameleon
The Parson's chameleon is a large
and striking reptile found on the
island of Madagascar, and Angel
realised that its eye would make an
arresting subject for a close-up. By
using a macro lens (and avoiding
flash, which would have produced
a distracting reflection on the
reptile's pupil) she was able to
achieve a dramatic same-size image.

Nikon F4, 105mm Micro-Nikkor, Kodak
Ektachrome 100S

Snow leopard
On a glorious, sunny
midwinter's day in Montana
USA, Angel shared a short
helicopter ride with a captive-
bred snow leopard to a pristine
snow-covered ridge. Within
moments of walking out onto
the snow, Angel began to
unpack her gear and, when she
sensed a movement out of the
corner of her eye, she turned
and instinctively dropped on to
her knees to gain a low angle
just as the cat leaped into the air.

Hasselblad 501CM, 250mm lens,
Kodak Ektachrome 100 Plus

Leopard, Namibia
Angel spent two nights sitting in a
hide to get this shot. As the light
was failing, this leopard appeared
and descended the rock face
towards an orange pool of light at
the bottom. Angel knew it was
touch and go whether the cat would
reach the spot in time, but she was
rewarded by the animal pausing to
look up towards the hide just as its
entire body became bathed by the
last rays of sunlight. Moments later,
the light faded as the sun sank
below the horizon.

Nikon F5, 500mm lens, Kodak
Ektachrome 100VS

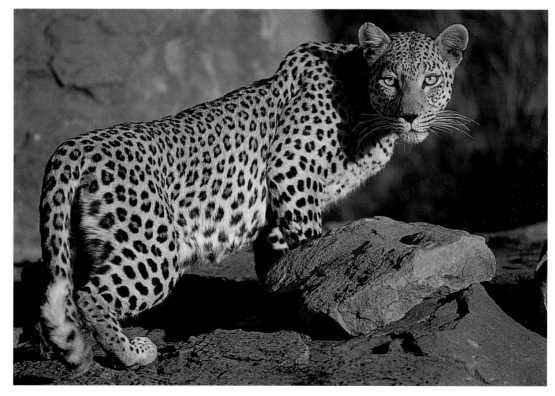

Heather Angel

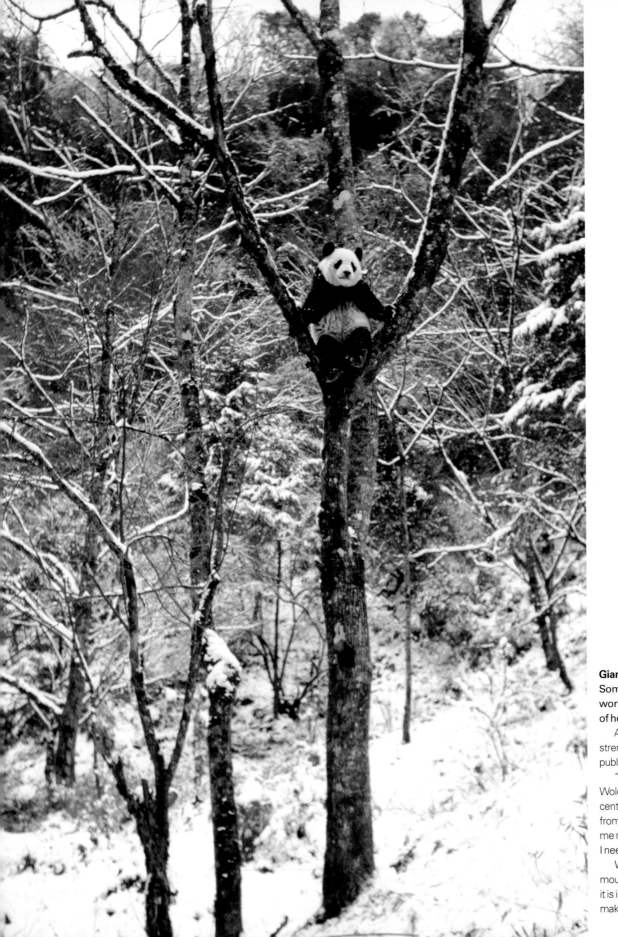

Giant panda

Sometimes wildlife photographers gain a reputation for their work with one particular creature and, for Heather Angel, some of her most successful pictures have featured the giant panda.

Angel had made eight previous visits to China when, on the strength of one of her giant panda images, she was invited by a US publisher to produce a book on the charismatic animals.

"That image had been taken at a natural forested enclosure at Wolong, China's largest panda reserve, where there is a breeding centre," says Angel, "but I knew that I didn't have enough material from that initial visit. I took a second trip to the reserve, which gave me new panda pictures with spring flowers, but I still wasn't satisfied. I needed more unusual pictures of pandas in the snow."

While the chances of snow are high during the winter in the mountainous region of Sichuan Province, where Wolong is situated, it is impossible to predict exactly when it will fall, so Angel had to make plans for a lengthy trip of three weeks to guarantee snow.

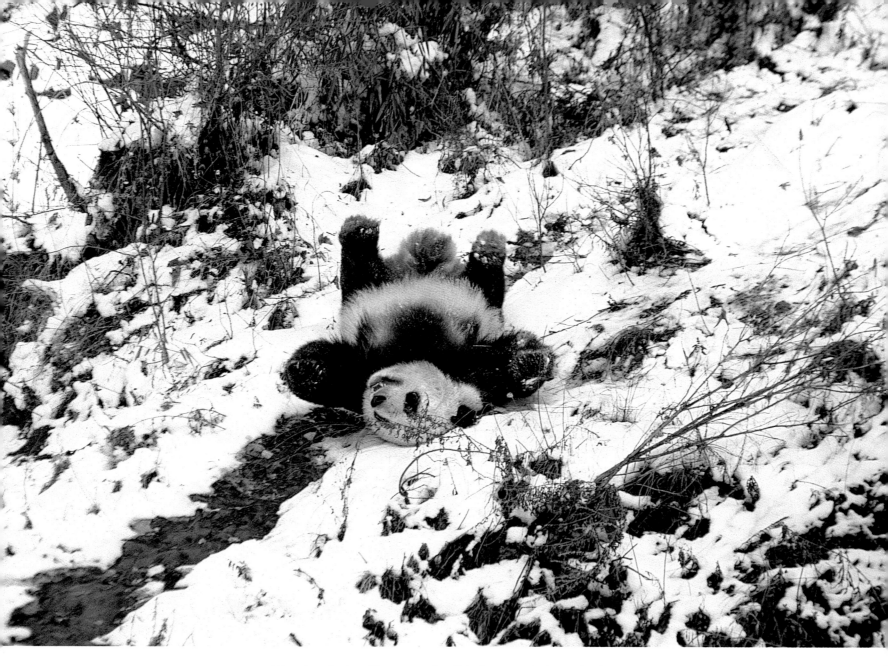

When she arrived conditions were perfect: "It had been snowing for a couple of months," she says, "although once the sun emerged, the snow melted very quickly, so the trip was still something of a gamble.

"What I wanted were action shots of pandas. Their bamboo diet is so unnutritious that they have to feed for long periods every day, and so it's rare to see – let alone to photograph – them doing anything else. The young pandas though, like all youngsters, tend to be reasonably active and like exploring, so it was just a case of waiting.

"I came across the panda in the tree on my first day in Wolong, and my initial reaction was to use a long lens to frame it in the fork of the tree. Then I realised that it was important to show the animal in its environment, and so I used the long end of a 35-70mm lens and pulled back to convey the panda aloft surveying the winter scene. "The picture of the panda sliding down the slope was taken later in the trip, and it was a grab shot. I was looking in the opposite direction, heard a noise and turned round to see the panda lose its foothold. I managed to fire off three to four frames using my 80-200mm zoom. This was the only one of the sequence where the panda had both feet in the air, but as I pressed the shutter I knew that I had captured a fun picture, which always gets a positive reaction."

Panda in tree: Nikon F4, 35-70mm lens, Kodak Ektachrome 100S
Panda sliding: Nikon F4, 80-200mm lens, Kodak Ektachrome 100 Plus

Heather Angel

Fred Bavendam _{USA}

Fred Bavendam has always harboured a love for natural history, with photography becoming an increasingly important hobby during his last years at high school. He studied Zoology for three years at the University of New Hampshire before dropping out in 1966 to enlist in the Marine Corps. Returning to civilian life in 1968, he completed his degree in 1970.

After school, he became a commercial photographer, working for the university. "I was shooting a very diverse range of subjects out of a small studio," he says, "and then, in the spring of 1973, a guy who lived in the apartment upstairs from mine, and who had been doing some diving, told me about someone he knew who was teaching diving classes. During my university years, I had been very interested in Marine Biology, but the only marine life I had seen had come from inter-tidal collecting trips or had been pickled in jars.

"I did my first dives in New Hampshire and Maine and started taking underwater photographs almost immediately. It soon became an obsession. In 1975, I traded my Nikonos III for a Canon F1 and an Ikelite housing. Made of lexan plastic, the housing was relatively inexpensive and unsophisticated, but my photographs improved immensely almost right away because for the first time I could frame my subjects and pinpoint the focus with an accuracy that was impossible with the Nikonos. It was the first of two really significant milestones in my becoming a successful underwater photographer.

"I've remained with housed cameras ever since because they allow me the working precision I need to shoot the kinds of subjects I like. From the Canons I moved first to the Nikon F4 and then to the F5, and work with lenses ranging from the 200mm Micro-Nikkor to the 16mm full frame fisheye. My most heavily used lenses are the 70-180 Micro-Nikkor zoom and the 24-85mm Nikon zoom. I use the F5 in aluminium housings made by SeaCam in Austria, which I have modified extensively in order to retain the most advantageous features of the F5 camera system underwater."

Bavendam's underwater photography remained a passionate hobby for a number of years, but more and more he started to look for a way to make it his career, particularly as he felt that the work he was starting to produce was up to the standard of underwater pictures he was seeing in magazines. In the mid-1980s, he made the decision to sell his studio gear and use the proceeds to fund more underwater equipment and diving trips, and the first place he chose to concentrate on was British Columbia, in Canada.

"It was cold water," he says, "and unpredictable. The visibility could be two to three metres one day, and 30 metres two days later. Tidal currents often exceeded ten knots. Perhaps that was the reason why it hadn't been over-covered. But the marine life was spectacular; more than I'd hoped for. Starting in 1986, I made two extended trips a year to BC, a four-day drive each way from my home in New Hampshire. Near the end of my autumn 1987 trip, Mike Richmond, a dive operator on Quadra Island, took me to see a female giant octopus guarding eggs in a den and I got some very good pictures of her.

"I returned to Quadra Island the following spring to concentrate on a story about the giant octopus, despite being told by many people that you just wouldn't see them often enough to be able to do a good behavioural story. I spent four and a half months in BC that spring, and another six weeks in the autumn of 1988. There were times when I didn't see an octopus for weeks, but in the end the huge amount of time I put into the project, combined with the help of several friends and the co-operation of a few incredible octopuses, allowed me to get some really great images and resulted in what has been my bestselling story ever.

"The giant octopus story was published first in Germany's *Geo* magazine, followed shortly by French *Geo* and then *National Geographic*. To date the story has sold over 30 times in more than a dozen different countries. It was the second big milestone in my underwater career and from that point on my work was taken seriously by the major magazines."

Since then Bavendam has dived in the Great Barrier Reef, southern Australia, Papua New Guinea, Indonesia, and other destinations in Southeast Asia and the South Pacific, all the while enhancing his reputation as an underwater specialist.

Despite his heightened profile, Bavendam remains a true enthusiast at heart. "I absolutely love being in the water and feel much more like a naturalist with a camera than a pure photographer," he says. "Animal behaviour is what fascinates me and basically what I like best is doing a story about a single species or related group of species, and the ecology that's associated with them. I want to find out how they survive in an ocean full of hungry mouths.

"I almost never take assignments from the major magazines. You just can't put nature on a deadline, or relate it to some editor's preconceptions. I want to work on something for as long as it takes for me to be satisfied, and then show it. The story will be my concept and my vision. Over the years I've learned that, as long as I'm really satisfied with a story, someone else will like it too and then, hopefully, buy it. If I really get it right, that purchaser will be *National Geographic* or *Geo*."

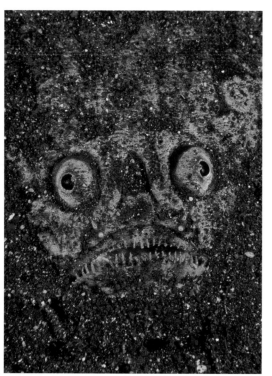

Stargazer in black sand
"This picture was shot in the Lembeh Strait, Northern Sulawesi Island, Indonesia. It was taken on a night dive in about ten metres of water. The stargazer buries itself in the sand with only its eyes and mouth showing while it waits for prey to ambush. I liked the almost goblin-like appearance of the fish. It has real 'character.'"

Nikon F5 in an underwater housing, Nikon 70-180mm f/4.5-5.6 Micro-Nikkor lens, 1/250sec at f/32, Kodak Ektachrome 100VS, Twin Hartenberger 625 ws strobes

Over/under day photo

"This picture was shot at the Bunaken Island Marine National Park, Northern Sulawesi Island, Indonesia. The Bunaken Island shallow coral reefs are some of the most beautiful I've seen.
To connect the reefs with the volcanic origins of many Indonesian islands, I used the over/under technique so that I could have the volcano Manado Tua in the background, while showing a section of the underwater reef."

Nikon F4 in an underwater housing used on a tripod, Sigma 14mm f/3.5 lens used with an 8≤ dome port, 1/60sec at f/16, Kodak Ektachrome 100SW, Twin Hartenberger 500 ws strobes used for lighting the underwater portion of the picture, both to increase colour quality and to raise the underwater brightness to a level equal to that of the topside portion

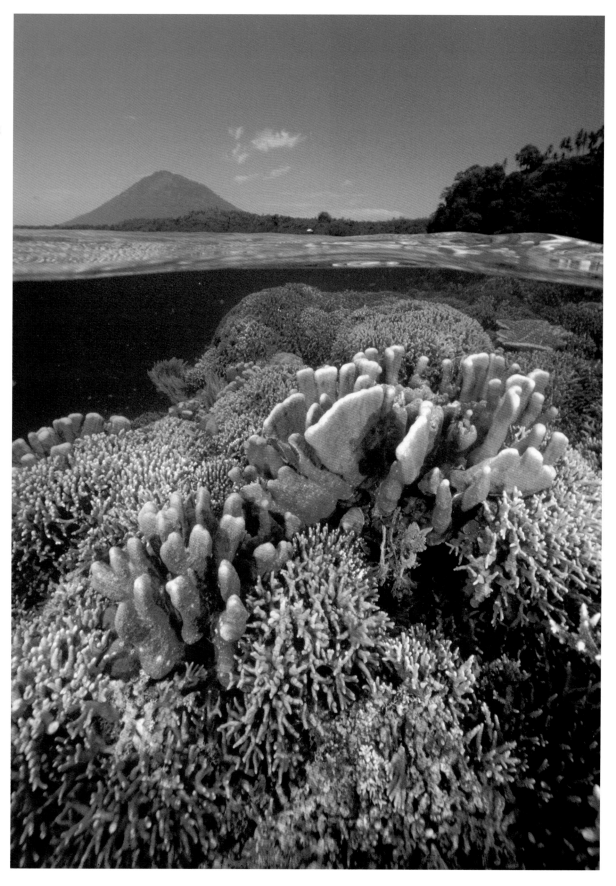

Fred Bavendam

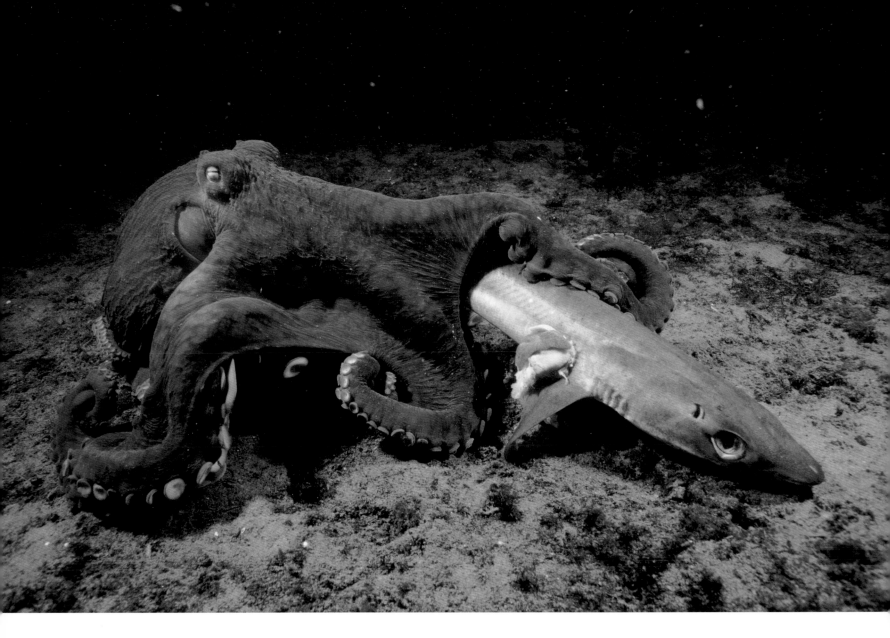

Giant octopus eating dogfish shark

"This picture was taken at Quadra Island, BC, Canada during the time I spent working on the giant octopus story. Local dive operator Mike Richmond had just returned from a dive at Argonaut Wharf and saw a fisherman catch a dogfish and throw it back. An octopus came out from a den under the wharf, grabbed the shark, and hurried away with it. On hearing this, I jumped into my Zodiac and raced to the spot. I soon found the den and saw the shark's tail sticking out.

"I yanked it out, carried it about 15 feet away, then set it down on the bottom in plain view. Then I swam up among the pilings of the wharf and waited. After ten or 15 minutes , the octopus crept cautiously out of the den. Satisfied that the coast was clear he scuttled over to reclaim his shark, at which point I appeared. He turned brighter red and changed postures several times, seemingly torn between his desire for dinner and his urge to dash for safety.

"I used two strobes, spread wide on arms from each side of my housing to illuminate the picture, as this gives more even illumination than a single strobe when you are using a wide-angle lens. This image is the biggest-selling picture I've ever taken."

Canon F1 in an underwater housing, 20mm lens, 1/60sec at f/5.6, Kodachrome 64, Twin Ikelite 150 strobes

Octopus dropping down

"When octopuses hunt, they often make a quick dash across the bottom and then 'jump' upward just a little so that they can drop down on top of their prey. To try to illustrate what might be called 'the last thing the crab ever saw,' I asked Mike Richmond to carry a large octopus up into the water a few feet above me and then to drop it straight down on top of me as I shot."

Canon F1N camera in housing, Canon 15mm f/2.8 fisheye lens, Kodachrome 64, Twin Ikelite 150 strobes (set on higher power to give more detail in arms and suckers

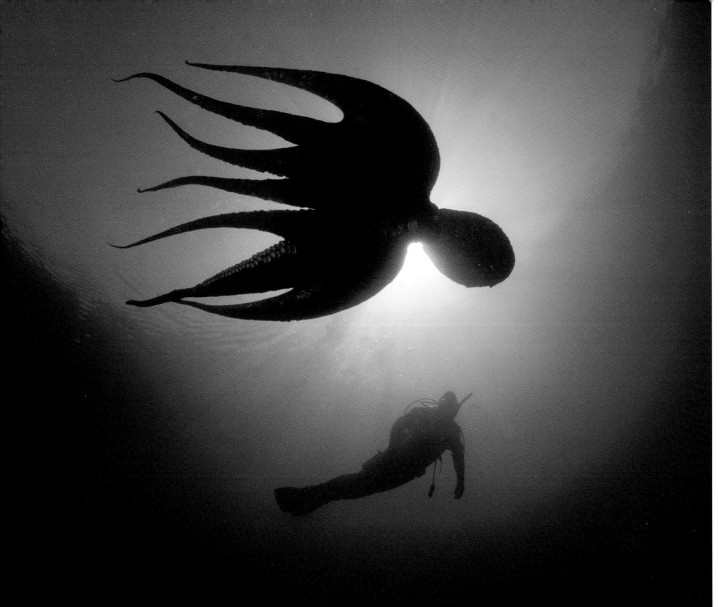

Swimming giant octopus
"This picture shows the way a giant octopus flattens itself out into a more hydrodynamic shape while jetting through the water. Despite being primarily bottom dwellers, they are very good swimmers. I wanted a diver in the picture, who in this case is Mike Richmond, to help convey the size they sometimes attain. Although octopuses are very sensitive and shy, if they realise that you are not really a threat to them, they can become quite unafraid. To help me read this tricky lighting situation, I used the spot-metering feature of the Canon F1N that I was using at the time (just as I was to do later with the Nikon F4 and now the F5) to read the brightness value of the water towards the surface. Then I used strobes to add some fill light, which gave me just a small bit of detail in the octopus itself. This is one of my personal favourites of the entire octopus series."

Canon F1N camera in an underwater housing, Canon 14mm f/2.8 lens, 1/60sec at f/8 or f/11, Kodachrome 64, Twin Ikelite 150 strobes

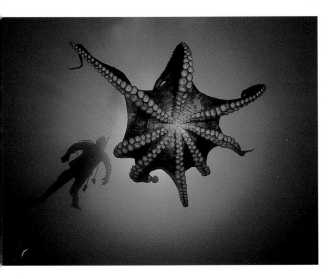

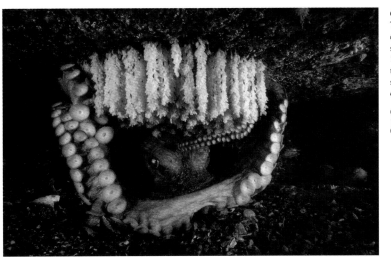

Octopus guarding her eggs
This female octopus tending her eggs was taken on Fred Bavendam's second trip to British Columbia in 1987, and was one of the images that persuaded him to undertake a story dedicated to these fascinating creatures.

Canon F1N camera in housing, Canon 15mm f/2.8 fisheye lens, Kodachrome 64, Twin Ikelite 150 strobes

Fred Bavendam

Niall Benvie UK

Born in Angus, Scotland in 1964, Niall Benvie was fortunate enough to grow up in an area surrounded by open country and relatively abundant wildlife, and this encouraged him to take an interest in natural history from an early age.

On leaving school, he spent the next seven years working on his family's fruit farm near Friockheim. When the farm was sold, Benvie decided to take an Honours degree in Geography at the University of Dundee.

"I had started to get interested in photography long before this," he says, "but felt that the four years that was required for an Honours degree course in the subject would have been largely wasted since there was nothing specifically geared towards natural history photographers at that time, and I would instead have been learning techniques that would have had little practical application for me. Geography, on the other hand, encompassed many different subjects that I was interested in, and it served to give me a much better all-round education."

While at university, Benvie founded and organised the first Scottish Nature Photography Fair, an event that was taken on after five years and is still run today by Scottish Natural Heritage. This quickly established a high reputation among those who were looking for a forum where the whole range of issues facing wildlife photography could be discussed, and where it was also possible to hear some of the world's greatest practitioners talk about their work.

"The fair was my way of having a legitimate excuse to get in touch with professionals and to meet with others who were tackling similar areas to myself," he says. "It was also a good way for me to deal with magazines who were interested in covering the event, and it helped me to get my first pictures published."

Since graduating in 1993, Benvie has concentrated largely on the wildlife of his home country, preferring the subjects that he knows intimately to those that are more dramatic. "Initially, some of it was down to the limited budget that I had," he says. "When I started out the only reason that I was able to survive as a photographer was because my wife was working and supported me while I supported my business until I started to get some work published regularly. I found that an excellent grounding, however, because it made me look closer at the creatures that were accessible to me, and it helped me to look at ways of getting the best pictures from things that were not necessarily considered to be the most exciting subjects.

"Now I'm more established, I don't dream of going to places such as Africa and South America to photograph some of the exotic species there, because I know that there are others who live in these areas who are always going to be in a better position than me to produce insightful photographs. When I travel to take pictures I prefer to go to somewhere such as Latvia or Estonia, which have landscapes that are familiar to those that I know in Scotland, and are likely to offer me more in the way of indigenous wildlife."

American alligator
Niall Benvie's philosophy about wildlife photography sees him dedicated to producing pictures that are often abstracted so that the viewer can see something different and unexpected about a subject. "People tend to be turned off by an alligator," he says, "and don't want to look too closely. I wanted to move in on this captive specimen and to show an aspect of it that I thought was interesting and different."

Nikon F4, 300mm f/2.8 lens, Fujifilm Velvia, fill-in flash

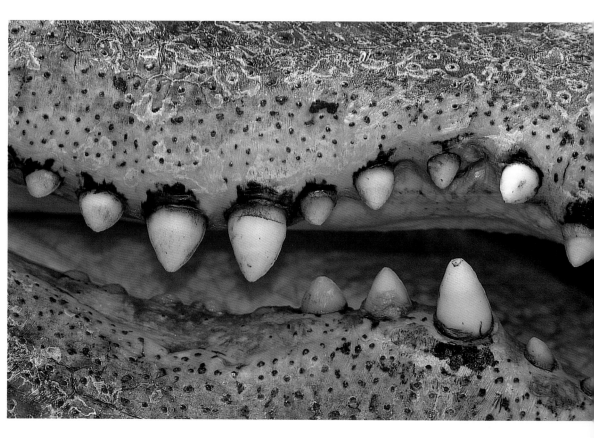

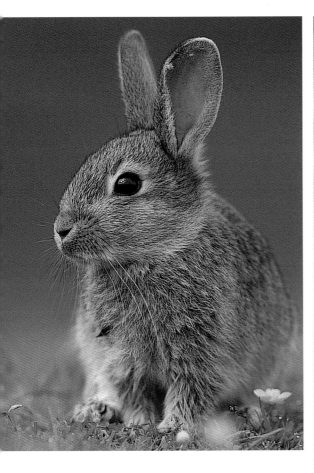

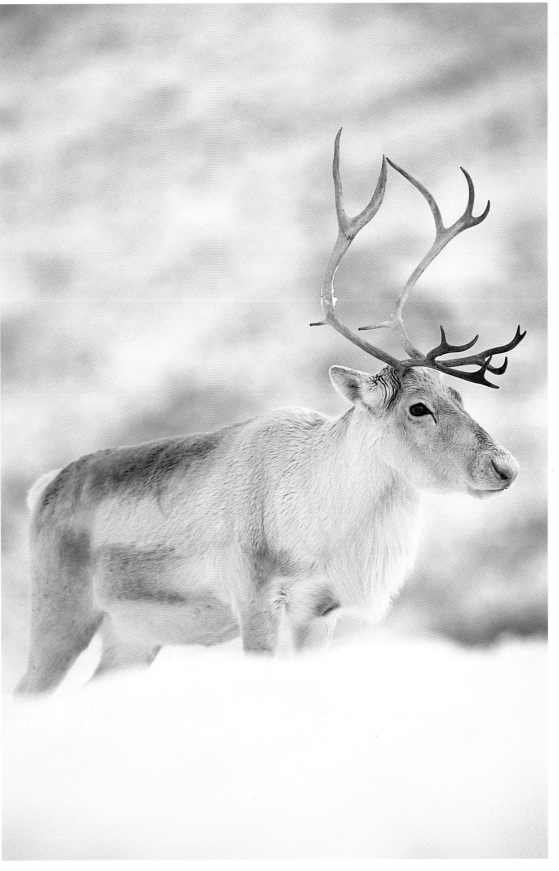

Rabbit, Scotland

This baby rabbit was photographed by Benvie locally at a time when budgets didn't extend to foreign trips. "With young rabbits it's possible to anticipate what they are going to do to a certain extent," he says. "Once they see you they will pop down into their burrow, but you know that if you can move around into a position that's downwind and then wait for around half a minute or so, they are likely to pop back up again. I took this picture using a beanbag to provide support for the camera, and shot at maximum aperture to obtain a very narrow depth of field."

Nikon F4, 300mm f/2.8 lens, 1.4 converter, Kodachrome 200

Reindeer in the snow

A herd of free-ranging reindeer in the Scottish Cairngorms was an ideal subject for Benvie once there had been a heavy fall of snow. Like reindeer in much of their range, they were domesticated, and he was able to move around them to take this portrait.

Nikon F5, 300mm f/2.8 lens, Fujifilm Velvia, Gitzo 340 tripod with 1380 fluid head

Niall Benvie

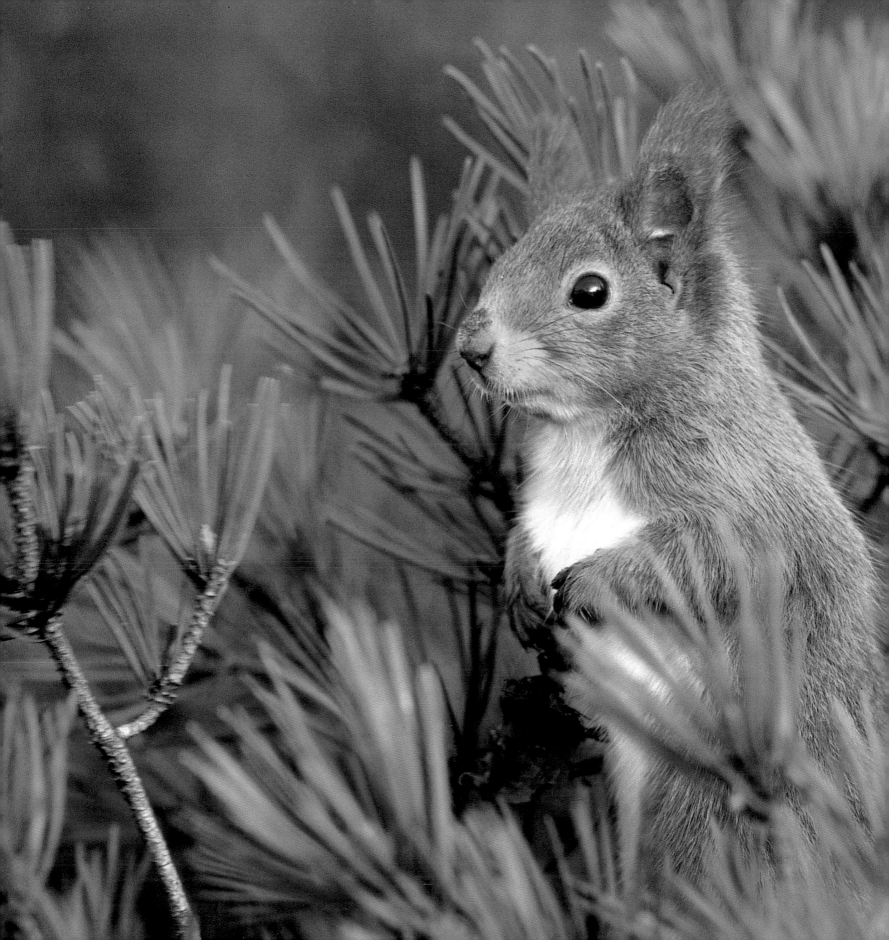

Red squirrel, Scotland

"I wanted to photograph the red squirrel, " says Benvie, "because they are charismatic and a typical Scottish species. I needed to find a good location, however, and so I advertised in the local paper to see if anyone had them in their garden. I got quite a good response from this and found a place that was ideal for my needs. I then spent the next five years working on the project on an occasional basis and, in time, the squirrels became habituated enough to allow me to approach quite close to them. The results were eventually published as a book.

"When I took this particular photograph, I was only a few metres away from the subject. I had attracted the squirrel to this area by secreting a few nuts in the branches, and it had become used to finding them there. I lightened the scene slightly by using a flash: this was held off-camera and was placed just about as far away from the camera as its lead would allow. Previously, I had taken a whole roll of film with the flash on-camera and every picture had been ruined by the reflection of the flash from the creature's eyes."

Nikon F4, manual focus 300mm f/2.8 lens with 1.4 converter, Fujifilm Sensia 100

Niall Benvie

Steve Bloom SOUTH AFRICA

Born in South Africa in 1953, Steve Bloom spent his childhood there before moving to the UK in 1977. It was to be a further 13 years before he returned to Africa, and his first visit back proved to be fundamentally life-changing. Ten days of the trip were taken up with a safari to the Kruger National Park and, after photographing the wildlife there, he found himself completely captivated by the experience. He decided there and then to dedicate himself full-time to wildlife photography, and from that point on he laid the foundations for what was to be a fundamental change of career.

Bloom already had strong connections with the photographic world, having co-founded a photo lab and special effects company that served the advertising industry. With the use of pioneering digital techniques, he helped to build up a worldwide client base and the company was involved in numerous high-profile campaigns, including the official posters for the 1992 Barcelona Olympic Games.

With his heart now set on a different direction, Bloom concentrated on building up a strong initial portfolio of wildlife images, which he sold through picture agencies. Once he'd reached a stage where he felt that he was becoming sufficiently established, he decided to sell his share in his business to concentrate full time on his new career behind the camera.

"The money this brought in helped me to set myself up properly," he says, "and right from the beginning I was keen to be closely involved with the emerging digital technology. It was something that I was obviously already familiar with so for me it was a straightforward decision, but I was one of the first wildlife photographers to really get involved in such things as digital manipulation of images and the electronic transfer of images to clients."

In many ways Bloom was trail-blazing, and many initially saw his enhancement of images as something that was completely alien to the ethos of wildlife photography. Attitudes have softened considerably over the past few years, however, as more and more professionals working in this area have seen the commercial value of some degree of manipulation in their own work. It's still a thorny issue, however, as Bloom himself is one of the first to recognise.

"I believe that manipulation is acceptable," he says, "so long as the basic integrity of the original picture is maintained. I wouldn't, for example, change a picture so that an animal is shown in the wrong environment or doing something that was completely out of character.

"Manipulation, however, is part of the image-making process and it's always been part of photography, well before digital processes made it all easier. The use of a wide-angle lens, for example, will change the way that a scene is recorded, while the choice of film will have a bearing on how saturated a picture might be. By the same token, the removal in the field of a leaf that might be in the way of a viewpoint to me is no different to the subsequent removing of it from the image in a digital way.

"In terms of operating a business, digital technology has helped enormously. I can do a quick scan of a newly taken image and get it up on my website almost immediately so that potential clients can see it. If anyone subsequently wants to buy a licence to use the image, wherever they are in the world I can send them a high-resolution copy in minutes, saving me the expense of producing duplicate transparencies and potentially cutting days off delivery times."

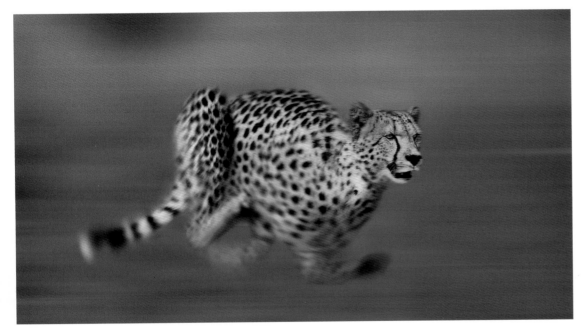

Running cheetah
"This picture was taken at a breeding centre for cheetahs in South Africa's Kapama Game Reserve. I was fortunate to be in a position where the cheetah was running towards the camera."

Canon EOS1N, 300mm f/4 lens, Fujifilm Provia

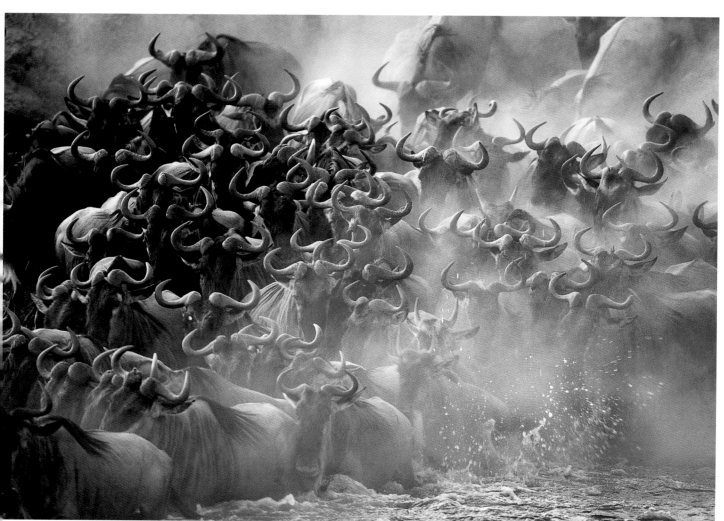

Wildebeest migration

Bloom visited Kenya's Masai Mara reserve over a three-year period specifically to photograph the annual migration, when a million wildebeest and zebras follow the rainfall in search of food. "They must cross the Mara River and risk being swept away in the currents, or being eaten by crocodiles. I used a long lens, in order to show how tightly packed and frenzied they are when entering the water."

Canon EOS 1V, 600mm f/4 lens,
Fujifilm Provia

Elephants from the air

This graphic image was taken from a microlight in Kenya's Amboseli National Park. "We took off as the sun rose," Bloom remembers, "and after flying for about 20 minutes we encountered this group. I was able to photograph them during a single overhead pass."

Canon EOS 3, 70-200mm f/2.8 lens,
Fujifilm Provia

Orphan chimpanzees

"These chimpanzees had all been rescued by the Monkey World Ape Rescue Centre in England from captors and smugglers. The older chimp acted as a surrogate mother and was very protective of the younger chimps in her care."

Canon EOS 1N, 70-200mm f/2.8 lens,
Fujifilm Velvia

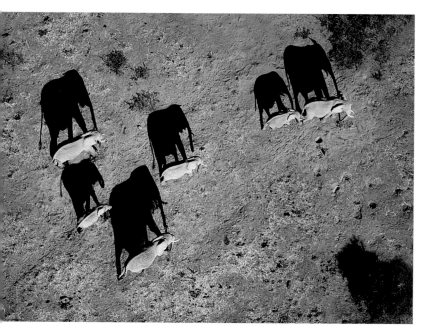

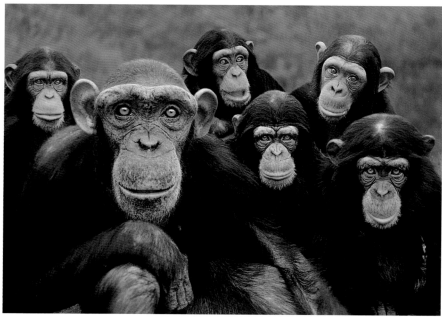

Steve Bloom

Orang-utan sequence

Steve Bloom's first book, *In Praise of Primates*, involved him travelling around the world to photograph in a whole series of locations. He undertook a two-week shoot in Borneo's Tanjung Putting National Park to cover orang-utans that were being rehabilitated back into the jungle by the Indonesian government.

"I hired a flat-bottomed river boat at the port town of Kumai," he says, "and travelled for several hours along the Sekonya River to a camp at the edge of the park. Once there I hired a couple of guides and, although I couldn't speak a word of their language, nor they of mine, we managed to communicate with each other and arranged to set off every day to travel on the river for around three to four hours to the area where the orang-utans could be found.

"Generally I arrived at around 9 am and then we would have to go looking for Orang-utans. They were semi-wild but were being fed by park rangers to help them while they reintegrated themselves back into their surroundings. This meant that they were likely to be around at this time, although on occasions they were much more difficult to find.

"I worked with a variety of lenses to make sure that I got a good selection of pictures. My worst moment was when one of the orang-utans grabbed a camera from me and took it with him up into a tree, where he proceeded to try to take a bite out of it. When he realised it wasn't good to eat, he threw it to the ground and broke it to pieces!"

Canon EOS 1N, 70-200mm f/2.8 and 300mm f/4 lenses, Fujifilm Velvia and Provia

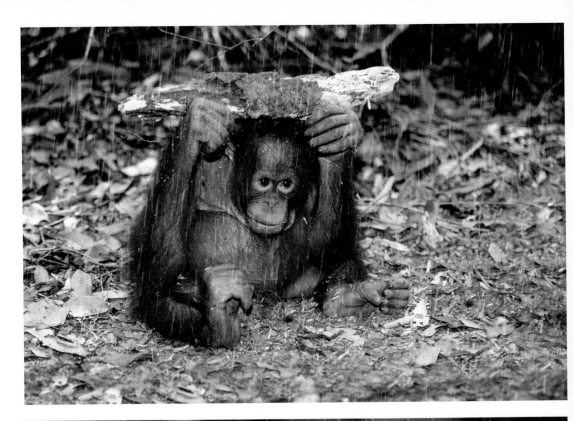

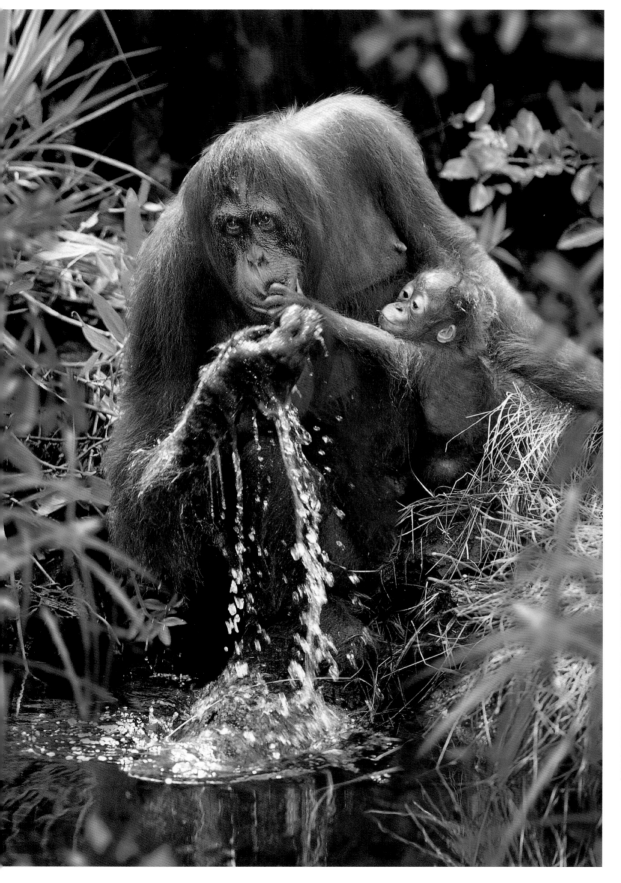
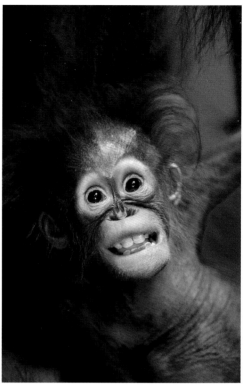
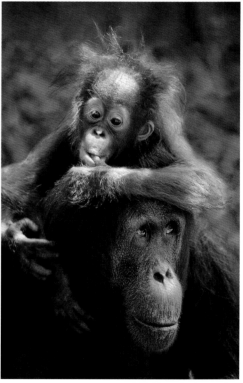

Steve Bloom

Dr John Brackenbury UK

"I like a challenge," is the reason put forward by Dr John Brackenbury to explain his tenacity in overcoming a whole host of technical problems to engineer himself systems that would allow him to photograph insects in remarkable new ways.

Even more surprising is the fact that Brackenbury doesn't count himself as a wildlife photographer at all. "I'm actually a zoologist," he explains, "and I lecture in Veterinary Medicine at Cambridge University, although I also lecture in photography at a couple of colleges and give regular talks to photographic societies as well."

A Fellow of the Royal Photographic Society, Brackenbury has always had a love of photography, but can't quite put his finger on the moment when he decided to set himself the near-impossible task to move his camera in alongside insects and to try to present their world as it actually was, not as humans normally saw it.

"It happened quite suddenly, about 15 years ago," he says. "I had so much knowledge and expertise about insects inside my head that I wanted some way of passing this on to others. The best way of doing this, I reasoned, was to do something that was visually exciting and that would enthuse people."

His train of thought led him to explore the possibility of producing what he was later to term "panoramic close-ups," where a tiny creature was shown at life size or bigger but with its surroundings clearly visible as well. "If you produce a conventional close-up of an insect with a macro lens," he says, "you may pull it up big in the picture, but the rest of the world around it disappears into a blur. This isn't the way that insects see the world. I wanted to bring everything into sharp focus and to show the whole scene as it really was."

Once he had looked around and established that there were no conventional means whereby he could achieve the pictures that he wanted, Brackenbury started to see how he might build the set-up that he required from scratch. He was prepared to think laterally and to look outside conventional photography for the answer, and finally found what he was looking for in an unexpected place.

"I discovered that the perfect optic for this kind of view was a wide-angle television lens," he says. "It's designed to do something completely different, but it could do the job that I wanted. My main problem was how to get this lens to project on to a normal 35mm camera."

After much trial and error, and with the incorporation of two iris diaphragms and two separate bellows extensions, he was able to solve the technical problems, and found himself with a bespoke lens that had an effective aperture of around f/190. "It's effectively a pin-hole picture," he says, "although the quality is far superior to anything that a pin-hole lens could ever resolve."

Having solved one technical problem, he now determined to solve another, beginning work on a set-up that would permit the freezing of motion so that insects could be captured sharply in mid-flight. Others, such as Stephen Dalton, had been working along similar lines, but Brackenbury once again went his own individual way and eventually succeeded in devising his own system, one that eventually was to give him consistently good results and a real insight into a world that the human eye unaided has no chance of observing.

He's still refining his technique and discovering just how far he can go with it, but the process of discovery through experimentation is one that clearly appeals to him and continually drives him to push back the boundaries of macro-photography as far as he can. "My feeling is that there is just so much exciting material down there around your feet," he says. "You don't have to head off to exotic parts of the world to take dramatic nature photographs: what you are looking for could turn out to be just down the street."

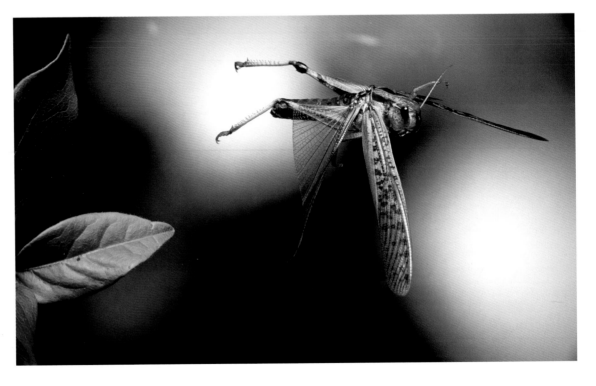

Grasshopper on wall
"I took this picture in Spain during a trip to find some more exotic insects," says Dr John Brackenbury. "This is a panoramic close-up of an insect sitting in its world. It's the scene as it would appear to another grasshopper, and this was what I was trying to achieve when I set out to perfect this technique."

Nikon FM2, home-made lens set-up, Fujifilm Velvia

Locust in flight
"The human eye is about 100 times too slow to see insect movement like this," says Brackenbury. "The only way that you will ever see it is through photography." His home-made set-up features a laser beam across a point where the subject is expected to fly, and the lens is pre-focused to this spot. Once the beam is broken, a circuit fires an electro-magnetic shutter (fitted over the camera lens) almost instantaneously, and two high-speed flashguns made by Eagle Electronics fire at the same time at around 1/20,000sec. "Once again I used equipment that didn't have photographic origins to help me solve the technical problems," he says. "I used a scientific device known as a 'laser chopper,' to open and close the laser beam at the speed required."

Nikon FM2, 105mm Micro-Nikkor f/2.8, Fujifilm Velvia

Ladybirds in churchyard

Dr John Brackenbury is extremely fond of the environment that the churchyard can offer the nature photographer. "Many of them are effectively nature reserves," he says, "providing a safe haven for a diverse number of birds, insects and flowers."

This particular location is the village church of Willingham near Cambridge, and Brackenbury visited there one sunny midwinter's day in his search for ladybirds to photograph. "It was really cold," he recalls, "around minus five degrees, and the ladybirds were huddled together for warmth and were more or less in hibernation and so not likely to move much." That was just as well, because the equipment required to produce "panoramic close-ups" takes some time to set up, and exposures are always on the lengthy side.

Eventually Brackenbury was ready to shoot and he decided to use a touch of fill-in flash to punch a little light into the foreground shadows and to even up the contrast within the scene a little. "Because I was using a slow shutter speed, around one second, I had a lot of control over the situation," he says, "and was able to hold the flash in my hand and to fire it manually exactly in the position that I wanted while the exposure was taking place."

With exposures that long there is always the risk of camera shake and Brackenbury takes the precaution of using a sturdy tripod and manually raising the mirror on his Nikon FM2 SLR camera before pressing the shutter. "It's an old camera," he concedes, "but it's one of the few that will allow you to flip the mirror like this, and it reduces the chance of vibration considerably." He also trusted the camera's TTL light meter to calculate the exposure required, and has found it to be unfailingly accurate.

Nikon FM2, home-made lens set-up, exposure one second, Fujifilm Velvia, flash fill-in

Jim Brandenburg _{USA}

Jim Brandenburg began his career as a natural history photographer and filmmaker while majoring in studio art at the University of Minnesota. He went on to become picture editor of the *Worthington Daily Globe* in Minnesota and, while there, began freelancing for *National Geographic* magazine, having his first story published by the title in January 1980.

Since then he's become one of the world's most respected wildlife photographers, producing another 18 features for *National Geographic* along with 19 books and innumerable television features.

He lives in an area of the US that is renowned as being one of the wildest and most unspoiled tracts of land in the country. The town of Ely is close to the border with Canada, situated in the heart of the Boundary Waters Canoe Area Wilderness, which consists of nearly three million acres of protected land, with further land protected in Canada as the Quetico National Park. Within a 30-mile radius of his home are around 1,000 lakes, and the whole region is teeming with wildlife.

"I came to this place to study wolves," he says. "I've set up a permanent camp around a mile away from my home and the tent doubles as a hide. Over the years the wolves in the locality have become accustomed to me and I can now get really close to them. They're intelligent creatures and sense they're safe in this area. I have 1,500 acres of my own private property and don't allow people to come and hunt here, and that has encouraged the wolves to stay."

While the wolf may be the subject that Brandenburg is best known for, he's covered a huge range of subjects over the years and picked up an impressive list of national and international awards for his work. He was twice named Magazine photographer of the Year by the National Press Photographers' Association (NNPA) and also won the Wildlife Photographer of the Year title. In 1991 he was the recipient of the World Achievement Award from the United Nations Environmental Programme. King Gustaf of Sweden presented the award to Brandenburg in recognition of his "using photography to raise public awareness of the environment."

One of Brandenburg's most lauded projects was termed the *North Woods Journal* and involved him taking one picture a day for 90 days between the autumnal equinox and the winter solstice. He produced all his work close to home and allowed himself just one click of the shutter in which to get his image. Published in its entirety in *National Geographic* in November 1997, it included the most images ever used in one feature in the magazine's entire history and was achieved using a minimal amount of film. The series was subsequently made into a book, *Chased by the Light*, which elaborated on Brandenburg's experience during those 90 days. This went on to become a bestseller and a travelling exhibition. It also led to a further project titled *Days of Summer*, following the same principles as the first, but this time documenting the summer seasons in Brandenburg's beloved North Woods.

It's a way of working that is close to Brandenburg's heart, an exercise in the importance of really looking at and appreciating a subject and taking time to get to understand its significance before pressing the shutter. His exercise took him right back to basics and reminded others that simplicity can be the key to great imagery.

Brandenburg has long been a Nikon user and currently his main cameras are Nikon F100s and 90s. "I don't tend to use the F5," he says, "because I travel around a lot in a canoe and if my camera was to fall overboard it would cost a fortune to replace it!" Accompanying his SLRs are a full range of lenses, but he estimates that he shoots some 80-90 per cent of all his pictures with just two optics, a 14mm wide angle and an 80-400mm image stabilising lens, which has recently replaced an 80-200mm model.

The zoom is a lens that suits his philosophy perfectly. "I use a tripod less often than most people," he says. "Over the years this has meant that I have lost many wonderful images due to camera shake but I reckon that I've gained many more by being ready to shoot a picture while others have been trying to set up their gear.

"The image-stabilising capability of the Nikon lens has been a revelation. With the zoom set to its longest focal length I can now hand hold down to 1/30sec easily and have even managed to go as slow as 1/8sec without problems. It's revolutionised my photography."

Other cameras favoured by Brandenburg include a Fujifilm 6x17cm and a Hasselblad X-Pan, both panoramic models, and a Pentax 6x7cm. "The X-Pan is a particular favourite of mine at the moment," he says. "Because it's a 35mm model I can just put it in my pocket and take it anywhere."

The most interesting recent development for Brandenburg, however, has been his embracing of digital technology. All of the images in the *Days of Summer* project were shot with the Nikon D1X and he's convinced that this is the way that he will primarily operate in the future. "It's changed my style," he says, "and made me much more confident in the field, as I can see what's happening as I go along."

Wolf howling

In Brandenburg's estimation there are few more evocative sounds in nature than the sound of a wolf howling. This classic image was taken at his permanent base camp near his Minnesota home using a 300mm lens fitted with a doubler, taking its effective focal length up to 600mm. As with most of his images, the camera was hand-held.

Nikon F4, 300mm lens, doubler, Kodachrome 64

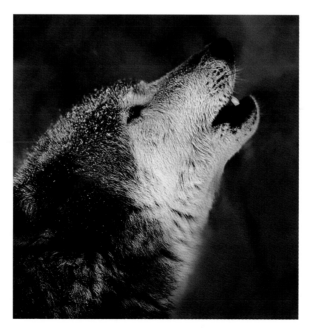

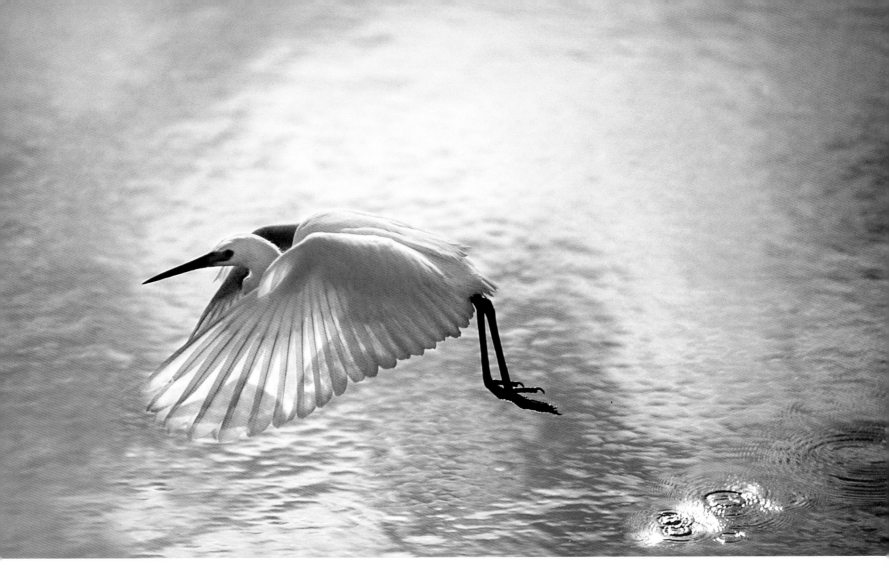

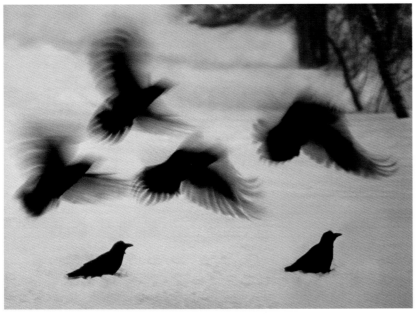

Ravens
Ravens are a subject very close to Brandenburg's heart, due to the dark reputation that they have gained in some quarters. This picture was taken close to his home in Minnesota, and he fitted a blue filter to the camera to emphasise the mysterious nature of the scene and set a shutter speed of 1/8sec to allow a mixture of sharpness and blur.

Nikon F4, 300mm lens, Fujifilm Velvia

Snowy egret
"The picture of the snowy egret, taken in the Florida Keys, was one of the things that I came up with for a *National Geographic* assignment to show America as it may have appeared when first viewed by Christopher Columbus.

"It worked perhaps a little better than I had expected. The egret took off against the light and consequently its wing feathers were highlighted and, to emphasise this, I underexposed by around one third to a half stop. For me this was unusual, because I tend to trust my cameras' meters implicitly."

Nikon N90, 300mm lens, Fujifilm Velvia

Jim Brandenburg

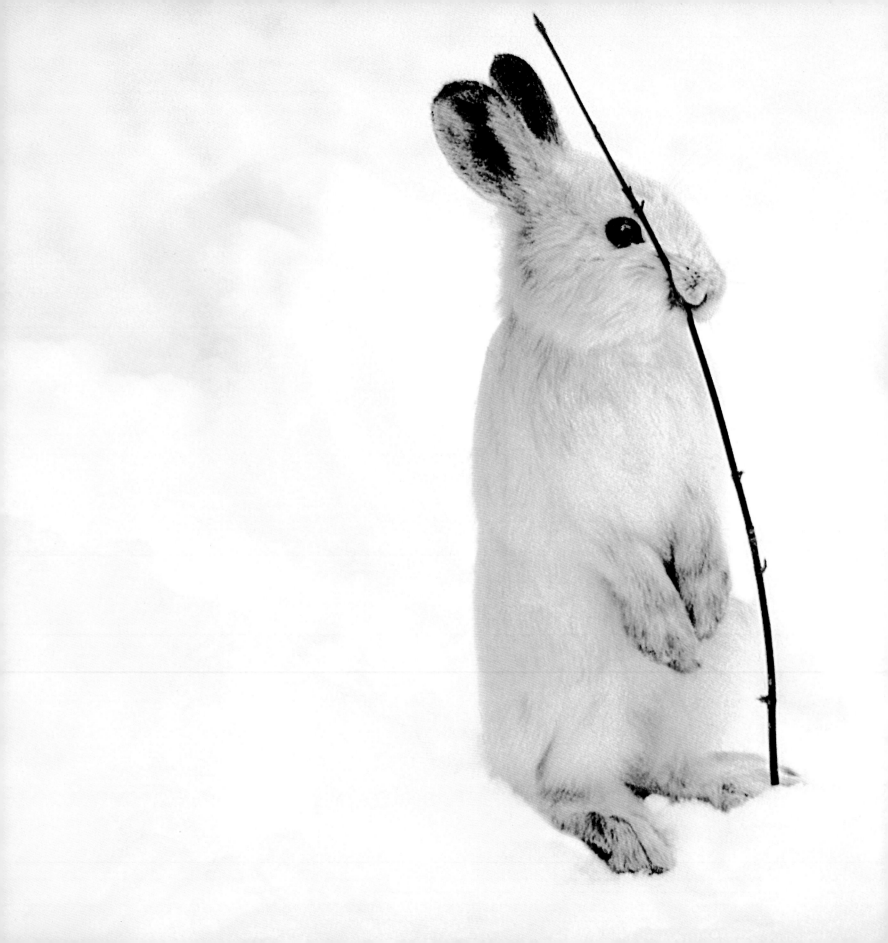

Snowshoe hare

"One of the joys of wildlife photography is to capture a moment that lasts in reality for just a fraction of a second and then, through your picture, lives on," says Brandenburg. "This was taken close to my home in Minnesota and it shows a snowshoe hare – so called because of the very large feet that are designed to help them walk across soft snow – in its white winter coat, feeding off a shoot that it has found.

"It's one of those images that can make people smile, and people warm to the subject in the way that they wouldn't do if it was something like a stoat or a weasel. For that reason, although it's quite an old image now, it's always been one that has been very popular."

In terms of technique, the picture was fairly straightforward. "I live in an area which is rich in wildlife," says Brandenburg, "and some are more tolerant towards humans than others. By making very slow and careful movements I was able to approach quite close to this hare and, when I was within range, I took this image using a Nikon F fitted with a 300mm lens."

Nikon F, 300mm lens, Kodachrome 64

Jim Brandenburg

Oryx

This is one of Jim Brandenburg's most famous images and it won him the title of Wildlife Photographer of the Year in 1988.

"It's almost a mix of landscape and wildlife photography," he says, "and that's the way that I like to work. I would much rather place a creature in its environment if possible than move in for a tight close-up and, on this occasion, everything just happened to work for me."

Brandenburg was on an assignment for *National Geographic* in Namibia when he took this picture. The country was in the process of gaining independence at the time and was still in the throes of a guerrilla war, and the story Brandenburg was working on involved pictures showing all aspects of the situation.

"These were the days when *National Geographic* was prepared to really let photographers spend the time on stories," he says, "and I was in Namibia for around three months taking pictures. I spent two weeks on this picture alone, and it was an image that I had in my mind and was prepared to pursue. When an idea is set in your mind to that degree it can be dangerous, but I really felt that I could produce an image like this."

At the time, there was a drought and many of the oryx were dying of starvation. Brandenburg's vision was of an animal wandering through a vegetation-free landscape looking for sustenance. "It was a very challenging environment within which to work," he says. "You would take one step forwards and fall two back and the wind driving the sand around caused equipment to malfunction on occasions."

Finally, his perseverance paid off and he produced this magnificent image with a Nikon F3, using the long end of an 80-200mm zoom, enhancing the result by underexposing between a stop and a stop-and-a-half to darken down the shadows and make the contrast of the scene even more pronounced.

"To me the picture is almost like a nude," he says. "It has a certain sensuality to it and that, to me, is where its appeal really lies."

Nikon F3, 80-200mm zoom, Kodachrome 64

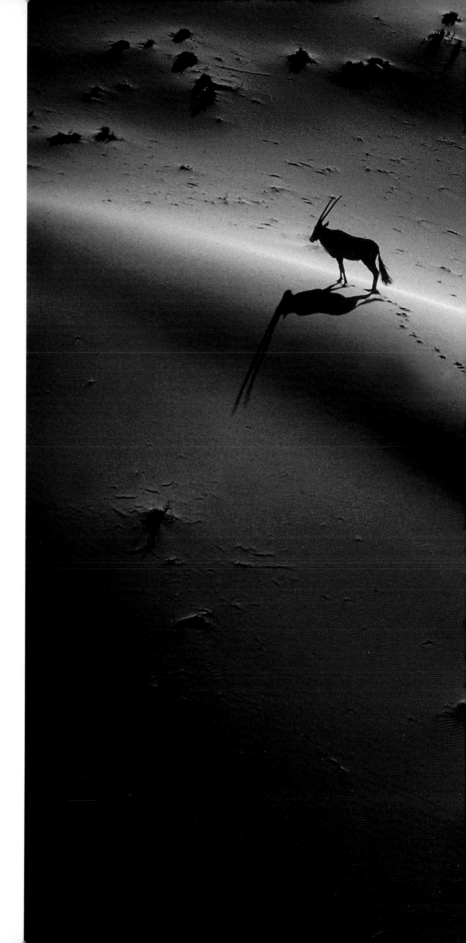

Laurie Campbell UK

Born in 1958 in Berwick on Tweed on the Scottish borders, Laurie Campbell grew up in a location with access to areas that were rich in wildlife. He was heavily influenced by an upbringing that encouraged him to have an appreciation of even the most everyday of creatures. "As a boy I remember keeping such things as worms and spiders in matchboxes," he says, "and I grew to understand them and to have an affinity with nature."

As he grew older, Campbell began to make expeditions out into the countryside to observe the natural world and the more dramatic wildlife that lay on his doorstep. From there, it was a logical step to pick up a camera so that he could bring back images from his forays that would enable him to share his experiences with others. Campbell's first pictures were taken in 1972, and he soon became immersed in the world of photography and was determined to try to build a career around it.

"One of my first jobs was at Edinburgh Zoo," he recalls, "and even then I knew that I wanted to be a wildlife photographer, and I was making black and white prints and selling them to visitors." He studied photography at Napier University in Edinburgh from 1977 to 1981 and, despite being given a grounding that was more suited to advertising and the commercial world, he came out with a thorough grasp of technical skills that has since proved to be of immeasurable value.

"Like many wildlife photographers these days I appreciate the things that modern equipment can offer," he says. "Autofocus has been a tremendous help and the quality of modern zoom lenses and doublers has allowed me to carry around a great deal less equipment, and yet still have the same range of focal lengths to work with.

"That said, there is still a need for the contemporary wildlife photographer to have a real understanding of photography so that they can take control when necessary. I have run seminars for many years and I will always insist that those on my courses use their cameras manually and learn how to meter from mid-tones and to use functions such as the depth of field preview button and the mirror lock to improve their results.

"I also stress the importance of using a good, steady tripod for wildlife work. It's amazing to me to see how many photographers will put a camera fitted with a huge lens on to an inadequate tripod: it means that, however good that lens may happen to be, they will never achieve true consistency in their pictures."

Campbell himself uses a Gitzo Carbon Fibre 1548 model, which is fairly compact but extremely solid, and he secures it still further by hanging rocks from it when he's shooting so that it's pulled into the ground and prevented from moving in any direction. A choice of two heads can be attached to allow different situations to be successfully tackled: for landscape and macro work Campbell fits a traditional pan and tilt head, while for wildlife he uses a fluid head that is more commonly employed by those shooting moving footage. The tension of this can be adjusted so that pans are extremely smooth and controlled and the camera can also quickly be locked off at whatever angle is required, saving precious seconds in a shooting situation.

Campbell has made his reputation by concentrating on subjects that he can find close to his home, preferring to leave the more exotic wildlife to those who are specialists. "I think you achieve the best results by taking the time to get to know your subject inside out," he says. "There are photographers who concentrate on just one part of the world and they are always likely to get better pictures than I would, if I was just to go to that place for a few weeks. By staying fairly close to home, I can devote the time required to cover a subject properly and can keep returning until I'm satisfied."

Past projects have included marathon series on golden eagles, badgers and the Cairngorm reindeer, and Campbell has recently started a long-term project on otters that has tested his commitment to the full. "Otters are more active towards the beginning and the end of the day," he says. "I have been arriving at my location around two hours before sunset and then photographing them until the sun went down, grabbing a little sleep on site and then photographing them again as dawn arrives. It's only by really getting to know your subject in depth like this that you're going to achieve the pictures that are special."

Campbell has proved many times over that, with the right level of skill and commitment, it's possible to come up with something unique even if some consider the subject in front of the camera to be a little ordinary. An eye for a picture and an empathy with the creatures he photographs creates an insight that only the very few can ever achieve.

Mountain hare, Scotland
This picture of a mountain hare in its winter camouflage was only achieved after a painstaking stalking session lasting several hours. Campbell spotted the hare and then, realising that it would instinctively run uphill if scared, he circled it from a distance until he was in a position blocking its line of flight. Then he very slowly moved forwards on his stomach, inching from rock to rock, until he was close enough to fill his frame, the 500mm lens he was using being taken up to 700mm by the use of a 1.4 converter. The effective aperture was reduced to f/5.6 by the use of a converter, and Campbell had to shoot at 1/15sec, using a beanbag to steady his camera.

Nikon F5, 500mm lens, 1.4 coverter

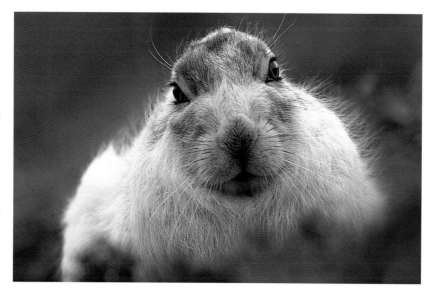

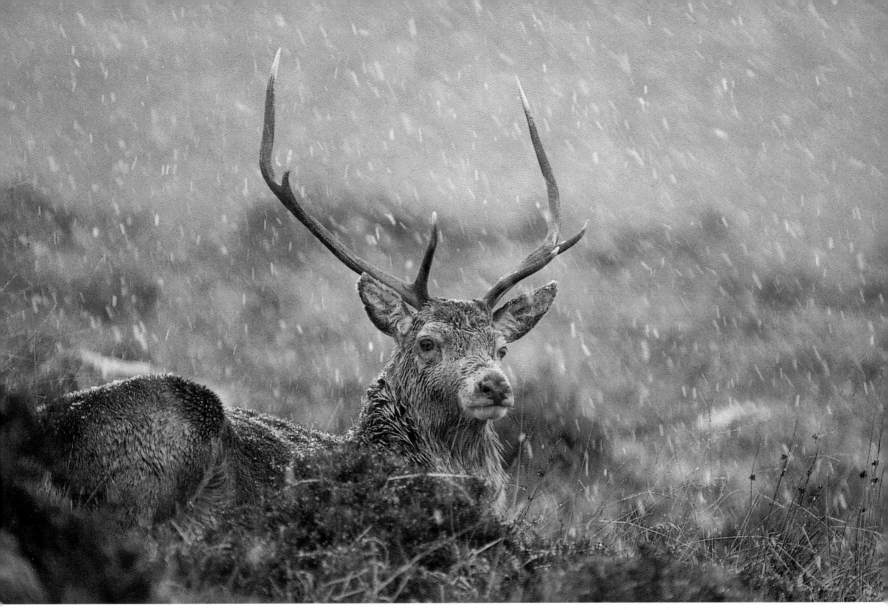

Red deer, Scotland
This red deer was photographed on a snowy day in Invernesshire, with a 500mm f/4 lens fitted to a Nikon F5. Campbell used a beanbag to steady the set-up and slowly stalked his quarry until he was close enough to fill his frame.

Nikon F5, 500mm 8/4 lens

Puffin
Campbell was returning from giving a workshop on the Farne Islands off the northeast coast of England, when he noticed how a strong wind coming from behind him was, for a fraction of a second, causing puffins coming in to land to hover in mid-air. Using a 300mm f/2.8 AFS lens on a Nikon F5, he set the camera to a 1/1000sec shutter speed to freeze movement and shot at f/4 hand held, achieving a series of 18 pictures that were all successful.

Nikon F5, 300mm f/2.8 lens

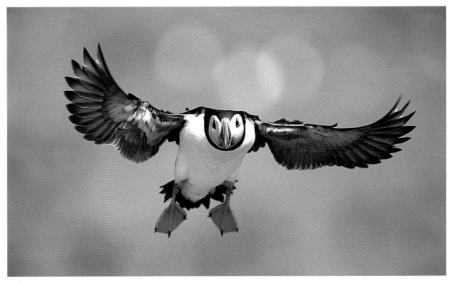

na

Laurie Campbell

Badger inside log, Scotland

A commission to produce the pictures for a recent book on badgers meant that Campbell had to undertake an extensive shoot in local woodlands. This involved painstakingly getting to know and to habituate a set of cubs that were growing up in one of the sets there. Faced with the need to obtain a variety of pictures of his subjects that would sustain interest throughout an entire volume, Campbell devised a series of situations that involved controlled lighting and, in some cases, a degree of scene-building. This image of a badger approaching through a hollow tree trunk was one of these.

"I dug around two to three feet into the ground to build myself a hide that allowed me a viewpoint that was on a level with the badgers," he says, "and took a lot of pictures from there. Although with the cubs it wasn't necessary to keep my distance, because they were used to me and happy for me to be around, the hide served as a good point from which to work and offered some shelter if the weather was bad. It also gave me a place in which I could sleep for a few hours, on occasions.

"One of the situations that I arranged involved this hollow tree, and I set it up so that I could see through the front of it through an opening in my hide. Then I hid some peanuts underneath the leaves in the foreground, knowing that it would only be a matter of time until one of the badgers picked up the scent and came to eat them.

"The picture was taken on Fujifilm Provia 100 film with a Nikon F4 and 35-70mm zoom, and I used an SB24 flash, softened with a small softbox, to illuminate the scene. There were several variations of this picture, including one where I set up lighting from behind the log to provide a rimlight behind the creature, but this one has been particularly successful because it is such a classic view."

Nikon F4, 35-70mm zoom, Fujifilm Provia 100, SB24 flash

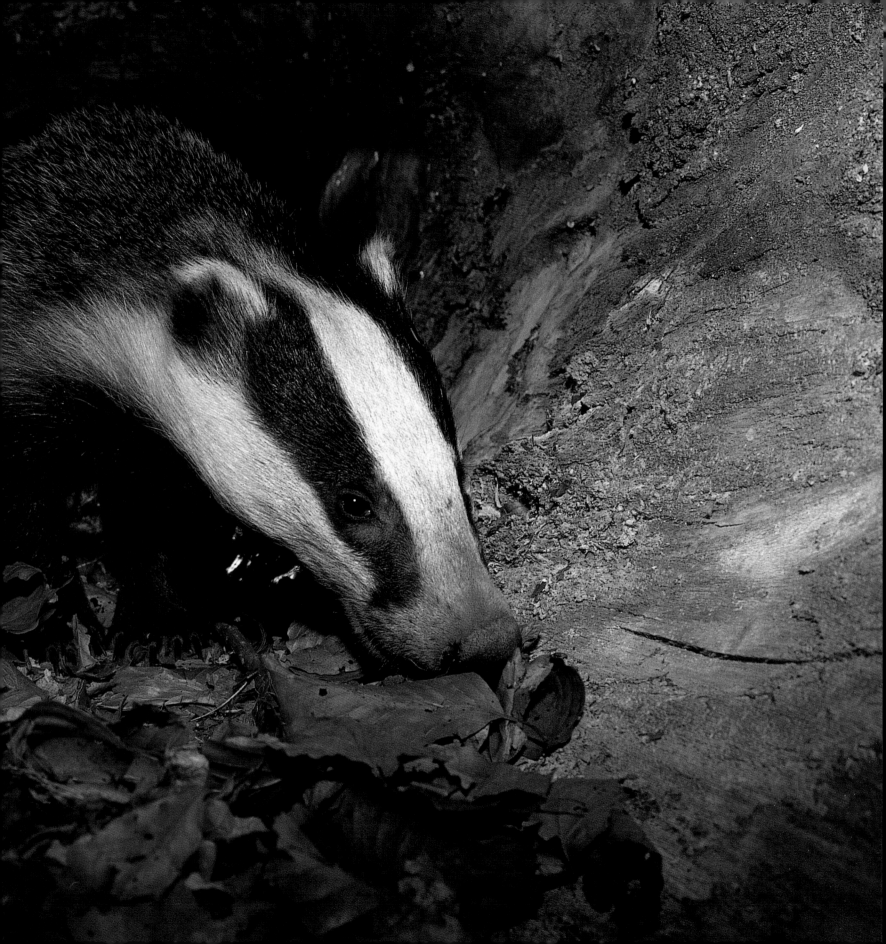

Stephen Dalton UK

Stephen Dalton's high-speed wildlife pictures were first presented to an enthralled public in the early 1970s, and they've been his trademark ever since. They are no mean trademark to have: when they first appeared they were revolutionary. No-one had ever seen anything like them before, which was scarcely surprising, since not only did a variety of formidable obstacles have to be isolated and overcome, but much of the equipment required to produce such images did not exist.

Photography had never been Dalton's first calling, although nature was a passion from his youth. "I was known as the 'Beetle King' at school," he recalls, "because I was fascinated with creepy-crawlies from an early age." A spell in London convinced him that he needed to get off the commuter treadmill and find some way of earning a living that didn't involve sitting in an office.

"I had fiddled around with my father's camera," he says, "and that had got me interested in photography. When I saw a three-year course advertised at Regent Street Polytechnic I jumped at the chance to sign up and, for the first time in my life, I found myself studying for something that I was genuinely interested in."

The marriage between natural history and photography was inevitable and Dalton published his first book of photographs, *Ants From Close-Up*, in 1967. However, his enquiring mind was already looking beyond simple close-ups: "Traditionally insects had always been photographed sitting on leaves in a very static way," he says, "and yet this was perhaps the least interesting aspect of their behaviour. The most amazing thing that some insects can do is to fly, and I felt that there had to be a way of capturing this on film."

The fact that, at that time, there was nothing available off the shelf that could do the job didn't deter Dalton. Instead it spurred him on to design, with the help of electronics engineer Ron Perkins, his own high-speed flash arrangement, which, after much trial and error and the incorporation of items such as household light switches and Kodachrome film boxes, finally allowed scenes to be captured that had never before been seen on film.

Once he had mastered his high-speed process, Dalton adapted it so that larger creatures could also be photographed. He worked to create scenes that, while usually done in the studio (to allow a degree of control impossible in the field) had a realistic feel to them, brought about by careful and accurate set-building and a dedication to lighting technique. "I wanted from the outset to recreate the natural habitat and natural lighting," says Dalton. "It would have been easier to have just put a light on either side to record the subject, but it would have given the image an aesthetically dull and artificial appearance."

Dalton's insect set-up is perhaps best described as a flight tunnel, in which the creature inside will instinctively head towards the light – the only practical way Dalton has discovered of ensuring any degree of predictability. Once the insect reaches a set point it breaks a series of light beams, visible or infrared, which have been focused on to a light-sensitive cell. The photocell relays the information to an amplifier, which in turn fires a high-speed flash, and at the same time activates a high-speed shutter mounted on a Leicaflex SL or R8 camera.

"It's a versatile system and I can easily adjust and modify it," says Dalton. "I can programme in a delay on the shutter, for example, so that it will fire a fraction later than usual, which is a good alternative to moving the position of the beam. And the trigger itself, which is sensitive enough to respond to something as delicate as a human hair, can be adjusted too, so that if I don't want something like an antenna or a clear wing to break the beam, I can lower the sensitivity and effectively alter the plane of focus."

It has also been possible to incorporate more than one beam into the system, so that the flash and camera will only fire when one or the other, or sometimes both in tandem, have been broken.

Along with the refinements, Dalton has also discovered that there is no such thing as one ideal flash speed for all subjects. When he started, he was using a speed of 1/30,000sec, which was enough to stop most living things, and yet there have been requirements for faster and slower speeds since then for specific pictures.

An assignment to photograph fleas jumping for *National Geographic*, for example, saw him working with a mind-boggling flash speed of 1/100,000sec, while slower creatures, such as butterflies, have required the speed to be dropped considerably.

"I can connect in extra capacitors in parallel with the existing ones to double the power that I'm outputting," he says, "and this halves the speed of the flash. So, instead of having a flash speed of 1/30,000sec, I can have one of 1/15,000sec. By the same token, when I photographed the fleas, I had to buy in some smaller capacitors, which produced less power."

The theory sounds odd, but Dalton insists that it's really very simple. "If you think about water going through a pipe, it obviously takes twice as long for a gallon of water to pass through the pipe as it does for half a gallon."

Of course, the greater the flash output, the further away the lights can be positioned, which becomes crucial when the larger creatures are being photographed. While the insect set-up is self-contained, the larger subjects may have to be tackled using the full area of the barn that serves as Dalton's studio, and the lights have to be positioned some distance from the subject.

Whether photographed in their wild habitat outside or in the studio, Dalton's pictures can take weeks to complete, particularly if there is a lot of set-building involved or technical and logistical problems to be overcome. "No-one believes that a picture can take that long to produce," Dalton says, "but I found out early on that the more you put into a picture the more you get out of it."

Butterfly
"I started my high-speed work by photographing insects, and to my mind they are one of the most difficult subjects to work with, because their flight paths tend to be very erratic. The principle remains the same as with the larger creatures however, and I work out as much as I can in great detail beforehand and then usually shoot masses of pictures to make sure I get the picture I want."

Leicaflex SL, 100mm Bellows Macro Elmar

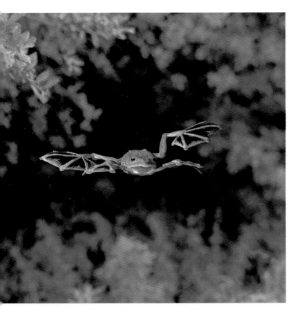

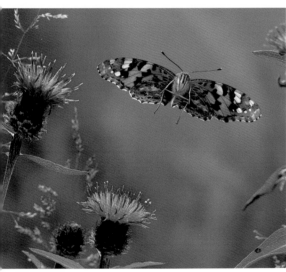

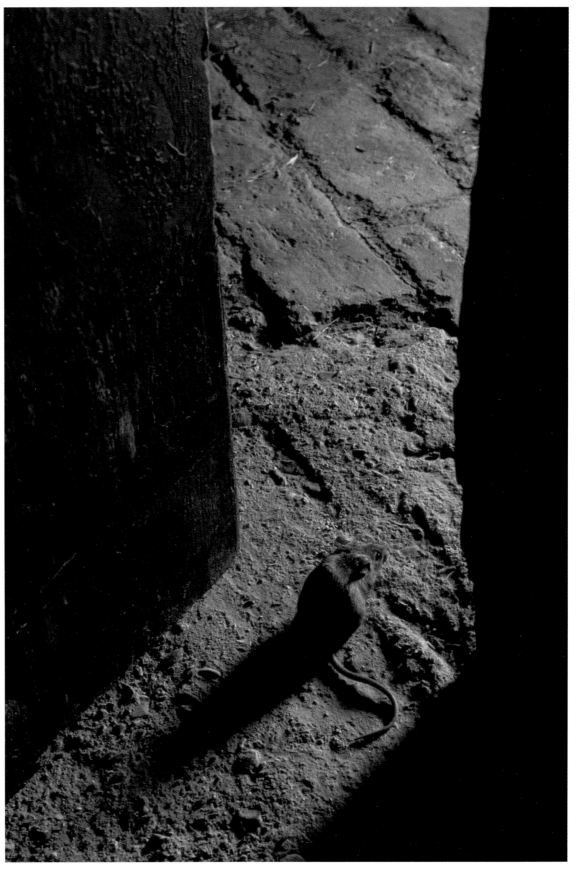

Flying frog
This shot of a flying frog in mid-air was completed within four days, because Dalton had the creature for just a short period. Four lights were set up to freeze the action and to produce the modelling that was required.

Hasselblad, 150mm lens

Mouse in doorway
Not all of Dalton's work involves high-speed flash, nor are the creatures he photographs always exotic. This picture of a common house mouse was set up on location in a stable for the book *The Secret Life of a Garden*.

Hasselblad, 50mm lens

Stephen Dalton

Basilisk running

This picture of a basilisk, or Jesus lizard, running across water is one of Stephen Dalton's best-known images. It was not only difficult to arrange technically, but also required an in-depth understanding of animal behaviour, plus an unlimited amount of patience — the shoot took three weeks to complete — before everything came together in the required fashion.

The first stage of the picture involved the construction of a set that contained a sizeable stretch of water – essential to allow the lizard to perform its party trick of scampering across the surface – surrounded by masses of vegetation that needed to be accurately sourced from the creature's natural habitat. Some idea of the scale involved can be gained from the fact that the basilisk is around 30 centimetres long.

Lighting too was complex, because Dalton was determined that it should convey the atmosphere of a forest scene. Six separate sources were used in total, including two fills, a backlight and a light overhead that was reflected in the water to mimic the sky.

Once everything had been arranged and tested, the problem that remained was how to encourage the lizard to run fast enough and in a straight line. "With this kind of photography you need to know how to handle an animal and be able to work out how it will react," says Dalton, "and you also need to be able to anticipate its future behaviour. In this case I worked out that the lizard would run towards a dark spot, and by setting one up we eventually encouraged it to go where we wanted it to go."

Hasselblad, 150mm lens

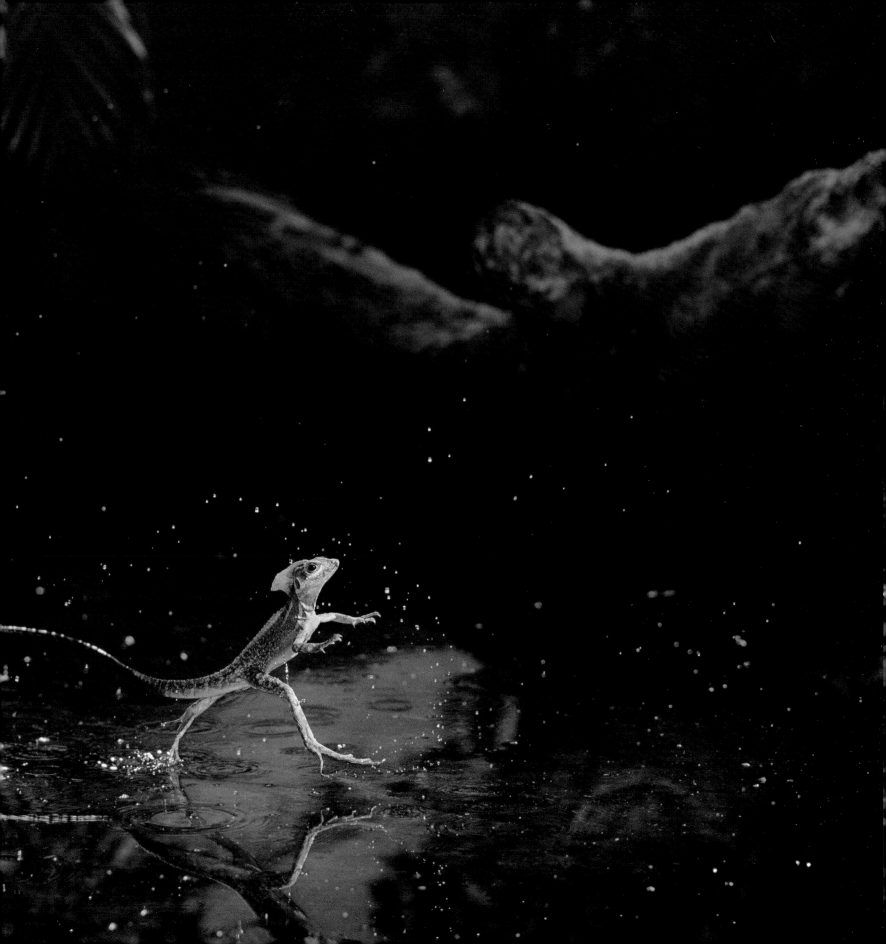

Manfred Danegger GERMANY

Being born with a love and solidarity for nature is, according to Manfred Danegger, the most basic requirement for anyone considering taking up wildlife photography. Throughout his childhood he spent a great deal of his time in the forest and field, observing and experiencing the flora and fauna. Initially he made drawings and paintings that documented his impressions of the things that he saw, but then, at around the age of 18, his interest started to turn towards photography.

Armed with an elderly 6x6cm Rolleiflex, the best camera his initial salary would buy him, Danegger worked exclusively in black and white. He processed and printed the results himself and invested his entire monthly income in his hobby, saving hard to buy himself equipment that would be better suited to his needs.

Because money was so tight, there was no prospect of travelling great distances to photograph the more exotic species. Instead, Danegger spent his free time concentrating on the animal and plant world close to his home in Konstanz, in southern Germany. He honed his skills on subjects others might have overlooked, spending hours in a camouflaged tent watching roe deer, foxes and hares.

His first successes as a wildlife photographer were noted by the press in his home town and the surrounding district, and slowly but surely he became recognised for the work that he was doing. After marrying, he began to travel through Europe with his wife and later his daughter, and this opened up a new world to him, allowing him to gain familiarity with further types of game, particularly mountain game.

Weekends and holidays were usually spent with his family in the mountain ranges of Austria and Switzerland, close to his home. There he tried to photograph chamois, ibex, red deer, marmot and other creatures indigenous to these areas. Climbing in the mountains while weighed down with cumbersome photographic gear was very tiring but, driven by their enthusiasm for nature, Danegger and his wife dragged their backpacks over the steep mountain paths. This effort was justified every time a photographic opportunity arose.

"One of the main problems with this way of working was the sheer weight of some of the equipment that I was using," says Danegger. "In particular I had an astro-objective 800mm lens which weighed 1 kilograms, and this came with a stand that was another five kilograms! This heavy lens often brought me to the point of exhaustion while I was stalking chamois." When Pentax brought ou a 600mm f/4 lens for the 6x7 format he was using, Danegger soon updated his gear and shed some of the weight he was carrying.

Winning a photographic competition took Danegger's career or to another stage, with the prize being a trip to Canada. Hiring a mobile home, he and his wife visited the national parks of Jasper, Banff and Kooteney in western Canada, and he became acquainted with the local fauna. Later, he had the opportunity to travel to East Africa, where he was inspired by the stunning diversity of species. But he was also frustrated, because the high-quality images that he wanted to take were time-consuming and, with a job back home in Germany, he had no opportunity to concentrate on his pictures.

The conflict was obvious to him and, in 1992, he decided to quit his job as a clerk to dedicate his time and efforts to full-time wildlife photography. He wanted, however, to pursue an individual path and not to concentrate on some of the more glamorous locations aroun the world that others were heading to.

"There are some who find that hard to understand," he says. "I am, however, very fond of European wildlife and find it very exciting I've specialised in taking action shots and in making a record of the wildlife in my homeland, whose behaviour I have studied for several years. I've learned that there is little in wildlife photography that is down to coincidence or luck. Detailed knowledge of animal behaviou is a prerequisite for those who want to make the best pictures of their subjects. In addition, experience of lighting conditions, weathe vegetation and the environment of a particular area is also required. Only if all the conditions are met are you likely to be successful."

Danegger is constantly testing different photographic products to ensure that he keeps abreast of technological advancements, an he is quite prepared to make wholesale changes to the equipment that he uses if he considers that another manufacturer has produce a product that is more geared towards his requirements. These long and extensive searches for the best equipment culminated in his renowned series of hare pictures, one of which, "Boxing Hares," won him the Wildlife Photographer of the Year title in 1998, an honou that he considers to be the pinnacle of his achievement to date.

Currently he's working with the Canon EOS 1V cameras and he partners these with an 80-200mm f/2.8 zoom, a 300mm f/2.8, a 400mm f/2.8 and a 600mm f/4. He also still uses a Pentax 645 camera and lenses on occasions. Film choice is Fujifilm Provia 100, which he uprates to ISO 200 or 320. Danegger's pictures are now sold worldwide through independent agencies and through self-promotion, being used to illustrate books, calendars and magazines

Fox and tree
This image was taken by Danegger in southern Germany while he was working on a project to photograph the rutting season of the roe deer. This red fox appeared and then suddenly changed direction to head towards a rotten tree stump, probably attracted by the nest of a black bird.

Pentax 645, 800mm f/6.7 lens with 1.4 converter, Fujifilm Provia 100 uprated one stop to ISO 200

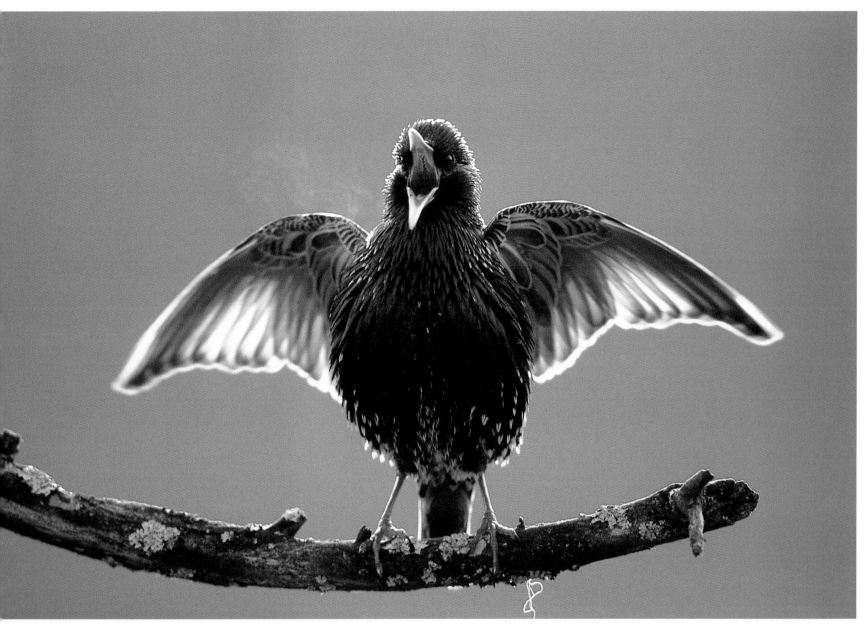

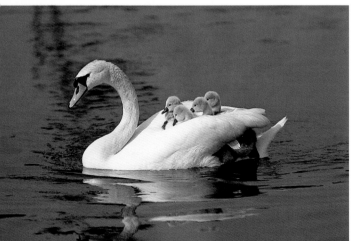

Swan with cygnets
A gently flowing brook provided the ideal setting for this picture, which was taken in Krauchenwies in southern Germany.
To avoid drifting in the running water, the cygnets were forced to rest on the back of their mother because they could not hold on to the steep banks.

Pentax 645, 400mm f/4 lens, Fujifilm Provia 100

Starling, Germany
This starling portrait was taken near Lake Constanze, Germany, from inside a camouflaged tent . Danegger prevented the extreme backlighting from creating flare within his lens by making an improvised lens hood from a sheet of board, which was held above the front element to prevent direct light striking it.

Canon EOS 3, 600mm f/4 lens, Fujifilm Provia 100 uprated two stops to ISO 400

Manfred Danegger

Boxing hares

Manfred Danegger invests an enormous amount of time in studying the behaviour of his subjects before he even considers photographing them. "This preparation is very time-consuming," he says, "but it is very important – especially for action scenes such as this. Only through observation will you get to know your subject well enough to capture moments that might take place in fractions of a second."

This picture, which won him the title of Wildlife Photographer of the Year in 1998, was the result of a year-long study of the behaviour of mating hares. This acquired knowledge, combined with his thorough mastery of photographic technique, enabled him to create a very special picture. The atmosphere of the scene, which was captured near Überlingen, on Lake Constanze in southern Germany, was greatly enhanced by Danegger's choice of viewpoint. He positioned himself so that he could take advantage of the extreme backlighting, which created an attractive halo around the hares and picked out the morning dew that was still on the meadow.

"The picture was created in the preliminary state of the hare wedding," he says. "During this phase the female hare was not yet ready for mating, but the male hare nevertheless came closer and touched her with its front runs. This behaviour became too annoying for the female hare, and she attacked him, the importunate male hare evading her move with a jump to the side. This scene repeated itself several times within one hour, and this resulted in a good opportunity to capture the event in a picture."

Nikon F4, 400mm f/2.8 lens, 1/1000sec at f/2.8, Fujichrome Sensia

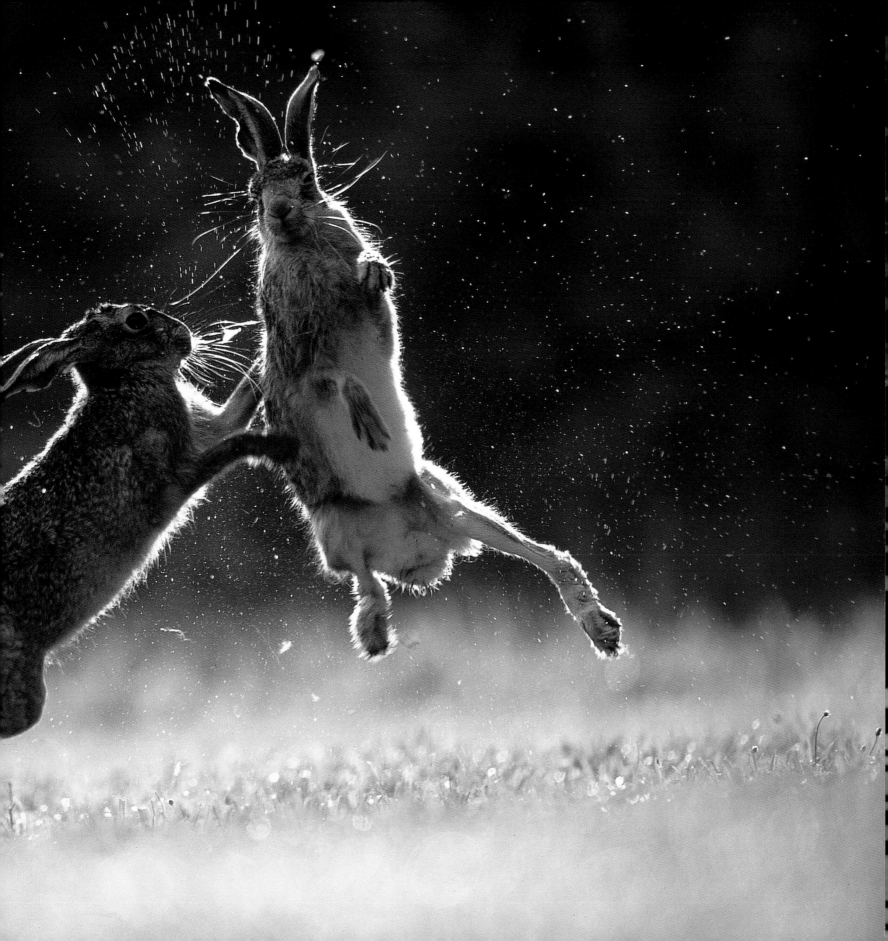

David Doubilet USA

Born in New York in 1946, David Doubilet always had a strong affinity with the sea, and began his close association with the underwater world by snorkelling off the coast of New Jersey aged eight. He remember Jacques Cousteau's book *The Silent World* making an enormous impression on him when he read it in 1956, and he also recalls the awe he felt when, as a diver, he looked up at the underside of the water's surface and saw what looked in effect like the reflections from a looking glass. It's a view he's always loved and found magical and, after a trip to the Bahamas with his father, during which he learned how to scuba dive, his bond with the sea was further strengthened.

It had always seemed logical to Doubilet to try to record the incredible sights that he was seeing, and he started taking photographs with a Brownie Hawkeye camera in a rubber bag at the age of 12. With every new technological development, he graduated to a more professional outfit. He slowly refined his photographic skills, and began winning competitions, such as the one run by the Underwater Photography Society of California, when he was 14.

Doubilet dreamed of the opportunity of using the skills he was acquiring to earn his living, and took his early portfolio to show to Bob Gilka, the editor of *National Geographic*. Gilka was brutally honest: he saw nothing new in the work, and neither did Doubilet's friend, the famed underwater photographer Bates Littlehales.

Doubilet accepts that his work at that time was derivative, but there were technical reasons why it was hard to be anything else, especially when the 6x6cm Rolleiflex and Rolleimarine housing that he was using, the best underwater kit of its time, was provided with a fixed 75mm or 80mm lens that made it impossible to photograph anything that wasn't at least the size of a soccer ball.

It was Bates Littlehales, together with Gomer McNeill, who came u with a solution to this problem, designing the "Ocean Eye," one of the first housings designed for the Nikon F – so universally popular with land-based professional photographers at that time – to feature a dome that corrected for distortion. "The wonderful thing that this housing allowed me was the ability to use wide-angle lenses," says Doubilet, "such as a 17mm Takumar full frame fisheye. The beauty c a fisheye lens underwater, of course, lies not so much in the technical aspects but in the fact that this environment is made for a lens of this kind, containing no straight lines that could be distorted." It also meant that, for the first time, Doubilet had the option to move in close and to photograph the beautiful world that he had been experiencing for years in more like its full glory.

The break he was looking for came in 1971, when he was invited by Stan Waterman, a well-known underwater filmmaker, to join the marine biologist Eugenie Clark on a *National Geographic* expedition to the Red Sea to study garden eels. The staff photographer on the trip, James L. Stanfield, was generous enough to allow Doubilet to get involved with the shoot, and the result was a series of wonderfu images of the eels extending into the current from the sandy seabed The published pictures featured a joint by-line for Doubilet and Stanfield, and from there things started to happen quickly.

More stories for *National Geographic* followed, including a serie with Eugenie Clark, and in 1976 he was offered the chance to become a contract photographer with the magazine. He is now a contributin photographer-in-residence at the National Geographic Society.

Many things have changed in Doubilet's working methods over the years, but his own passion for the underwater world and the incredible variety of sights that can be found there has never left him "I started shooting in black and white," he says, "and for years never used colour at all. It's a completely different discipline, and one that many people don't attempt these days, but the experience taught me a lot about the technicalities of shooting underwater."

Doubilet's current kit comprises Nikon F4 and N90 cameras in Nexus housings, having previously used Aquavision Aquatica housings with the F3 and F4. These are nowadays loaded with eithe Fujifilm Velvia, Provia 100 or 400, or Kodachrome 200, though he used Kodachrome 64 until recently.

His lenses range from a 13mm Nikkor to a 200mm Micro-Nikkor, but his favourites are the 16mm fisheye, the 60mm Micro-Nikkor an the 105mm Micro-Nikkor. For lighting he used a range of Sea & Sea strobes (specifically the YS300, YS200, YS150 and YS120 models) which he considers to be superb lights. He also uses small sonic research SR-2000 strobes and slave lights.

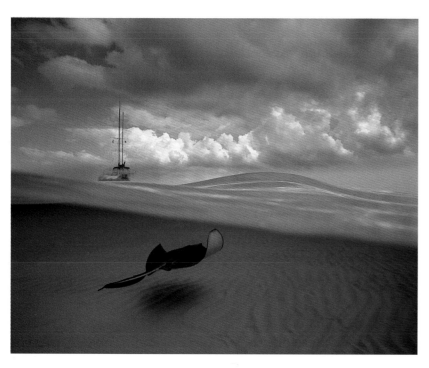

Stingray and sailboat,
Grand Cayman, West Indies
David Doubilet perfected a technique that allowed him to shoot above and below the waves at the same time, and this is one of his most successful shots using this method. "The timing was perfect," says Doubilet. "The curve of the ray's wings perfectly matches the curve of the water above. It's what Cartier-Bresson would have termed the decisive moment, and these happen underwater as well, although much more rarely." His technique revolves around the use of a split dioptre filter that allows focusing to be applied to two different areas of the picture at the same time. A graded neutral density filter is also used to darken down the sky.

Nikon F4, Aquatica 4 housing, Nikkor 18mm f/3.5 lens, Kodachrome 64

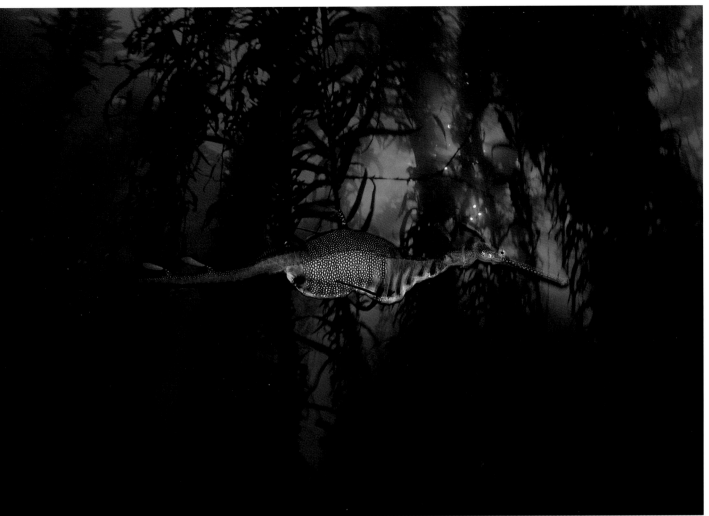

Weedy sea dragon and kelp forest
This portrait of the wonderfully named weedy sea dragon was taken in a kelp forest near Waterfall Bay in Tasmania.

"The biggest of the sea dragons are a little under a foot in length, and I saw this guy swimming along and just followed him. My 28mm f/2.8 lens allowed me to get quite close to him, and I framed the shot so that I was looking up towards the kelp. The subject was lit by two low, upward pointing strobes, fitted to either side of my camera by ultra light flexible aluminium arms. This threw some light at the creature, and I also used a slow shutter speed, probably a 1/15sec or maybe even a 1/4sec, to capture some ambient light. When you use this combination of natural light and strobe you get an edge around the subject. It's something fashion photographers have discovered and I like the effect too!"

Nikon F4, Nexus housing, 22mm f/2.8 lens, Fujifilm Velvia

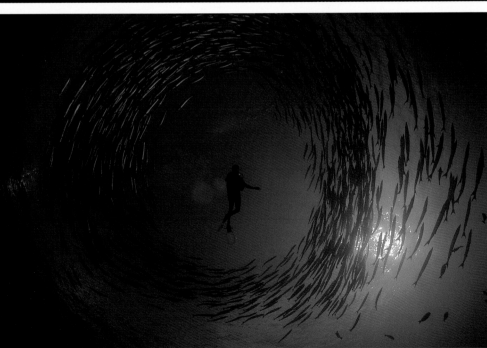

Circle of barracuda, Papua New Guinea
"I had known that barracuda were prone to form circles around divers on occasions for years," says Doubilet, "and I was determined to photograph this if I could. Then, during a dive off Papua New Guinea, I found myself surrounded in this way, and realised that I was the picture. Quickly I got back to the boat and persuaded Dinah Halstead, who was there, to get into her wetsuit and to follow me back into the water in the hope that they would do the same to her. We swam side by side into the school and I rolled on my back and looked around and they were doing what I had hoped, and I was able to get my picture."

Nikon F4, Aquatica 4 housing, 16mm f/2.8 lens, Kodachrome 64

David Doubilet

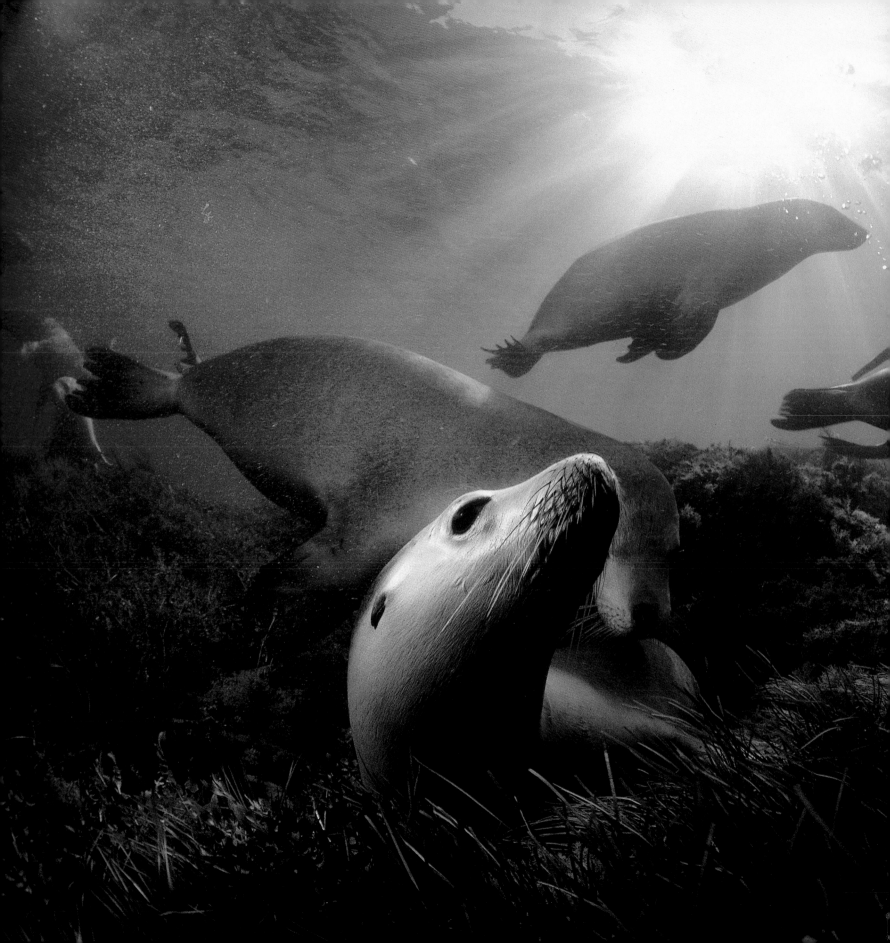

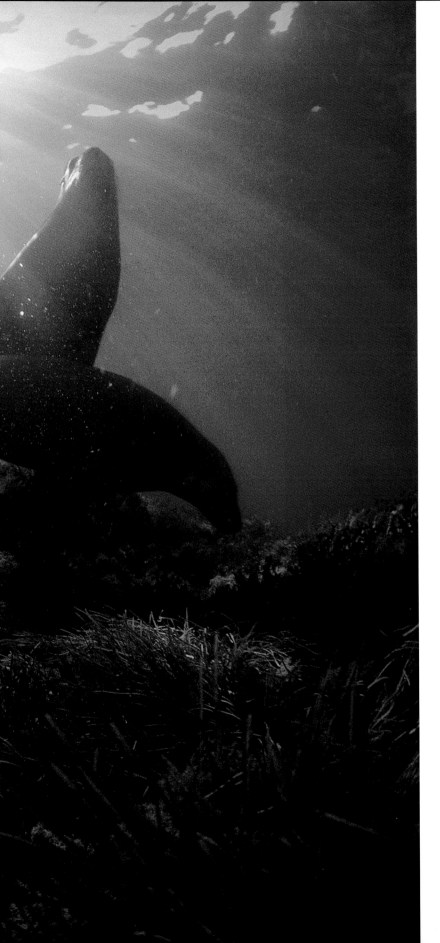

South Australian hair sea lions
This was one of the last pictures that Doubilet took using the "Ocean Eye" housing that had changed the course of his career. "There is a colony of seals in this location at Little Hopkins Island," he says, "and I've visited it three to four times, but I've never seen such a perfect combination of shapes before or since."

Nikon F1, Ocean Eye housing, 16mm f/2.8 fisheye lens, Kodachrome 64

Richard du Toit SOUTH AFRICA

As a child growing up on a farm near Pietermaritzburg, South Africa, Richard du Toit had a keen interest in photography and wildlife, and bird watching in particular. He did a BSc Honours degree at the University of Natal in Pietermaritzburg from 1980 to 1983, majoring in Zoology and Entomology. He then worked at MalaMala Game Reserve for six years, mainly in ecotourism.

In the 1995 Wildlife Photographer of the Year Competition, du Toit won first place in the Mammals Behaviour category with an image of fighting leopards. "As you'd expect, this provided me with major encouragement and enthusiasm," he says. "It played a significant role in helping me undertake the big jump that year from a keen amateur to professional wildlife photographer." He followed up his success in this most prestigious of competitions by winning the Animal Portraits category in 1997.

Being based in Africa has given du Toit a considerable advantage in terms of subjects to photograph. "With its extraordinary variety of wild beasts, Africa is a wildlife photographer's dream," he says. "I travel widely to the parks and wilderness areas in South Africa, Namibia and Botswana photographing wild animals, plants and scenery. One of my favourite regions is the Chobe National Park in Botswana. I love that part of the world for its vast unspoiled wilderness and great congregations of wildlife.

"From a photographic perspective I am a bit of a purist. I prefer only to work in natural environments and wilderness areas to photograph African wildlife. I don't photograph captive animals, only animals that are living wild and free. I photograph my subjects under totally natural circumstances, and I don't use baiting or calling of animals as a technique.

"I like to wait patiently and to let nature unfold at its own pace. I find this the best way to shoot unusual behaviour and action shots. I specialise mainly in mammals and birds, and am particularly fond of action photography.

"I really dislike the digital manipulation of wildlife images. For me it destroys the authenticity of the image, and is damaging the public's perception of nature photography. In my books I state that none of my photographs are manipulated or altered in any way with the use of computers. I want my images to be an accurate record of the behaviour of animals as captured by the camera in the natural environment. I believe that's what the public wants also."

Running his own library of wildlife and nature images, du Toit uses his wildlife images in a range of publications, primarily natural history books and calendars in South Africa. Some of his images have featured in international magazines such as *Geo*, *Sierra*, *BBC Wildlife* and *Outside Magazine*. In South Africa itself he contributes regularly to *Getaway*, *Africa Geographic* and *Africa Birds & Birding*.

Equipment-wise, du Toit uses Canon EOS 1N bodies, and has three Canon zoom lenses, namely the 17-35mm f2.8, 28-70mm f2.8 and a 70-200mm f2.8. He also uses a Canon 500mm f4.5 lens. "I rely heavily on autofocus to obtain the action shots I love to take," he says. "Autofocus has taken a while to master but it allows me to capture fantastic moments that the eye could never have seen."

Although he particularly likes shooting in low light conditions, du Toit takes care to use flash as little as possible, and has standardised his film stock, using Fujichrome Velvia and Provia 100 exclusively.

Diving hippo, Botswana
This shot was taken on the Khwai River, in Botswana's Okavango Delta. As the hippo unexpectedly charged towards him, du Toit managed to fire off several shots. "I had set my exposure settings manually by taking a reading off the grass in the background," he says, "because I knew that I was dealing with such a dark subject. After he charged he gave me a second chance by rolling over and revealing his waterlogged toenails. It just showed that you always have to be ready for the unexpected."

Canon EOS 1N, 70-200mm f/2.8 lens, 1/640sec at f/4, ISO 50 film

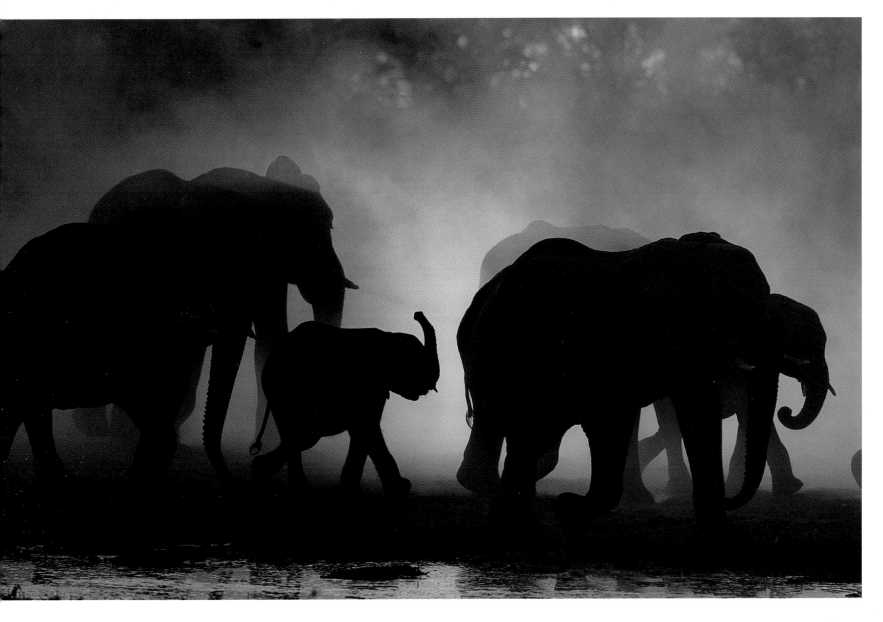

Sunset elephants, Botswana
The reflections that these elephants made as they passed by a river at sunset was the detail that caught Richard du Toit's eye in this image. He metered off the surface of the water to establish the exposure that was required in this tricky lighting situation.

Canon EOS 1N, 500mm f/4.5 lens, 1/500sec at f/4.5, ISO 100 film

Richard du Toit

Red-billed quelea

The red-billed quelea is one the most abundant bird species in the world, and often gathers in giant flocks to create one of nature's most extraordinary spectacles. Richard du Toit took this remarkable photograph in Botswana while on a journey through the Mababe Depression in the Chobe National Park.

"One winter afternoon I encountered numerous huge flocks of red-billed quelea," he says. "The birds were particularly abundant in this area because there was a waterhole nearby, which was one of the few in the area at this stage of the dry season.

"All together there were tens, if not hundreds, of thousands of these birds. Of course such a vast food supply attracted numerous raptors. In nearby trees sat dozens of tawny eagles. Marabou storks marched over the ground, and lanner falcons and other small raptors swooped past.

"In the late afternoon the flocks rolled like silver smoke across the grasslands as they fed. Their sheer numbers puffed up clouds of dust and seed. It was a sight and sound that was simply staggering. I wanted to take a picture that would capture the sheer grandeur of this spectacle. At dusk I found a position where I was looking directly at the setting sun, but this presented me with a tricky lighting situation. Against the dark background, however, the brightly backlit feathers made the queleas appear like butterflies fluttering past.

"The resulting image has become my favourite bird photograph; an unusual picture that I feel does justice to this awesome natural phenomenon."

Canon EOS 1N, 500mm f/4.5 lens, 1/320sec at f/8, ISO 100 film

Richard du Toit

Tim Fitzharris _{CANADA}

Having spent a lifetime interested in wildlife and the natural world, Tim Fitzharris began his career in nature photography in 1971. His very first project involved the photographing of nesting blue herons from a camouflaged treetop hide 20 metres above the ground. For the next six years he developed his passion for photography on a part-time basis while teaching English to high school and elementary school pupils in Alberta, Canada.

Finally in 1979 photography won out, and Fitzharris went full time, shooting in the field and teaching workshops in a variety of venues, including the Southern Alberta Institute of Technology in Calgary and the Cornell University Laboratory of Ornithology.

In 1983 his first book, *The Adventure of Nature Photography* was published, and around the same time his pictures featured four times on the cover of *Audubon* magazine in a single year. Since that time Fitzharris has travelled to many of the world's wildest places in search of new wildlife subjects to photograph, and his pictures have appeared regularly in an international selection of magazines.

He has written and taken photographs for more than 25 major books and produced more than 70 one-man calendars for such publishers as Firefly Books, Penguin Books, Little, Brown and Co, Oxford University Press, HarperCollins, Sierra Club Books, Pomegranate Publishing, Portal Publications and many others.

In 2000 Fitzharris began writing a monthly nature photography column for *Popular Photography*, the US magazine that has the largest circulation (500,000) of any photographic title in the world. In the same year, he won first place in the bird behaviour category of the Wildlife Photographer of the Year Competition. The following year, he won the mammal behaviour section of the same competition.

Spoonbill
This spoonbill in the Teacapan Estuary in the State of Sinaloa, Mexico, was photographed by Fitzharris from his floating hide

Canon EOS A2, 500mm IS lens plus 1.4 converter, Fujifilm Velvia

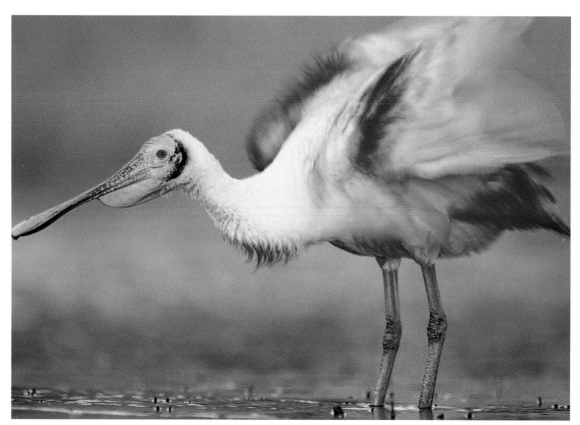

Iguana
This iguana portrait was taken on the island of Roatan, which is part of Honduras. The creature had been caught by Fitzharris the previous evening and had spent the night in the fridge, which cooled it down and slowed its movement.

Canon EOS A2, 70-200mm zoom, Fujifilm Velvia

Elephant seals
This is from the sequence that won Fitzharris the mammal behaviour section of the Wildlife Photographer of the Year Competition in 2001. "I had been photographing an elephant seal colony on the Big Sur coast just south of San Francisco for a few days," he says "when I saw these two elephant seal bulls start to fight. It's not something you see often, but it turned into an all-out battle, in and out of the surf, for around ten to 15 minutes, and all the time I was shooting as fast as I could."

Canon EOS A2, 500mm IS lens, Fujifilm Velvia

Tim Fitzharris

Flamingos at Lake Bogoria

This abstract image of flamingos on Kenya's Lake Bogoria was taken by Tim Fitzharris from a floating hide that he designed himself. "It's made from Styrofoam and marine plywood," he says, "and it's configured to fold up so that it can fit in a bicycle carton and travel in an aeroplane hold.

"While I was at Lake Bogoria, I would arrive at sunrise and set the hide up. Its design allows me to put my feet through and with a lake such this one, which has large areas of shallow water and extensive areas of marsh, I can then either wade or paddle to get myself around. The hide has a steel plate bolted to the deck, with a standard quarter-inch tripod bush welded onto this, to which is fitted a ball and socket head. This allows the camera to be held perfectly steady, even if a long lens is being used.

"On this particular occasion I headed out across the lake and initially the flamingos that were out there were a little skittish and wary of me. After around 30 to 45 minutes, however, they started to settle down and thousands of them congregated around me until eventually I was completely surrounded on all sides, with the nearest birds just 40 feet away.

"This was too close for me to try the abstract pictures that I wanted to take, and I had to wait until they were nearer 60 to 70 feet before taking this image. I used a 500mm lens with a 1.4 converter and set a shutter speed of around 1/30sec, panning with the birds as they took off across the lake.

"It's one of my favourite pictures, because part of the creature is defined so that you are aware of what it is, but the blur has created a sense of movement that suits the subject perfectly."

Canon EOS A2, 400mm f/2.8 lens with 1.4 converter, Fujifilm Velvia

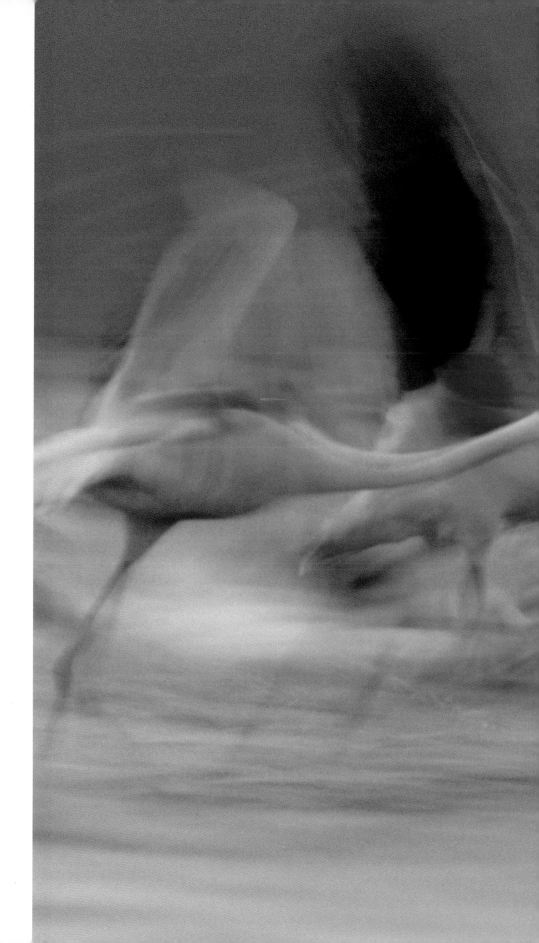

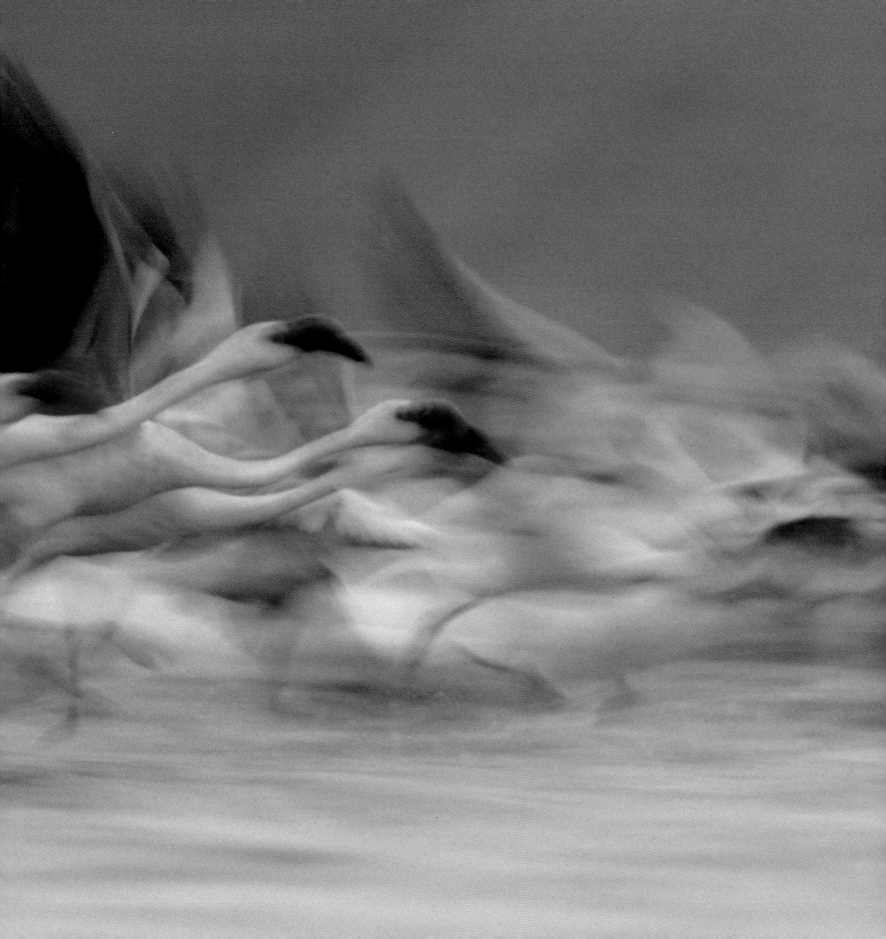

Anders Geidemark SWEDEN

Born in 1963 in the forest region located in the middle of Sweden, Anders Geidemark experienced a lonely childhood, simply because there were few other children in the area that he could play with. "The forest became my playground," he says, "and I had plenty of time to philosophise. My father was an enthusiastic hunter and I listened to his great stories. He didn't read fairytales to help send me to sleep: he read hunting novels!"

While it may not have been the ideal environment for making friends, it was a good preparation for someone planning to embark on a career in nature photography, and Geidemark started young, buying his first real camera outfit when he was just 13 years old. "Although I had just one body and a 400mm lens I was convinced I was now ready to shoot all the pictures that I ever wanted of foxes, roe deer and moose," he says.

After a few years he refined his philosophy a little. He was now no longer concerned simply with getting as close as he could to his subjects, seeking instead to tell a story through the pictures that he took. This decision was related to the fact that he had started to give talks and to show his photographs to the public, but he also wanted to define his own feelings for nature.

"I had decided that I needed to take different kinds of pictures to those that I had started out producing," he says. "Of course these s had to be true records of the creatures that I saw, but I wanted to build the atmosphere and to give them more of an aesthetic quality. This remains my ambition to this day: to combine biological accurac with a touch of my own feeling for the subject in the one picture.

"When I'm in the field I'm more likely to have a pen in my hand than a camera. I draw sketches and write down ideas for forthcomir books and slideshows. I seldom take pictures that are intended to stand by themselves. I always have a plan to combine them with te within a book project, or to produce a picture sequence that will be matched with a special piece of music to make a slideshow.

"I like to tell stories that fascinate me. They may be about evolutio or the geological history of a landscape, or perhaps the background to a particular species: whatever, I try to make my story more interesting by delivering it in a poetic or artistic way.

"A good example of my way of working is my project on Iceland 'Stigen ur hav – av vingar skuggad' (Risen from sea – shadowed by wings). I spent a total of seven months in the country putting togeth the pictures that I needed to produce a slideshow and a book about time perspective. The story was about Iceland's geological history, but also my personal reflections of evolution and the way we, the human race, are part of the world for a relatively short period of time

"For me it is very important to fulfil my story by also producing the layout for each project, and consequently I am my own publishe Not because I necessarily think that things will be better because I have complete control, but because I believe very strongly that if yo have taken the pictures and written the text, and the whole idea anc concept is yours, you must tell the story to its end.

"Likewise, when I take picture sequences for a multi-slide show I always bring the piece of music that I'm intending to use in the show out with me in the field and then I listen to it in the car, over an over again, just to get the atmosphere right and to put myself in the right frame of mind to take pictures that will be complementary."

In terms of equipment, Geidemark uses 35mm, medium and large format cameras, but keeps things as technically simple as possible. His 35mm gear, which tends to be used the most, consist of two old Canon F1s and a selection of lenses ranging from 14mm up to 500mm, supplemented by converters.

Medium format is catered for by a Rolleiflex 6008 Integral, for which he has 50mm, 90mm, 180mm and 300mm lenses, while the large format gear is a Wista 9x12cm camera with three lenses.

"One of the most important pieces of equipment that I have is a heavy old wooden tripod," he says. "Of course I get tired carrying it around with me, but when I'm in place and waiting for things to happen I really enjoy its company. The tripod is like an old friend that have shared so many good times with!"

Arctic fox
Geidemark made several trips to Iceland while working on his project about the island's geological history. In all, it took him seven months to get the shots he wanted, including this one of a curious arctic fox.

Canon F1, 500mm f/4.5, Fujifilm Velvia, tripod

Arctic tern
Geidemark photographed this arctic tern in Iceland. As it came in to land during the early hours of the morning its wings were backlit by the red-orange light of the midnight sun, creating a spectacular effect.

Canon F1, 500mm f/4.5, Fujifilm Velvia, tripod

Harbour seal
This shot was also taken in Iceland. Geidemark lay flat on the sand and composed the shot to include the seal's reflection in the wet sand. His expression adds a touch of humour to the image.

Canon F1, 500mm f/4.5, Fujifilm Velvia, tripod

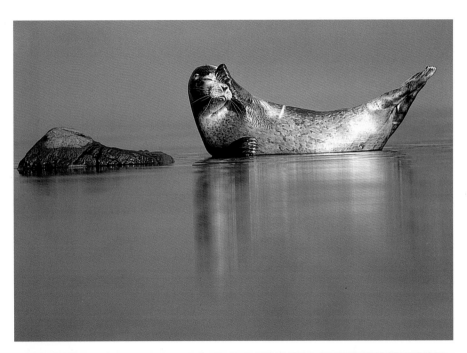

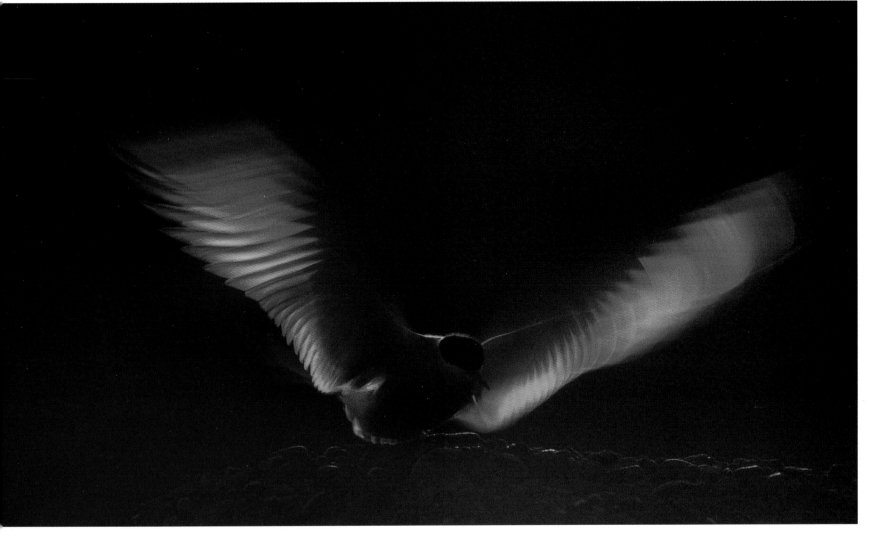

Anders Geidemark

Gannets and dawn waves, Iceland

The night was very cloudy and dark despite the fact that it was June on the north coast of Iceland, close to the polar circle. "I decided to make the ten-kilometre walk out to where I knew there was a gannet colony in any case," says Geidemark. "I was curious to see the colony and to get the chance, for the first time in my life, to study these majestic birds at close quarters. In the boring light that prevailed, however, I didn't have any expectations of getting good pictures.

"I reached the cliff where the birds were and, from a place on the edge, got a great view over the colony. Through my binoculars I could get close up to see the family business of these maritime birds: when you're watching them this closely it's easy to understand the theory that all birds are developed from prehistoric lizards. It's something to do with their elongated bodies and stiff movements and, of course, their lightning reptile-like eyes!

"With eyes filling with tears from the chilly wind blowing in from the sea, I took just a couple of documentary pictures. The light wasn't really inspiring at all. Suddenly, however, everything changed. The thick cloud cover in the north broke up and a glimpse of the midnight sun shone through. The stage in front of me was transformed into a scene from an Icelandic saga. I have never, before or since, witnessed such a fantastic light. It was unbelievable!

"Four birds were resting to the right, away from the colony. Behind them were the dawn waves rolling in, reflecting the very warm light from the sun. I thought I must choose a slow shutter speed – I set one second – so that I could record as many reflections as possible on the film.

"I forget how long it all lasted, but it can only have been a matter of a few minutes. In that time I managed to shoot three to four rolls of film before the small gap leaking midnight light healed up again. The gannets look indifferent, but I just sat there happily exhausted. If I hadn't taken the pictures to record what I had seen, I think it would have been difficult to remember the intensity of that short, and magical, night light."

Canon F1, 500mm f/4.5, Fujifilm Velvia, tripod

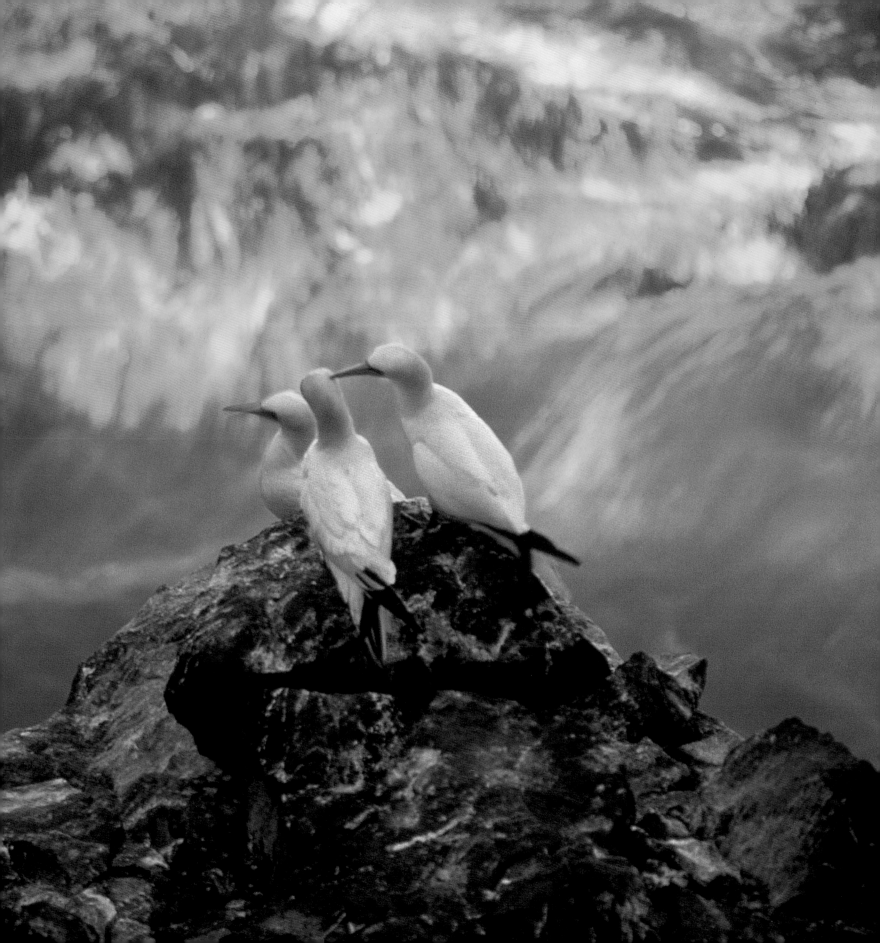

Hannu Hautala FINLAND

Hannu Hautala was born in 1941 in Ostrobothnia, the flat region along the west coast of Finland where, he claims, people are born stubborn. "When they have decided on something, they will do it, no matter what stands in their way," he says.

This is certainly the attitude that has characterised Hautala's own career. Already as a young boy he had decided to become a wildlife photographer, although in Finland in the 1950s, nobody took this very seriously. His neighbours, even his parents, thought this ambition was strange. "I remember one Saturday night when I was 16, I was setting off for the grouse mating," he says, "and I ran into a crowd of kids, the same age as me, coming back from a dance. Look, they said, there's that daft Hautala kid, off into the woods again."

He wanted only to photograph birds, but as he had to make his living somehow he trained as a motor mechanic. But all the money he earned was used to buy camera equipment and all his free time was spent out in the field photographing birds. Eventually this perseverance started to pay off, as he started to sell his photographs and wildlife articles to magazines. In 1968 he made further progress, when his first book, *Life in the Wild Woods*, was published.

In 1970 he received an artist's stipend from the government – the first time this had ever been given to a photographer – to record all the species of birds known to nest in holes in trees in Finland. The book that resulted was published in 1977. With the support of this stipend Hautala gave up his job as a mechanic to work as a full-time wildlife photographer and moved to Helsinki to establish himself.

Eight years later, he moved to Kuusamo near the Arctic Circle, 800 kilometres north of Helsinki. The plan was to live in the centre of Finland, where there would be a shorter journey either to the north or the south. In practice, however, there was little need to travel anywhere, because Kuusamo has inexhaustible resources for the wildlife photographer. This is the northern limit of the nesting area for many of the southern birds, and the southern limit for northern birds, and it's also possible to find eastern taiga wildlife species in this area.

Hautala starts to plan for the next summer's photography during the previous autumn. He knows exactly where to search for each subject he needs, and he visits the same sites over and over again, looking for the right moment, movement, light, colouring and clouds. Winter photography has become increasingly important too, and he revels in the extreme circumstances; the more difficult they are, the fewer rival photographers are likely to be around. Nowadays he has seven permanent hides set up for summer and winter photography; in spring he concentrates on whooper swans and ducks, and in winter the golden eagle, ravens, red fox and the other winter species.

"In wildlife photography, 90 per cent of the job depends on your knowledge of nature, and only ten per cent depends on your equipment," says Hautala, and that attitude has been with him ever since the earliest days. His first camera, a Felica, was purchased in 1957, and was the cheapest model available. The following year he purchased a Lubitel, then switched to an Exakta Varex II. After a brief spell with a Pentax Spotmatic he bought his first Canon F1 in 1971 and has stayed with Canon ever since. He currently uses EOS 1V cameras and his lenses include a 600 f/4 L, a 100-400mm IS zoom, 300mm f/2.8L, a 17-35mm, a 28-70mm, a 180mm macro, a 14mm and 2x and 1.4x extenders. He also owns a PB-E2 motordrive and the Canon Speedlite 550 EX flash, plus several heavy tripods, a monopod and a shoulder bracket. This being Finland, with its wilderness areas and harsh winters, his kit also includes several hides, a snowmobile and a canoe.

Snowy owl in flight
This snowy owl portrait was taken in Muhos, Finland. Hautala had with him the paw of a hare that had been killed by a car. He fixed this to a 100-metre-long white line, which he took to a field close to where the owl was. He watched it through his binoculars and, as the owl flew to sit on the roof of a barn around 500 metres away, he pulled the line. The owl saw the paw moving and flew towards it, but soon realised that it had been betrayed and flew away. Hautala followed the owl with autofocus, and, when it filled around half the frame, he shot this picture.

Canon EOS IV, 600mm and 2x converter, Fujifilm Astia 100

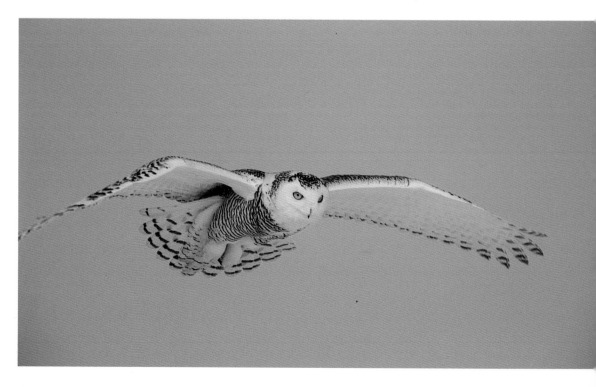

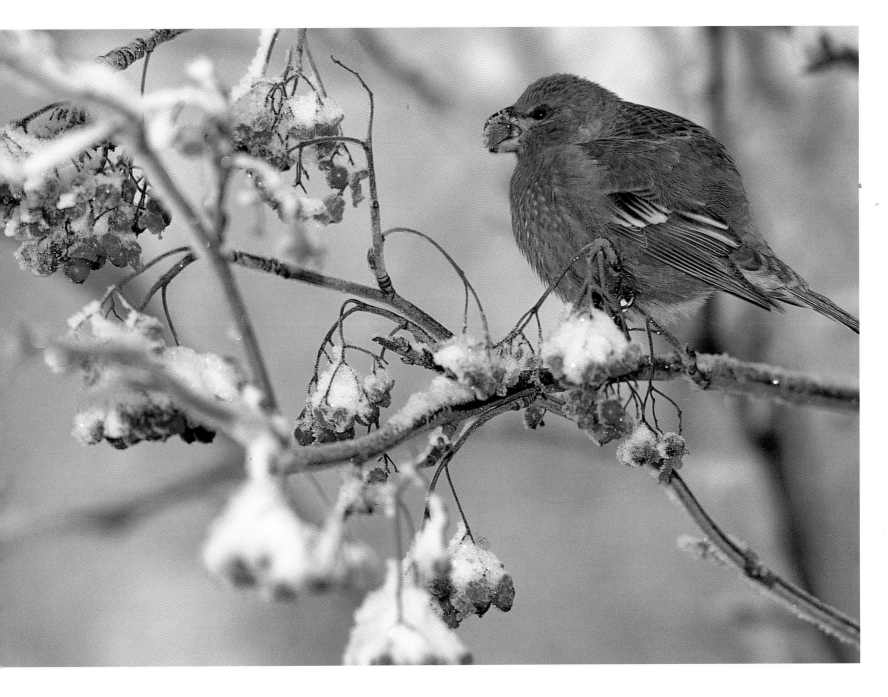

Pine grosbeak

This picture was taken in Kuusamo, Finland. "In the winter of 2000-2001 there were plenty of pine grosbeaks all over Finland," says Hautala, "and here in Kuusamo they stayed until the end of January, because there was an abundance of rowan berries for them to eat. We also had some very cold weather, sometimes as low as -35°C, which made photographing the birds even more interesting."

Canon EOS IV, 600mm lens and 1.4x converter, tripod, Canon Speedlite 550 EX flash

Hannu Hautala

Snowy owl

Snowy owls are very rare in Finland, and Hannu Hautala has been fascinated with them since he was a boy when, during mild winters, they could sometimes be seen in the large fields of Ostrobothnia.

This picture was taken in March 2000 in Muhos, near Oulu, Finland, about 200 kilometres from Hautala's home in Kuusamo. "I knew that there were two snowy owls near a large field, which had attracted plenty of other photographers," he says. "It was not possible to find the birds every day because they had very good camouflage in the snowy landscape. Mainly the bird simply sits in the snow and is consequently very difficult to see: only when it is preying can it sometimes be seen sitting on the roofs of barns, looking for voles.

"In Kuusamo I had with me some visiting photographers from central Finland who were also interested in photographing the snowy owls. There were six of us in total who started out together to Muhos early in the morning and, when we got there, we could not see the birds and started to look for them. Finally a call on one of our mobile phones told us that one of the owls had been spotted.

"Cooperation between us was very important if we were to get our pictures. In turn one or two photographers very carefully approached the owl, which we could clearly see sitting there. The other photographers were on different sides of the field keeping very still. This way the owl could fly to another place onto the snowy field, but one of us would always be close enough to be able to take some photographs.

"I was hiding in bushes when I saw through my binoculars that the snowy owl was approaching a barn, and it landed close to the spot that I had envisaged. Talking with the other photographers, we all agreed that we should be still for 15 minutes. Then, from the direction of the setting sun, two photographers approached the bird, carefully taking pictures. The sun was already at the horizon, and I had my camera ready on a tripod and fitted with a 600mm and 1.4x converter, with focusing concentrated on the owl.

"My exposure reading was taken from the sky, because I wanted to capture the colour of this winter's evening. I also had a new film in my camera. When the owl became restless, I was ready but remained still and then, as it started to fly sideways as I had anticipated, I shot half a roll of film with my Canon EOS 1V."

Canon EOS 1V, 600mm and 1.4x converter, Kodak Ektachrome 200

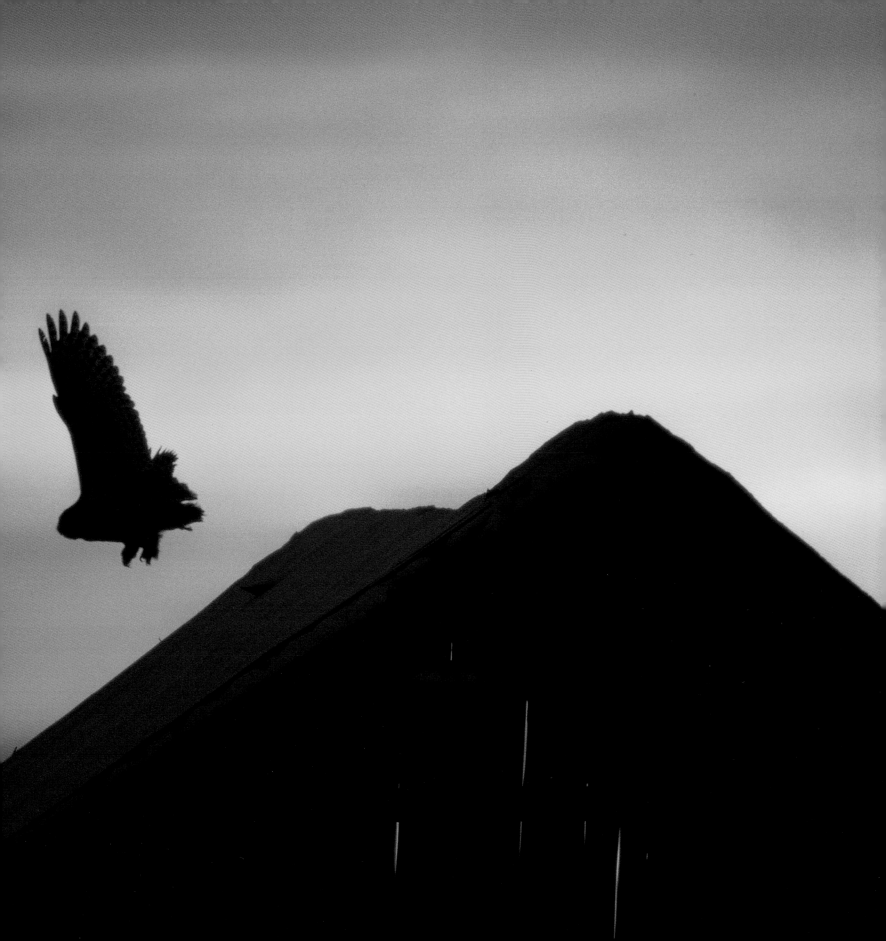

Mitsuhiko Imamori JAPAN

Born and raised in Shiga prefecture, Japan, Mitsuhiko Imamori grew up with an abiding interest in creatures such as birds, insects and fish, which were in abundance close to his home. "I was raised in the country," he says, "with mountains and the largest lake in Japan close by, and nature still abounded in this region. I was inspired to take photographs because I wanted to record nature and the life around me exactly as it was."

He was self-taught as a photographer, studying on his own, reading books and learning technique largely through trial and error. He first started to take his photography seriously when he was a university student, and has since worked abroad as well as locally in his search for wildlife and natural history subjects. "I concentrate not only on insects but on every aspect of nature," he says. "But the insects are especially attractive to me because they seem to have abilities which are beyond our imagination. Photography encourages you to look at the subject very closely, and get more involved with it."

His equipment consists of a Nikon F4 with a 105mm macro lens, and 20mm, 200mm, 300mm and 600mm lenses. He also uses a Pentax 6x7cm camera, and partners this with 45mm, 135mm and 300mm lenses.

Before attempting to photograph his subject, Imamori watches it closely so that he can learn about its behaviour and be in a position to anticipate how it is likely to react in various situations. "I want to bring out the best of its beauty and its mystery," he says, and much of his work is successful on two levels, conveying information about the creature but also placing it within the context of an exquisite image.

"There are many photographers whom I respect very much," says Imamori, "but none who influence my style of photography. I am more influenced by other people than by photographers."

His many awards include the 17th Shiga Cultural Encouragement Award in 1991, the 10th Higashikawa New Photographer Prize in 1994, the 42nd Sankei Children's Book Award – Grand Prix in 1995, the Shumei Culture Prize in 1996, the 9th Special Prize of Culture to Otsu Citizens in 1996 and the Blue Lake Prize, also in 1996.

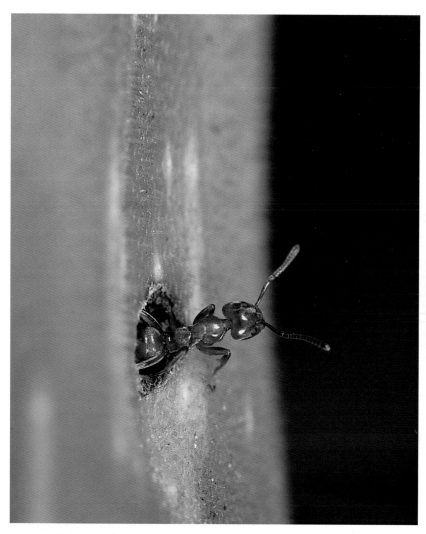

Azuteca ant, Brazil
This ant was photographed emerging from a hole in a leaf.

Pentax 6x7cm, adaped 50mm lens originally designed for 35mm use, Kodachrome 64

Poison spider
Imamori took this photograph of a poison spider in Narbonne, France.

Nikon F4, 105mm macro lens, Kodachrome 64

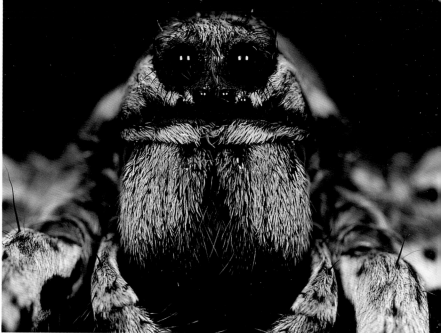

Leaf katydid

This leaf katydid (Tettigoniidae) was photographed by Imamori in Malaysia. "It was at a standstill on the other side of a leaf," he says, "but, when moving, it became like an ordinary katydid and went on foot. Surprisingly it became a part of the leaf, making its body, which was approximately eight centimetres long, extremely flat." To show that the leaf was transparent, Imamori needed to light it from behind. He set up a strobe to allow him to do this, positioning it on a tripod and directing its beam so that no branches caught the light and created unwanted shadows on the leaf. The clean lines and cool green tones of this picture have combined to create an unforgettable image of a simple and largely unsung creature.

Pentax 6x7cm, 90mm macro lens, Fujifilm Velvia

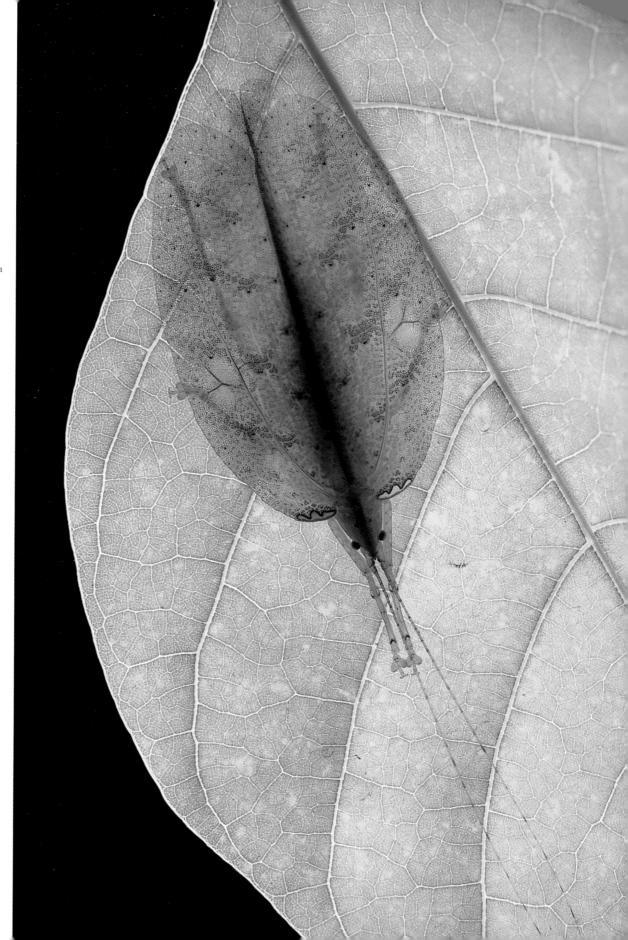

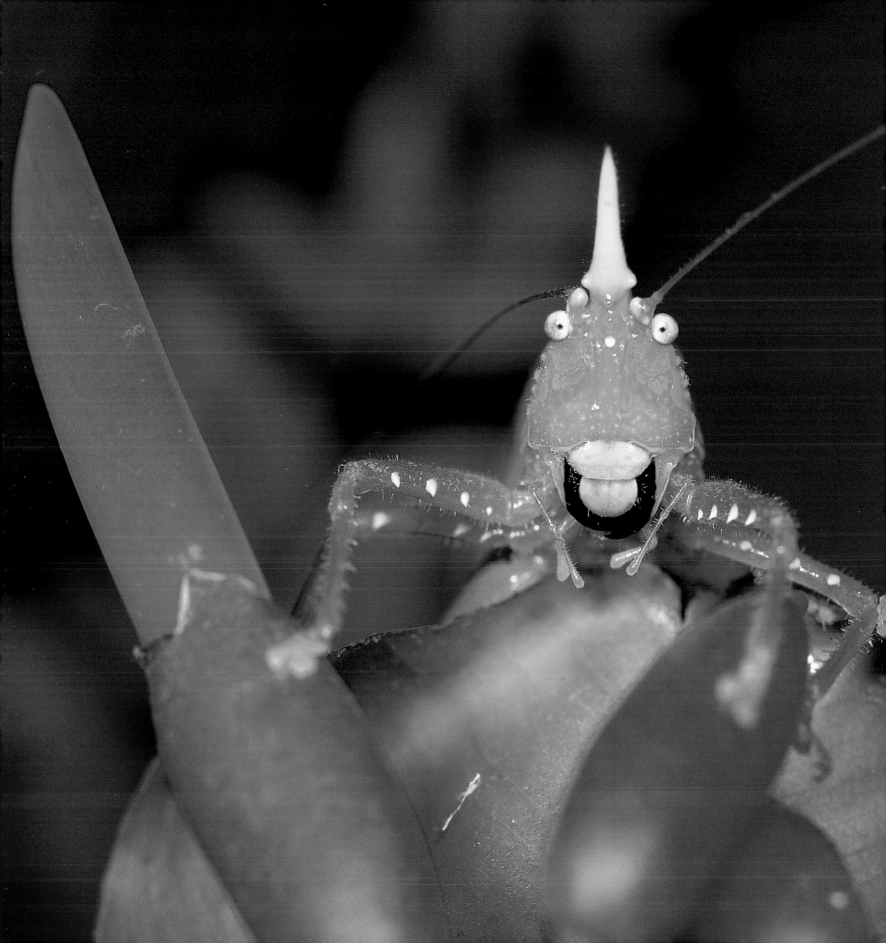

Spike headed katydid
Found by Mitsuhiko Imamori on a leaf in the lower part of a rain forest in Costa Rica, this spike headed katydid, around ten centimetres in length, was perfectly coloured and its extraordinary appearance inspired this unusual portrait.

"I wanted to take the picture so that it featured the full face of the insect," says Imamori, "and so I used a telephoto lens and shot from a distance, being careful not to touch any leaves of the plant that the katydid was sitting on, since this would have disturbed it and made it cautious."

Pentax 6x7cm, 135mm macro lens, Fujifilm Provia

Mitsuhiko Imamori

Mitsuaki Iwago JAPAN

Born in Tokyo in 1950, Mitsuaki Iwago was raised in the city and grew up watching *The Lucy Show* and perusing photographic books and *Life Magazine*. As a teenager he worked with his father, a wildlife photographer, and, following his graduation from college, he became a wildlife photographer himself. Following a series of outstanding projects, he has gained the reputation of being among the world's foremost wildlife and nature photographers.

In 1980, he received the Ihei Kimura Award, one of the most prestigious awards for photography in Japan for his work on *A Message from the Sea*, run serially in *Asahi Graph*. He was also honoured with the Kodansha Publishing Cultural Award in 1985 and the Annual Award of the Japan Photographic Association in 1985.

Widely travelled, with a range that has taken in locations as diverse as the Galapagos Islands and the Serengeti Plain, Iwago has taken award-winning images in more than 70 countries for the past 30 years. His work has appeared in numerous magazines, including *National Geographic*, *Paris Match* and *Life*.

He has also produced several books that have featured his pictures, including *Serengeti: Natural Order on the African Plain* (a collection of photographs made during a two-year stay in Africa's Serengeti National Park with his family), which became a worldwide bestseller after a selection of images from the book were published in *National Geographic* magazine. Shortly thereafter came *Mitsuaki Iwago's Kangaroos*, a product of his work in Australia from 1986 to 1988. More recently his work has been published in the spectacular *Mitsuaki Iwago's Whales*, *In the Lion's Den*, *Snow Monkey*, and *Wildlife*, a massive 600-page volume that brought together 450 of the best images produced throughout his career.

"As an animal photographer I try to be keen and bold in capturing nature," he says. "But I keep in mind that in our desire to see and understand animals it's important not to change their way of living.

"I took pictures of penguins because I wanted to see how they live in the Antarctic, laying eggs, hatching them and raising chicks. I remember their rookeries were red with their droppings. I photographed kangaroos because I wanted to understand how this marsupial has evolved so peculiarly on the island continent of Australia. I was fascinated by whales because they are so large, but when I photographed them I realised that the ocean where they live is much larger. It gave me the desire to explore more seas.

"On all these occasions I trusted my feelings. Man's five senses have drastically degenerated, but nature has the power to bring them back to us. When I press the shutter of my camera, I rely completely on these senses to seize images of wild animals that are continually in motion. It is this heightened awareness of being alive in nature that makes me continue to work as a wildlife photographer."

Kangaroo in pouch, Australia
"This picture of a young kangaroo in its mother's pouch was taken in a zoo," says Iwago. "The reason for this is simply that it is impossible to approach a mother and her young in the wild as close as this. I think it was a good situation, however, because the kangaroo was used to people and wasn't stressed and I had less of a struggle to get my picture."

Leica R7, 60mm lens

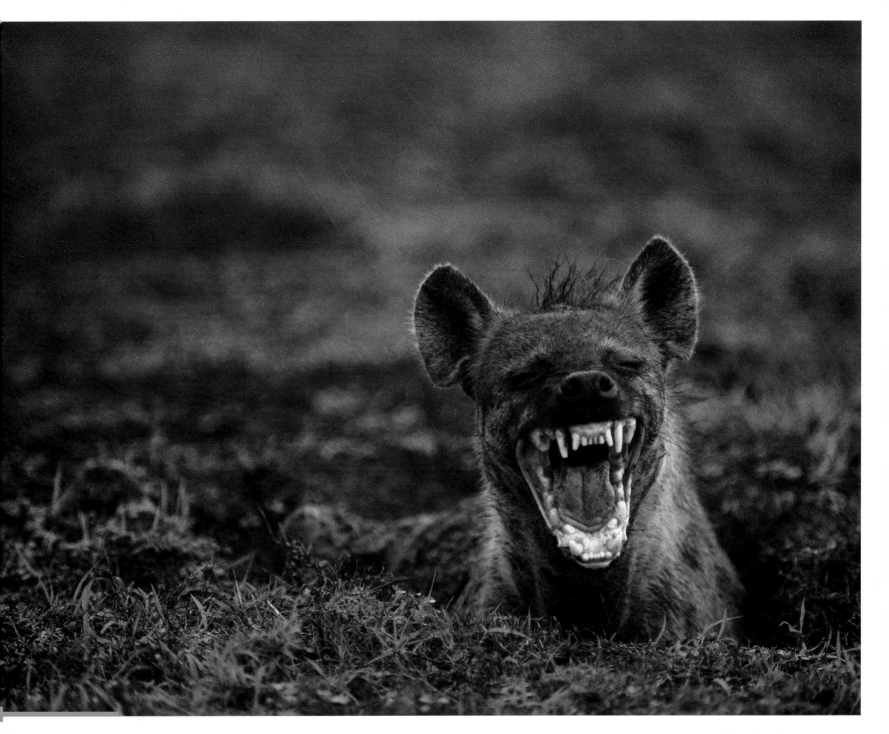

Hyena, Serengeti
"This picture was taken at the den of some spotted hyenas early one morning," says Iwago. "Hyenas share a den with one another and, at this time, they had been soaked by the overnight rain. Their hunting trip seemed to have ended in failure since there was no blood on their teeth, and now they were preparing to go to sleep."

Leica R7, 560mm lens

Mitsuaki Iwago

Lions

Despite having encountered such a huge variety of wildlife throughout his travels, Mitsuaki Iwago remains captivated by the lion. He spent two years between 1982 and 1984 photographing them in the Serengeti and has pictured them many times since.

"I think the lion is an interesting animal in terms of its behaviour, and the social life that it follows," he says, "and the only way to really show this in pictures is to photograph them as part of a long-term project. I also find their powerful hunting instincts very attractive as a photographer, and that is another reason why I have taken so many pictures of them over the years."

The selection of lion studies here, all of which were taken in the Serengeti, shows the variety that Iwago has been able to achieve through his patience and perseverance.

Lioness and cub

"In the evening the lionesses go hunting," says Iwago. "At this particular time there were two of them, and one saw a Thompson gazelle on the horizon and began t walk towards it. The other, however, stayed where she was, because she had her cub playing around her."

Leica R5, 560mm lens

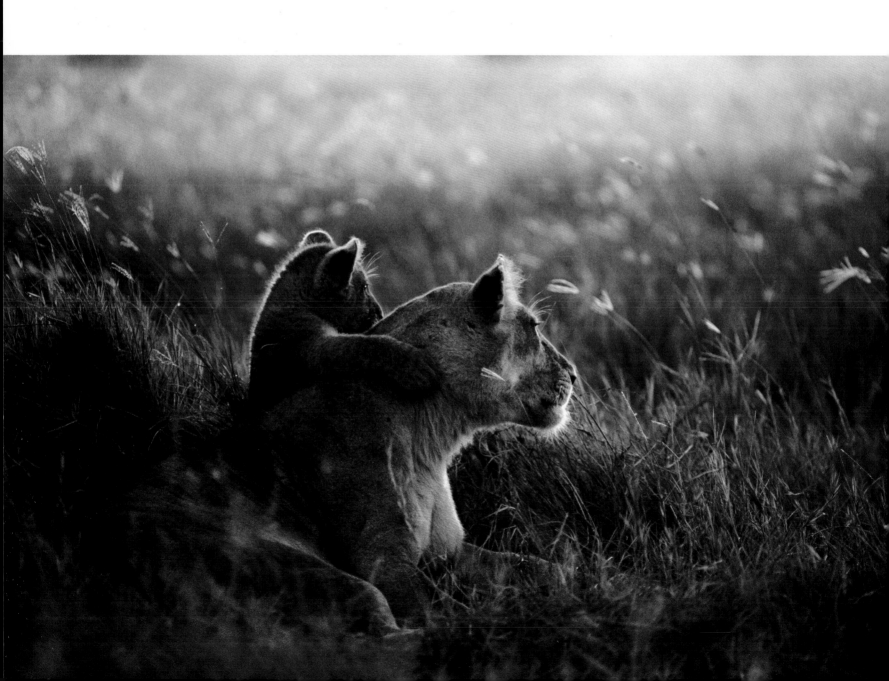

Lioness eating zebra
All the pride gathered around to eat this zebra that had been caught. "There was a rough bellow and a snorting sound throughout the area," says Iwago. "This lioness was showing her teeth towards a younger female and threatening it to protect her food."

Leica R6, 400mm lens

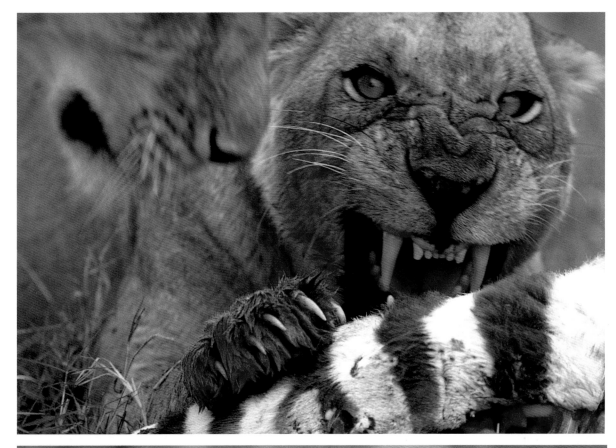

Muddy lioness
This picture was taken during a prolonged spell of hot and wet days in the Serengeti. "The lions cool their bodies in a mud bath," says Iwago. "This female eventually fell asleep in the mud and then started to blow a balloon through her nose!"

Leica R6, 180mm lens

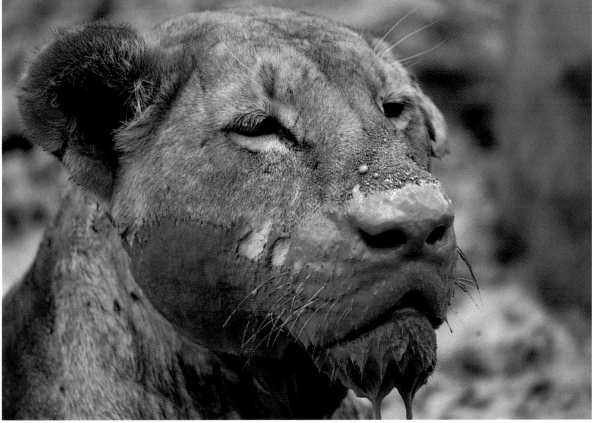

Mitsuaki Iwago

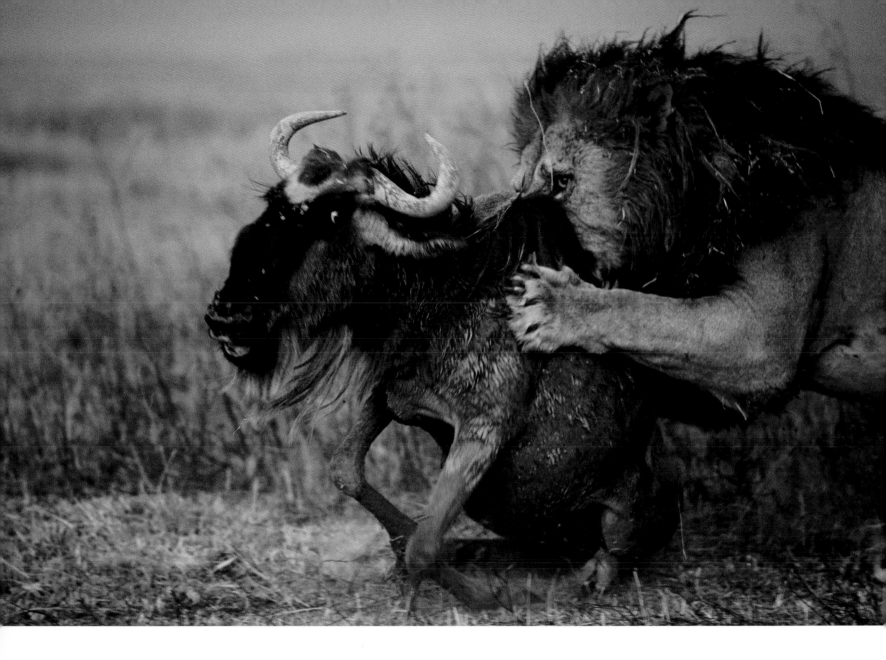

Lion killing a wildebeest
"In the early morning two spotted hyenas caught a wildebeest after a chase of several hundred metres," says Iwago. "Before they could finish their kill, however, a lion drove the hyenas away with a roar, and it was this lion that put an end to the life of the gnu. As for the hyenas, they had been deprived of precious game, and they had no choice but to sit and wait for the lion to eat its fill and to leave."

Leica R5, 560mm lens

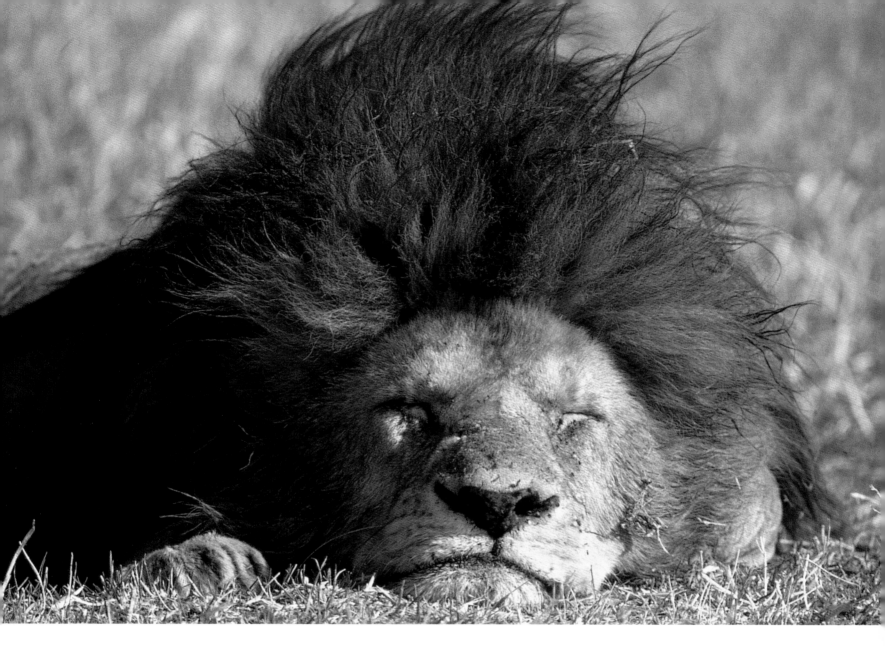

Lion sleeping
"This lion appears to be sleeping well," says Iwago, "but he's not sleeping deeply. When vultures fly in the sky, the lion can see what they fall on. When hyenas run in the distance, he can tell where they are going."

Leica R6, 560mm lens

Mitsuaki Iwago

Frans Lanting NETHERLANDS

One of the world's most widely celebrated wildlife photographers, Frans Lanting has achieved his status through a rich understanding and appreciation of his subject, coupled with an approach that is meticulous and insightful. Thomas R. Kennedy, *National Geographic*'s director of photography, considers that his aesthetic vision and knowledge of his subject matter is unlike that of any other nature photographer that the magazine has used. "He is able to understand and anticipate animal behaviour with the kind of alacrity that a photojournalist has when photographing people," he says. "The animals are not conscious of his presence and, as a result, he can get closer."

Lanting was born in 1951 in Rotterdam, and took his first serious pictures at the age of 21 during a hiking trip to the national parks in the US. The results disappointed him and, thinking that the fault lay with the camera, which he had borrowed from his mother, he bought himself a better one and started to teach himself the rudiments of photography. He immersed himself in how-to articles, studied the work of established photographers and honed his skills in a Rotterdam city park and in the Dutch countryside.

He earned a Master's degree in Environmental Economics from Erasmus University in 1977 and then headed for the US to enrol in a postgraduate programme in Environmental Planning. The call of photography was too strong by this time, however, and two years later he left the course to work on photography full time, dashing his family's hopes that he would take over his father's business

Lanting is quoted as saying that "a bad day in the field is better than a good day in the office," and he embraced his new career wholeheartedly, continuing to live on the Californian coast where he found limitless inspiration and a wealth of wildlife to photograph.

He was fascinated by the area's juxtaposition of urban and wild areas, describing the creatures that could be found in the region of his new home as being "just as fantastic as if bison were still running through the suburbs of Chicago." One of his first projects there was to photograph the sanderlings (a type of sandpiper) that foraged along the seashore. As part of his preparation, he learned everything that he could about their way of life, and that dedication to his subjects has remained with him ever since.

In the case of the sanderlings he observed them for weeks on end and even followed them for some distance when they migrated. In time, he became intimately familiar not only with their behaviour as a species but also with their individual idiosyncrasies. As they got used to his presence, he was able to get increasingly close to them until ultimately they accepted him as just another feature of their environment. When this point was reached, the pictures that Lanting was able to produce moved on to another level. He had discovered his photographic style, and it's the way that he's worked ever since.

A later project in California, for example, saw him tackling elephant seals and, given that adult males can weigh three tons when fully grown, he was genuinely taking his life into his hands by getting so close to his subjects. Once again the intimate knowledge he gained of his subjects over the long term allowed him to get close to the creatures and ultimately it kept him safe.

Likewise, when Lanting dedicated himself to a pride of lions for a month in Africa, living with them, he has said, "as an auxiliary lion," the reward for his patience and persistence was a spellbinding insight into their lives that was translated into remarkable pictures. He even sat just a few metres from them the night that they killed a giraffe, and spent several hours taking photographs as they devoured every part of the animal except the bones.

Typical of Lanting's long-term approach was his project on the environmental crisis in Madagascar, commissioned by *National Geographic* in 1985. He spent a year covering the wildlife, but also talking with farmers, subsistence hunters, government officials, scientists and other Malagasy.

The results appeared in the February 1987 issue of the magazine and awakened enormous interest in the country, leading to scores of foreign scientists and conservationists making visits there to set up projects in collaboration with their Malagasy counterparts, in an effort to halt the destruction of the environment and to tackle the country's economic and social ills.

Similarly, the publicity that followed the publication in *National Geographic* in December 1990 of Lanting's photographs of the wildlife of the Okavango Delta in Botswana was said to have led to the Botswana government altering its policies regarding a portion of the delta to ensure its conservation. In short Lanting had, as usual, given more than he had taken, and in his determination to tell the full story he had stirred the imagination of people who might otherwise have never taken an interest in conservation issues.

Lanting has been the recipient of a number of awards, including top honours in the 1988 and 1989 World Press Photo Competition and the title of Wildlife Photographer of the Year. He was also inducted as a Knight in the Royal Order of the Golden Ark by His Royal Highness Prince Bernard of the Netherlands in a ceremony at the Soestdijk Palace in 2001, becoming the first photographer to be presented with this award.

He remains as committed as ever to his photography and to the natural world in general. His ethic is quality not quantity; patience will always be the key to his approach and the reason why his insight into the natural world is so revealing and inspirational.

Gecko
"This gecko was photographed in Madagascar. The simplification that happens when you present something as a silhouette takes interest away from the animal and you can concentrate more on the pattern. People know that geckos live in trees, but here the statement has been simplified."

100mm macro lens

ildebeest

"his line of wildebeest was
otographed one morning in the
asai Mara in Kenya. I took it
ing a 600mm lens, which was
ld steady on a window mount
ed in my Land Rover. The sky
as incredible: mornings and
enings are classic times to take
ctures in this area."

0mm lens

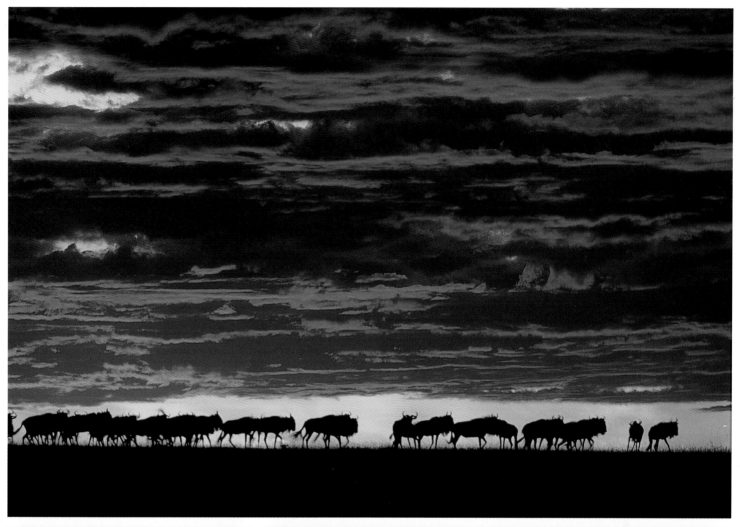

juar

his was a captive jaguar,
otographed in a zoo in Central
nerica that has become an
tstanding example of what zoos
ed to become to justify their
stence. This establishment is very
ively involved in conservation
orts, and in such places the
imals themselves become
bassadors for their whole
osystem. The animal was kept in a
ge enclosure, and I photographed
here over a period of two days. It's
kind of picture that really has to
taken in a captive situation:
uars are so difficult to
otograph that you would have to
nmit a year of your life to hope to
able to take an image such as this
he wild."

0mm f/2.8 lens

Frans Lanting

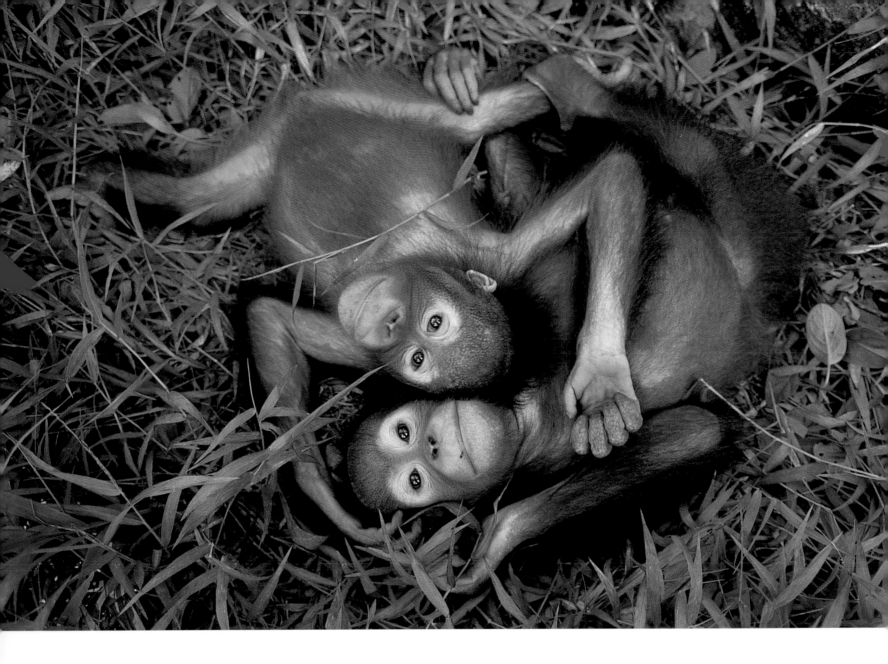

Orang-utan orphans, Sabah, Borneo

"I took this picture of orphaned orang-utans for my book *Jungles* (published in 2001)," says Lanting, "for the section that covered the theme of form and evolution.

"Really it's just an example of portraiture, and I photograph animals in the same way as I would people. It's no different to the way that you might cover a human family: you would look for expressions and signs of the relationships that exist between people, and that's exactly how I approached these two subjects.

"The picture was taken in a rehabilitation centre for orang-utans, so they were habituated, and I was able to work closely with them without them being intimidated by me. I used a wide-angle lens to frame the picture and worked with available light.

"The time that is spent getting to know the subject is no different whether you're working with captive animals or those that are in the wild. They both require patience. Encounters with wild animals are great because they help you to understand how the creature is part of its environment, but with captive animals you have the chance to create personality and to produce close-ups that are not possible in any other way.

"It's all part of the process of capturing animals on film and both ways of working are important in helping you to provide a full picture."

28mm lens

Emperor penguin chick

"This picture was taken in Antarctica," says Lanting, "and it was a challenge to produce simply because it was so cold. In order to be as little of a presence as I could (so that I didn't influence the behaviour of the penguins) I had to lie flat on the ice and make as few sudden movements as possible, while manoeuvring myself around the edge of the colony.

"While penguins are generally quite easy to work with, there is a big difference in visual impact between pictures that are taken 30 feet away and those that are taken ten feet away. I like to get close to my subjects if I can but, in lying on the ice for such a prolonged period of time, I ended up freezing my butt off!"

Some idea of Lanting's proximity to his subject can be gained by the knowledge that this picture was taken with nothing longer than an 80-200mm zoom. The impact of the picture is bolstered enormously by the tight framing that has been achieved.

80-200mm zoom

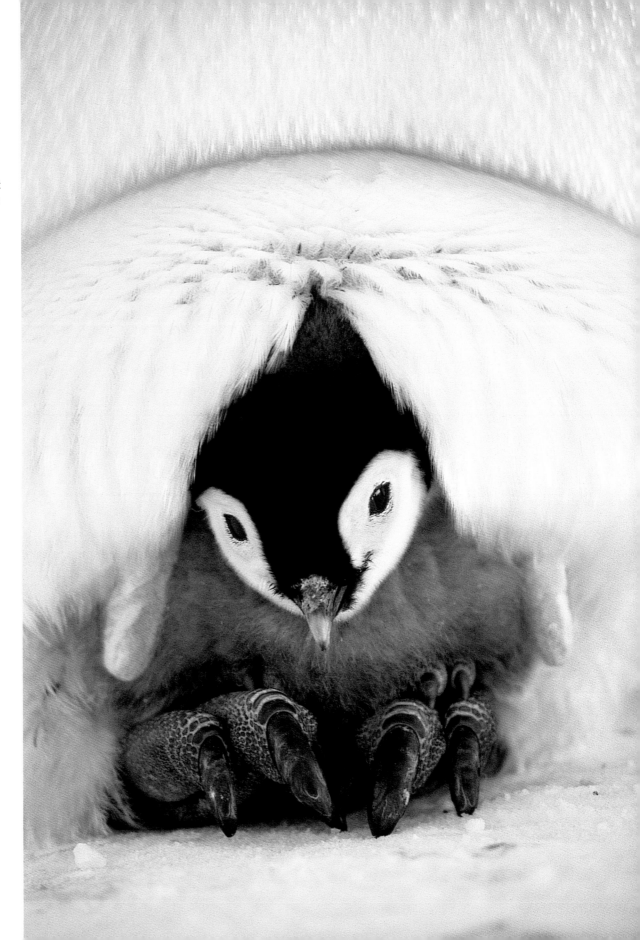

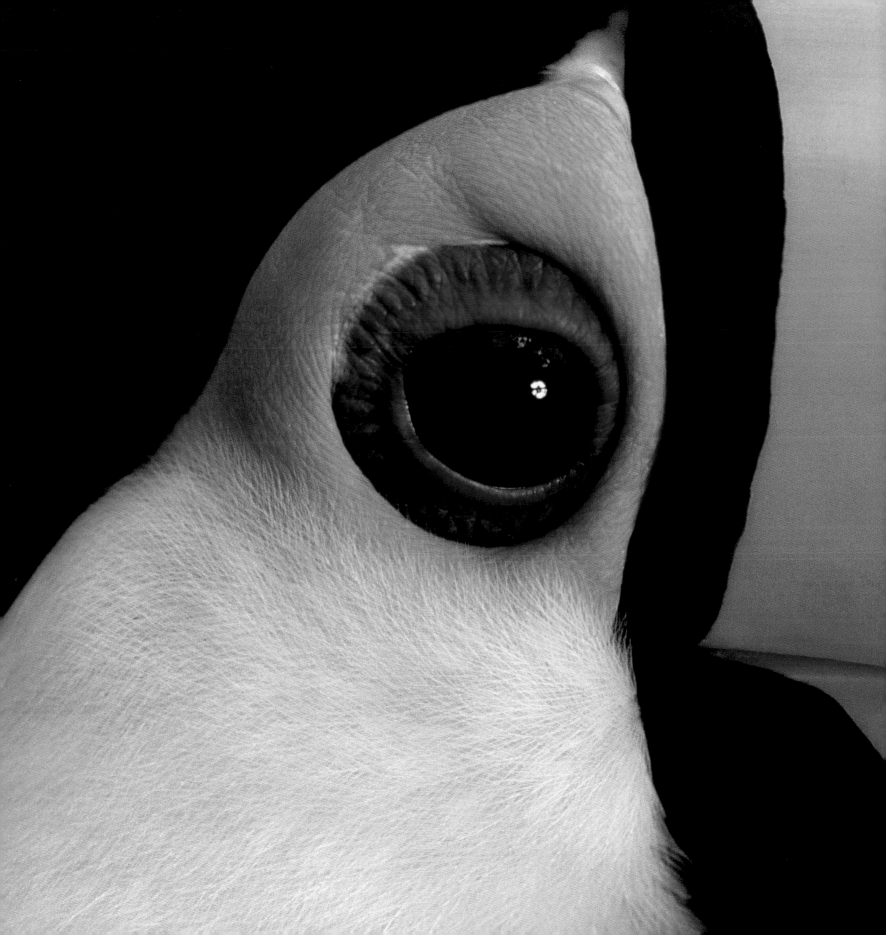

Toucan

"This is another image from the *Jungles* book," says Lanting, "and it was specifically created to fit into the colour and camouflage section. I was trying to come up with ways that I could show marvellous examples that would be relevant to the theme of this section and the colour here is so vivid that you can imagine it screaming out to any other toucan that might be in the vicinity.

"The picture was taken in Brazil and features an habituated bird because it just wouldn't have been possible to work this closely to a bird in the wild. I wanted to move right in on the subject and to cut out all the surroundings: people know what a toucan looks like and so it wasn't necessary to show the whole bird. By just pulling out a section I was able to make the picture into a series of textures, and the combination of the feathers, the hard skin around the eye and the smoothness of the beak all worked together well.

"I used a 100mm macro lens to allow me to fill the frame and I brought out the colours by using a single flash as a fill light, which I wrapped in a softbox to make sure that its intensity was reduced."

100mm macro lens

Frans Lanting

Joe & Mary Ann McDonald USA

Jackal
Mary Ann McDonald took this portrait of a jackal about ten minutes after sunrise one morning in the Masai Mara game reserve, at a time when the light was rich and saturated.

Canon EOS 3, 300mm f/2.8 lens with 2x converter, Kodak Ektachrome 100VS

Working as a team, Joe and Mary Ann McDonald have travelled the world, taking pictures and leading photography workshops, courses, tours and safaris together. A typical workshop year includes bird photography in the Everglades in February; Utah in late March; high-speed flash photography of hummingbirds in Arizona in April; workshops held at the couple's Pennsylvania home, Hoot Hollow, from May through to August; Yellowstone in September; and Kenya from October to November.

Add to this periodic trips to other locations, such as Uganda (for mountain gorillas); Baja, Mexico (for whales) and more general tours to Alaska, Africa, Antarctica and the Falkland Islands, and it can be seen that the couple's international credentials are second to none.

Joe has photographed nature professionally for more than 25 years, beginning as a serious-minded freshman in high school. A self-taught photographer, his earliest work, sold to the National Wildlife Federation's film library, netted him around $6 for each image that he sold outright to them. "It was slightly better than it sounds," he says. "The rate did increase a little throughout the time that I dealt with them, and I got a further fee if the picture was used. As a student this helped me to pay for films and equipment upgrades."

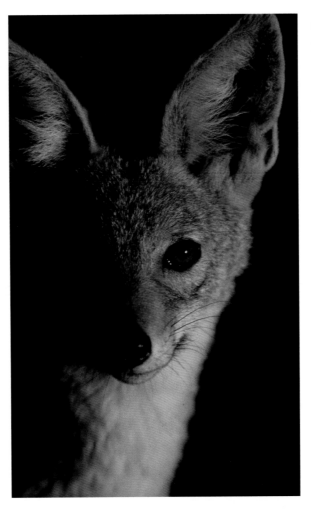

During his time at college, Joe had his first double-page spread published in the US-based *National Wildlife Magazine*. Motivated by that success, he contacted several stock agencies, was accepted, and has been supplying wildlife and nature images to various agencies ever since. His work has appeared in every major natural history magazine published in the US and in most European and Canadian publications as well. Additionally, he has written and illustrated seven books, and has contributed work to many more.

His qualifications include a BSc in Biology, a Masters in Learning Resources and Mass Media from the Indiana University of Pennsylvania, and an education degree from Lehigh University in Bethlehem, PA. He taught high school biology and a field zoology course for six years before leaving teaching to pursue his full-time career in wildlife photography.

Mary has a BSc in Biology from Elizabethtown College in Pennsylvania, where she majored in pre-med. She worked in research at the Hershey Medical Centre for 12 years and during her time there co-authored 12 papers and 10 abstracts in the fields of Cardiology and Paediatric research.

Despite a life-long interest in nature, Mary Ann's career as a wildlife and nature photographer only really began after she had attended a photography workshop run by her future husband. She tasted success almost immediately, her photograph of a Florida screech owl being selected as one of the 100 best in *National Wildlife*'s annual photographic competition.

Since then, Mary Ann has had photographs of wolves, bears, birds and a diversity of other subjects published in books, magazines and calendars throughout the world. She has also authored 29 natural history books for children, ranging from titles on blue whales, leopards and foxes, through to flying squirrels and mosquitos.

Although she and Joe market their work jointly, Mary Ann is also represented by four stock photo agencies. She was a winner in the Wildlife Photographer of the Year Competition in 1994, and also won the Bird Behaviour and Endangered Species sections that year. She also gained three highly commended awards in the 1998 event.

The couple shares a common outlook on the importance of the natural world and the need to value and sustain it, and have managed their property specifically for wildlife. This has had benefits for them as photographers too: they have been able to take pictures of flying squirrels, kingfishers, bluebirds and other songbird species, together with a variety of reptiles and amphibians, all within 100 metres of their doorstep.

"On the tours that Joe and I run," says Mary, "we try to instill in people the need to make as little impact on our subjects as possible. The best photographer tends to be a good naturalist as well, simply because of the importance of knowing the subject. This allows you to predict animal behaviour and to take your pictures without doing things that could distress them."

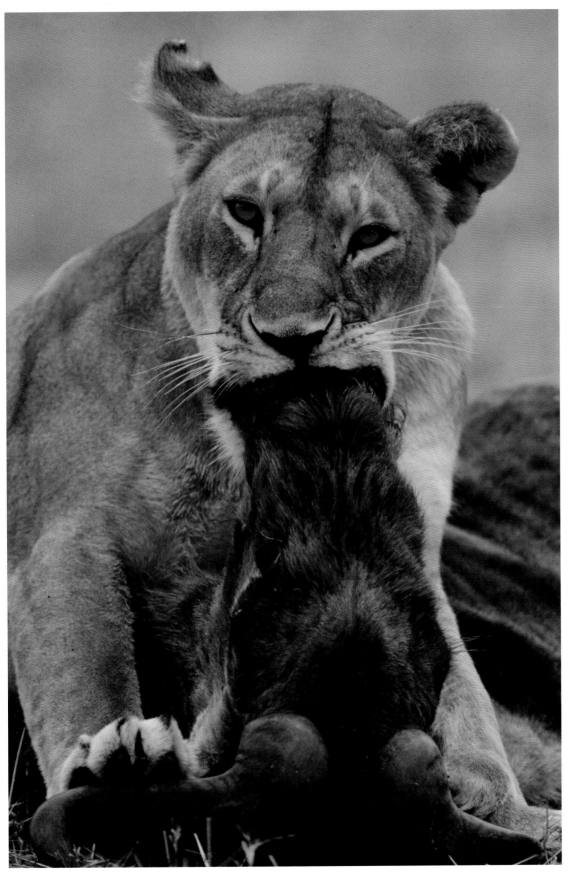

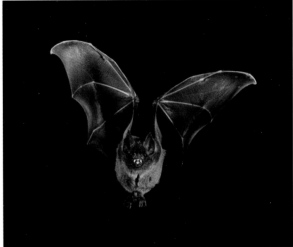

Lioness with wildebeest kill

"This was taken from a vehicle in the Masai Mara," says Joe . "We were leading a photo safari and encountered a group of lions in the grass. In the distance was a herd of wildebeest, but they were too far away and there was no cover, so it didn't look promising for the lions. Then, as we watched, one of the wildebeest stood up and started to walk with an obvious limp. One lioness saw this, ran after it and brought it down, then grabbed it by the muzzle to suffocate it. Unfortunately she didn't grab its lips properly so it could still breathe. While she was trying to kill it we were able to move much closer. "She stayed like this for a while and then went off to get her cubs. At this point the wildebeest tried to get up, but its neck was obviously dislocated and it couldn't get away. Eventually one of the other lions moved in and finally put this unfortunate beast out of its misery."

Canon EOS 3, 400mm f/2.8 lens, Kodak Ektachrome 100 VS film

Leafnosed bat

Joe McDonald took this photograph of a leafnosed bat for a friend of his, who required publicity pictures for the educational programme that he was running at his zoo. "I set this up in a flight tunnel," he says, "which is about the size of an American fridge on its side. Where the freezer box would be there is a roosting area for the bat that can be closed off and separated. The whole thing is made of plywood, and there are windows and doors positioned around it so that you can access lights from different positions. Food was positioned at the opposite end to where the bat was, so that it would fly towards it and break the trigger on its way. I used four Sunpack 444 units to provide the lighting for this image."

Canon EOS 1NRS, 70-200mm f/2.8 lens, Fujifilm Sensia, four Sunpack 444 flash units

Joe & Mary Ann McDonald

Striking rattlesnake

Joe is well known for his high-speed flash photography and has covered many subjects during his career but this rattlesnake was one of the most challenging – and dangerous. "I had to take my life in my hands, quite literally, to get this shot," he says, "because the snake would only strike at me, not at the props we were hoping he'd react to. This was because he could detect my body heat and that was the only thing that would provoke him, so I had to jump around like a mongoose to keep him interested in me. I had to make sure that I was close enough for him to detect me, but I still had to keep safely just out of range.

"Not only did I have to keep him animated, but I had to try to encourage him to strike upwards towards me so that he took up the right position within the frame."

The picture was shot in the studio, using flash equipment which is commercially available. Joe recently switched from the Olson high-speed flash system (which was used to light this photograph) to other high-speed units such as the Sunpak 522/544s, the Nikon SB24 and Canon 550EX.

"The flash units need to be as close to the creature as you can get them," says Joe, "to ensure that you have enough light to be able to generate a smaller aperture and, consequently, a good depth of field. This is because a subject may travel some distance before actually breaking the beam and triggering the exposure. This was especially true with the rattlesnake, which was sometimes extended to the full length of its strike before tripping the camera.

"For this high-speed action work, I use one of two commercially available units. The Shutterbeam is triggered when the subject breaks an invisible infrared beam. The Phototrapper can be triggered by breaking one of a variety of infrared beams, but also by breaking a beam produced by a laser pointer. I found the pointer extremely effective, since I can see exactly where the area of contact will be."

Canon EOS 1NRS, 70-200mm f/2.8 lens, Fujifilm Sensia, extension tube, Olson high-speed flash units

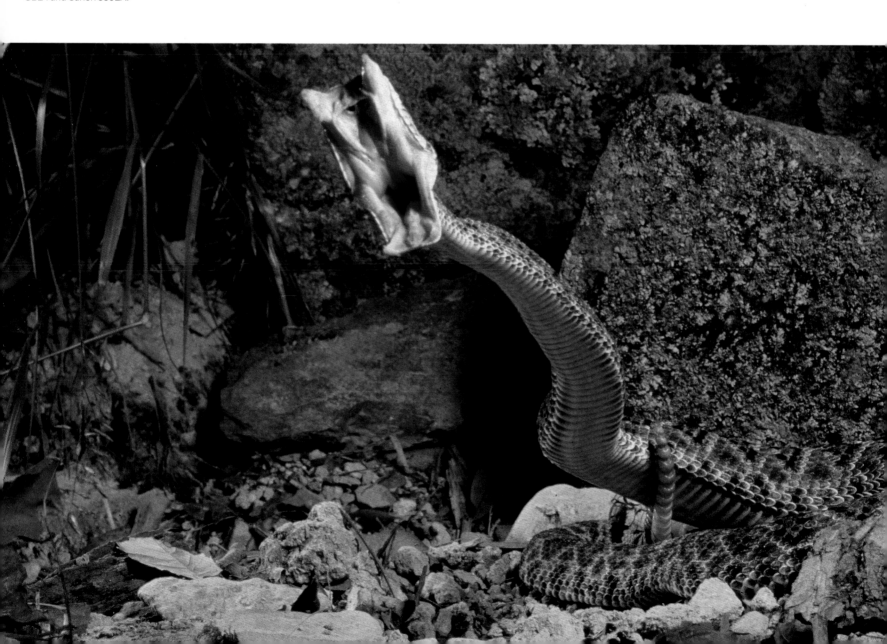

Mother and baby elephant

This charming scene was spotted by Mary Ann McDonald in the Samburu Game Reserve in Kenya. "I have a reputation for loving elephants," she says. "In fact my nickname is the 'elephant woman' for this very reason! We came across this small family group and decided to stay and watch them for a while, especially when we noticed that they had this baby with them.

"When elephants with a baby encounter you they tend to be very protective at first, and surround it to make sure that you can't come too close. If you sit and wait, however, they will eventually relax and then you can take pictures. It took around half an hour before we were able to get anything.

"The main group of elephants was eating and grazing, and then when it moved on the mother started walking and the baby walked underneath her. It must have been six months old or younger to be small enough to do this: as I took my pictures the mother suddenly stopped, but the baby kept on walking, and this was the result!

"I was working from a Land Rover and so had a slightly elevated view of the scene, which was useful because it allowed me to shoot at eye level to the baby. I steadied the camera and its 500mm lens by resting it on a beanbag that had been placed over the window frame in the car's door. Alternatively we can shoot from roof hatches in the vehicle or fit a window mount to give extra stability."

Nikon F3, 500mm f/4 lens, Fujifilm Sensia

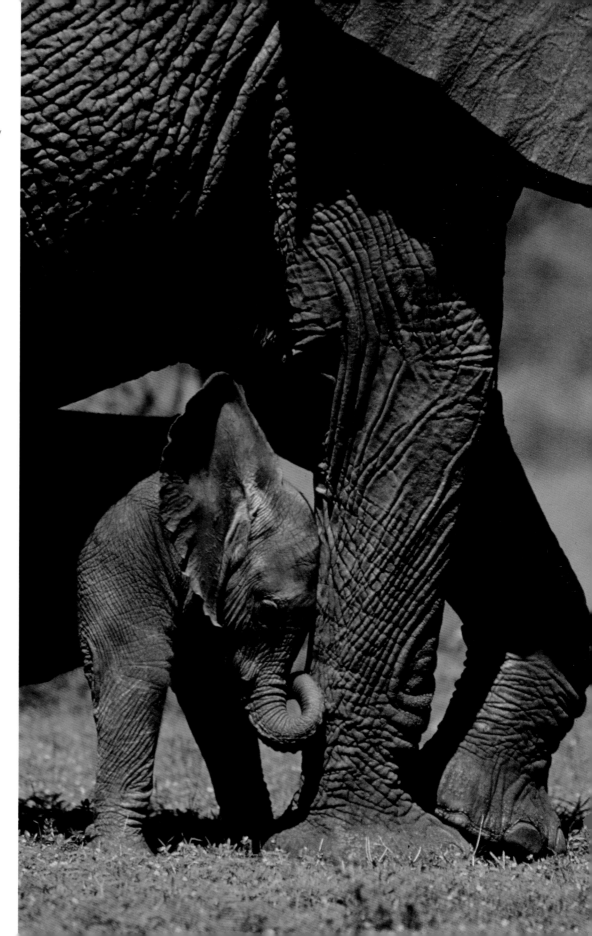

Tom Mangelsen USA

A Nebraskan native, Thomas D. Mangelsen's love of nature and the outdoor way of life were nurtured by his father, Harold. An avid sportsman, Harold took his sons Hal, David, Tom and Bill to favourite blinds along the Platte River in Nebraska to hunt and to observe the huge flocks of ducks, geese and cranes that migrate through the area. It was during these outings that young Mangelsen learned the important lessons that would become invaluable to him as he pursued a career in wildlife photography: patience, the importance of realising the magic moment, and how to understand and interpret animal behaviour.

In 1965, Mangelsen began studying Business at the University of Nebraska, transferring two years later to Doane College where his first love, Biology, prevailed. After receiving his Bachelor's degree he continued post-graduate study in Zoology and Wildlife Biology at the University of Nebraska and Colorado State University.

In 1971, he started work as a wildlife cinematographer, an opportunit[y] that would lead to filming a favourite species, the rare whooping crane. The resulting Emmy-nominated television special, *Flight of th[e] Whooping Crane*, chronicles the plight of these endangered birds and the efforts to bring them back from the brink of extinction. Later in 1990, Mangelsen built on this experience, acting as both produce[r] and cameraman on the PBS Nature/BBC Natural World co-production *Cranes of the Grey Wind*, a film documenting the life-cycle of the sandhill cranes of his native Nebraska.

Still photography, naturally, has also played a major role in Mangelsen's life, and by the early 1970s he had reached the stage where he and his brother David were selling limited edition prints of his work. By 1978, Mangelsen had opened his first Images of Natur[e] gallery in Jackson, Wyoming and printed his first brochure. Since then 15 galleries have been opened in locations all across the US. Today, Mangelsen's photography is widely known and collected.

In 1989, he published his first book, *Images of Nature: The Photographs of Thomas D. Mangelsen*, containing more than 200 photographs documenting the varied natural history of North America, and in 1994, his status as one of the world's top wildlife photographers was confirmed by receiving the coveted Wildlife Photographer of the Year Award.

Mangelsen's business acumen, also inherited from his father, has placed him in the role of chairman of his successful company, Images of Nature, but he's never forgotten his wildlife roots. A recognised champion of the environment, he is a strong supporter o[f] organisations committed to the conservation of natural resources, such as The Nature Conservancy, The Wilderness Society, Wildlife Conservation International, The East Africa Wildlife Society, Polar Bears Alive and Vital Ground.

In 2001, moved by the rare sighting of a family of pumas on whic[h] his most recent book, *Spirit of the Rockies: The Mountain Lions of Jackson Hole*, is based, Tom co-founded The Cougar Fund, a nonprofit organisation committed to protecting the American mountain lion. Today, between a hectic schedule and trips to East Africa, India and the Arctic, Mangelsen continues the tradition started by his father Harold, making an annual pilgrimage to his beloved family cabin along the banks of the Platte.

Mother's love
"I kind of got carried away with polar bears," admits Tom Mangelsen, by way of explaining why he spent 12 years dedicated to photographing them. "This image was taken from a tundra buggy in Wapusk National Park in Canada, near Hudson Bay."

Pentax 645, 300mm f/4 lens, Fujichrome Velvia

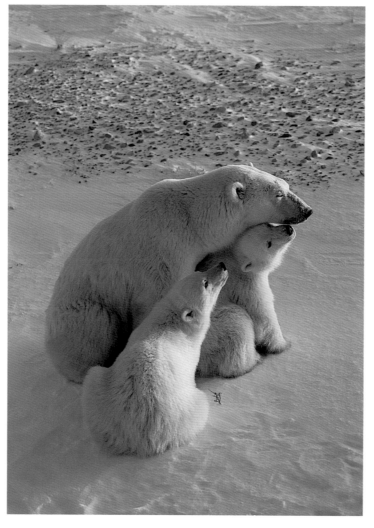

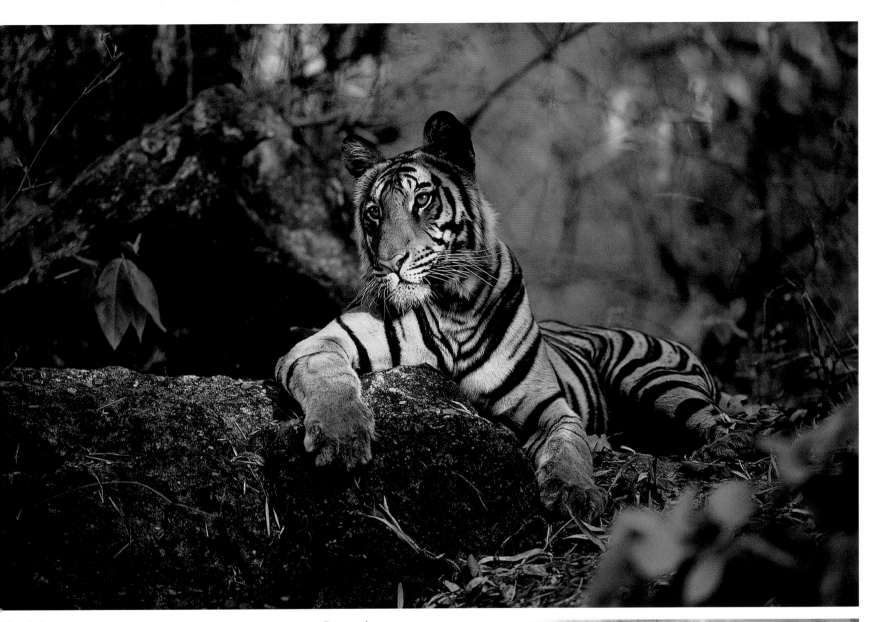

ight in the forest

om Mangelsen took this image
f a bengal tiger from the back of
n elephant – the only way that
umans can get close to tigers in the
ild – in Bandhavgarh National
ark in India. "We spent a couple
f weeks in the area," he says,
photographing one particular
amily of tigers, leaving them each
vening and then trying to locate
hem again the next day through
varning calls from monkeys and
potted deer. I was about 30 yards
vay from this young female,
rying to steady my 300mm lens
rom the back of a wobbly elephant!"

Nikon F5, 300mm f/2.8 lens, 1/250sec
t f/4, Fujichrome Velvia

Dream catcher
All of Tom Mangelsen's pictures are
of creatures in the wild. He made
this striking abstract portrait of a
bald eagle in Katchemak Bay, in
Southcentral Alaska.

Nikon F5, Nikkor 600mm f/4 lens with
2x extender, 1/15sec at f/16,
Fujichrome Provia

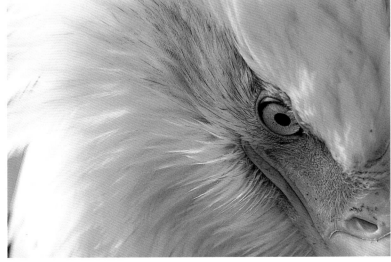

93

Tom Mangelsen

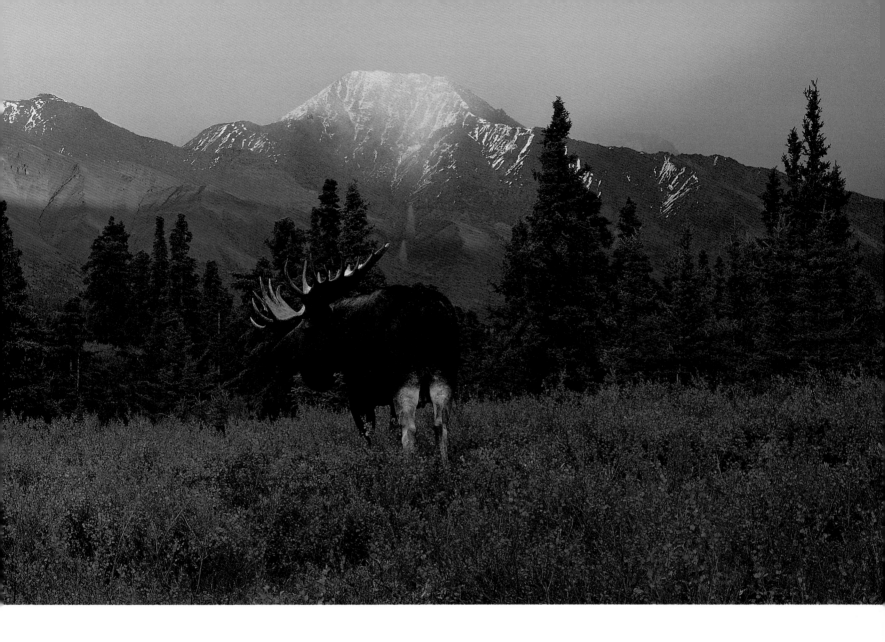

Alaskan moose in Denali

"My main aim is to show animals within their environment," says Mangelsen, "and, if possible, record some of their personality. To do this, you must be aware of what's going on and what might happen, and then be ready should the right moment occur."

This is precisely what happened in the photograph shown here. "I had been photographing moose in Denali National Park in Alaska for ten days," Mangelsen recounts, "and had spent six of those days with this particular male – one of the largest moose in the park – and his harem of 19 cows. Days are still long in September in Alaska, so by the time this moment was captured, I had been in the field for 14 hours already.

"I was working with my dear friend, filmmaker Chip Houseman, and just as we were about ready to pack up after a day of dreary weather, the clouds lifted to reveal a slice of clear sky on the horizon.

At that moment the big male, who had hardly moved all afternoon, slowly stood to follow his retreating harem. Incredibly, he made his way exactly to the area of the scene that I had composed in my mind, in the middle of a patch of autumn dwarf birch that added a splash of red to the scene.

"While he was there for no more than 30 seconds, I managed to expose five frames, and then the moment was gone. The resulting image has become one of my favourites shots, and yet it is one of just two photographs from that entire ten-day shoot that I've ever released as a limited edition print."

Fuji GX 617, Fujinon 180mm lens, 1 second at f/45, Fujichrome NHG II 800

Tom Mangelsen

Francisco Márquez SPAIN

Like so many wildlife photographers, Francisco Márquez developed his interest in nature during his formative years, inspired by documentaries produced for Spanish television by Dr Félix Rodríguez de la Fuente.

"At that time my favourite hobby was to go out to the countryside with friends at weekends, in order to watch the birds," he says. "My interest in photography was the logical consequence of my hobby: I wanted to try to take home with me everything that I had seen.

"When I finished my studies at high school I was ready to go into university to study Biology, which was what I always wanted to do, but I began to have my doubts because photography was already an obsession. At that time, at the beginning of the eighties, this was not a serious profession for a young man in Spain but, after receiving support from my parents, I decided to go ahead with my adventure.

"My photographic equipment was very basic to start with: it consisted of a Pentax K-1000 camera, a 50mm SMC Pentax lens and a Vivitar 100-300mm zoom, which was a gift from my parents. A few years later, with money that I had won from photographic awards, I was able to change to Nikon, buying my first FE and a Nikkor 300mm f/4.5 telephoto lens."

Márquez works mostly in Spain, although he has also visited many countries in Europe in order to complete stories started in his own country. His passion is to photograph creatures in the wild, which he finds challenging but exhilarating. "To get my pictures I sometimes have to spend 14 hours at a time hidden in my shelter, and be very patient. I believe it is a privilege to be able to observe, from a short distance and without being noticed, a scene such as a golden eagle devouring its food in the high mountains. It's pure nature. The landscapes and the flora also appeal to me very much, but as a complement to the story I am narrating about the life of a specific animal.

"I work hard to achieve the highest quality in my pictures, because I believe that the final value of your work will be dictated by the worst picture you have included, so it is absolutely necessary that all the images are excellent. I am not satisfied with taking mere record shots of animals, no matter how beautiful they might be. The challenge is to show in my images what is really essential to this living creature; its capacity to survive and its typical behaviour."

Márquez still works exclusively with Nikon equipment, based around F4 and F5 bodies, teamed with a variety of lenses, including 28mm, 50mm, 105mm Micro-Nikkor, 300mm, 500mm, 17-35mm, 35-70mm and 80-200mm, plus 1.4x and 2x extenders. He also uses Nikon SB-26 and SB-28 Speedlites. Film choice is Fujifilm Velvia, Kodak Ektachrome 100 VS and Fujifilm Provia 400F.

"I believe there is still much I have to learn," says Márquez. "My main wish is to accomplish one goal: my pictures should be able to grab the attention of the audience, to persuade and transmit deep emotions to those who look at them, not only because of the beautiful image of an animal, a landscape or a flower. I am gradually losing interest in the purely documentary vision of nature, and I wish to stamp in my pictures a personal style, something that is very difficult to do and has only been accomplished by a few masters."

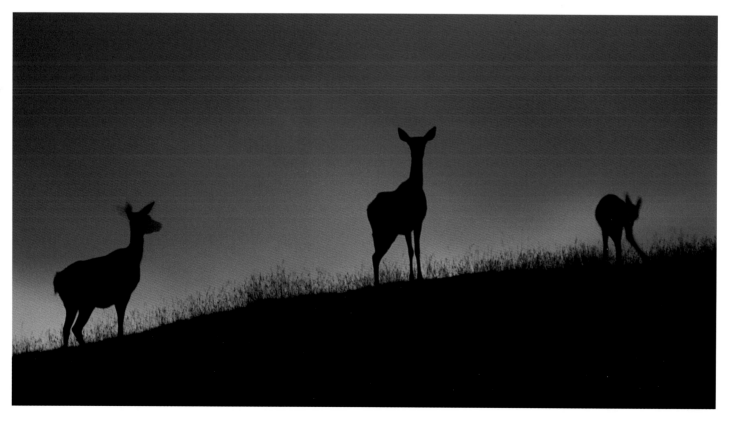

Red deer
This group of female red deer and their offspring was photographed by Márquez in the Scottish Highlands.

Nikon F3, Nikkor 300mm f/4.5 IF-ED, Kodachrome 64

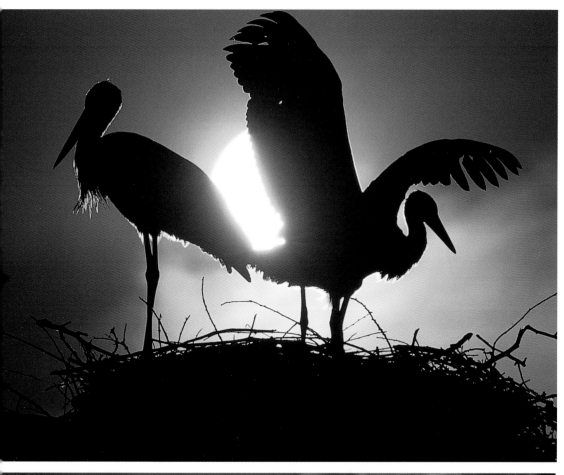

White stork
In the small town of Alfaro in Spain can be found the biggest urban colony of storks in the world, with more than 100 nests placed in the roof of San Miguel church, a building with the dimensions of a cathedral.

Nikon F5, Nikkor AF-I 500mm f/4D IF-ED, Fujichrome Velvia

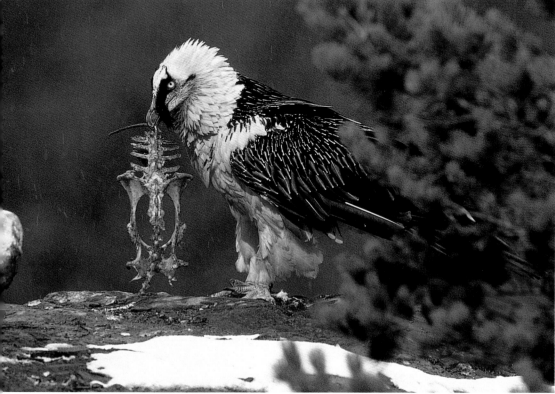

Bearded vulture
Márquez photographed this adult bearded vulture, which was showing its characteristic flashy black and orange feathers, while on a shoot in the Spanish Pyrenees.

Nikon F5, Nikkor AF-I 500mm f/4D IF-ED, Kodak Ektachrome Panther 100

Francisco Márquez

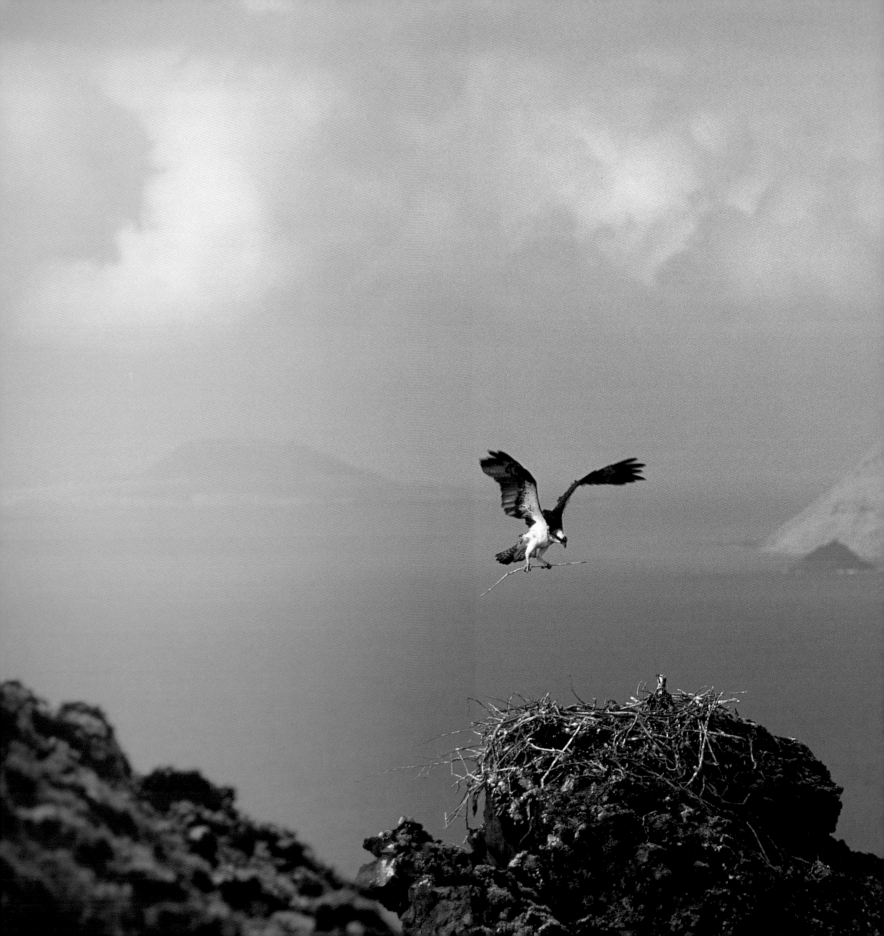

Osprey

"This image of an osprey was taken as part of an intensive project that I carried out between 1997 and 1999, gathering pictures for a book about the natural and rural parks of the Canary Islands. The place, full of spectacular volcanic landscapes and surviving primitive forests, is always covered by thick fog and features an overwhelming biodiversity formed by hundreds of endemic fauna and flora, only comparable to those we can find in the Galapagos or in Hawaii.

"The osprey is one of the most emblematic species in the world's fauna, so it was essential for me to include it in the book. In the Canary Islands there are only very few nesting couples, so it was never going to be an easy task to locate an appropriate nest due to the steep coasts that are found in the seven islands that form the archipelago. Finally I went, along with a movie cameraman friend of mine and two assistants, to a small uninhabited island where we had to land carrying enough food, water and tents to survive for a few days. It was just an adventure, because we weren't completely sure if the ospreys that we had come to see were even going to breed in their old nest.

"Once we were settled on the small island, the four of us started our journey before dawn to the top of the cliff where we hoped the nest would be. It was almost a two-hour walk until we reached the top, and once we arrived we saw that we were in luck – there was one offspring, around 45 days old, already feathered, in the nest.

"We had to face some difficulties, however. The nest was situated at the edge of a rock on a very steep cliff, with no protective vegetation where we could set up our cloth hides. It was a desolate place. In addition, the wind was blowing strongly, which was a serious handicap to our work. We decided to stay for just two hours and then to leave, in order not to disturb the eagles and the offspring too much. We set up two small hides, 40 metres from the nest, and the cameraman and I went inside while the two assistants went off to deceive the birds. We were facing 120 minutes of tension.

"Fortunately the ospreys were happy and, after half an hour, an adult perched on the nest carrying a branch. It did it a few more times, letting us take the pictures we were looking for. As we didn't have much time, and the hides were cramped, I decided to work mainly with an 80-200mm zoom to make a wider field of view than I would get with the 500mm I was also carrying in my bag. These kind of pictures provide the viewer with much more information about the animal and its habitat than the close-ups, and they are also more suggestive about nature in general, as something that we should preserve. After two hours we packed our equipment and left, as we had decided from the beginning."

Nikon F5, AF-S Nikkor 80-200mm f/2.8D IF-ED, Fujichrome Provia 100, Gitzo tripod G340 (with a G470 headstock and G321 levelling base), electromagnetic shooting cable to start the camera's motor whenever the eagles perched on the nest

Francisco Márquez

Dr Mark Moffett USA

According to Mark Moffett's parents, he was a naturalist from his very earliest days, apparently knowing ants as individuals in his back garden. "It's a skill I've since lost," he laments, "although I still love ants dearly." He declares himself forever astonished that what was once pure childhood play not only continues to define his life but has also led to the creation of a body of work that has been successful with both scientists and the public.

Throughout his youth, his love and knowledge of the natural world continued to develop, and he started to focus on the areas that would provide constant inspiration to him throughout his adult life. "I love rainforests," he says, "perhaps because my first exposure to a literary paradigm on them were the books of 19th-century naturalists. Throughout childhood I roamed the tropics in my mind with these explorers. I was a high school dropout from a family that had never travelled beyond the US, but I managed, as a teenager, to befriend a number of ecologists, and joined them for almost a year of expeditions across Latin America. From these I published my first research papers, meanwhile gaining a BA from Beloit College in Wisconsin with a Phi Beta Kappa and high honours." Following this achievement, and funded by a National Science Foundation fellowship, he went on to complete a PhD at Harvard under Edward O. Wilson, a man who has recently been named as one of the 100 most influential people in the history of science.

Moffett turned to the camera as a means of documenting the miniature world of insects that so captivated him. The first pictures he was to have published, which were taken in 14 separate countries during the course of 33 months of doctoral travel, appeared alongside an article that he wrote for National Geographic in 1986. Ever since that time, he has remained one the magazine's core group of photographers and writers.

His view of some of the world's smallest creatures fascinate those who experience it, and Moffett's approach is to treat his subjects with the kind of respect that is usually reserved for the larger and more high profile of animals. "If you're photographing a rhino or an elephant," he reasons, "you can only ever make them smaller on film. With insects you can achieve the opposite effect, and I always think it's one of the greatest achievements when people forget exactly how small some of my subjects actually are."

Moffett himself had to see the funny side when describing to underwater wildlife photographer David Doubilet an incident that he had pictured. "I was getting very excited," he says, "and was telling David how fantastic a distance jumping spiders can jump. For a moment he was really impressed, and he asked me exactly what the distance was that I was talking about. When I told him three inches he just started to laugh: to me a spider's leap was a real achievement, but then I find myself thinking about things on a miniature scale."

Moffett has been featured in television specials, has been ranked as among the very best nature photographers by leading magazine editors in Europe and America, and has had many of his images included in World Press Photo exhibitions in 40 countries.

Moffett now enjoys the lectures that he gives around the US and occasionally for Berkeley classes. He also holds research positions the University of California at Berkeley in Vertebrate Zoology and at the Smithsonian Institution in Entomology. His science pursuits continue to be varied. At one extreme he investigates the intricate behaviour of insects, such as the habits of the smallest ant (a Malay species named atomicus, which has a head the size of an amoeba) while at the other, he has studied at close range the structural ecology of tree crowns in America's Pacific Northwest.

It's this variety, mixed with a genuine regard and enthusiasm for his subjects, that keeps Moffett so very clearly at the top of his field. "At a time when biologists are shifting increasingly to 'high-tech' laboratory-based work," he says, "I am fortunate to have invented a life as a successful anachronism – the sort of itinerant biologist I dreamt of as a child."

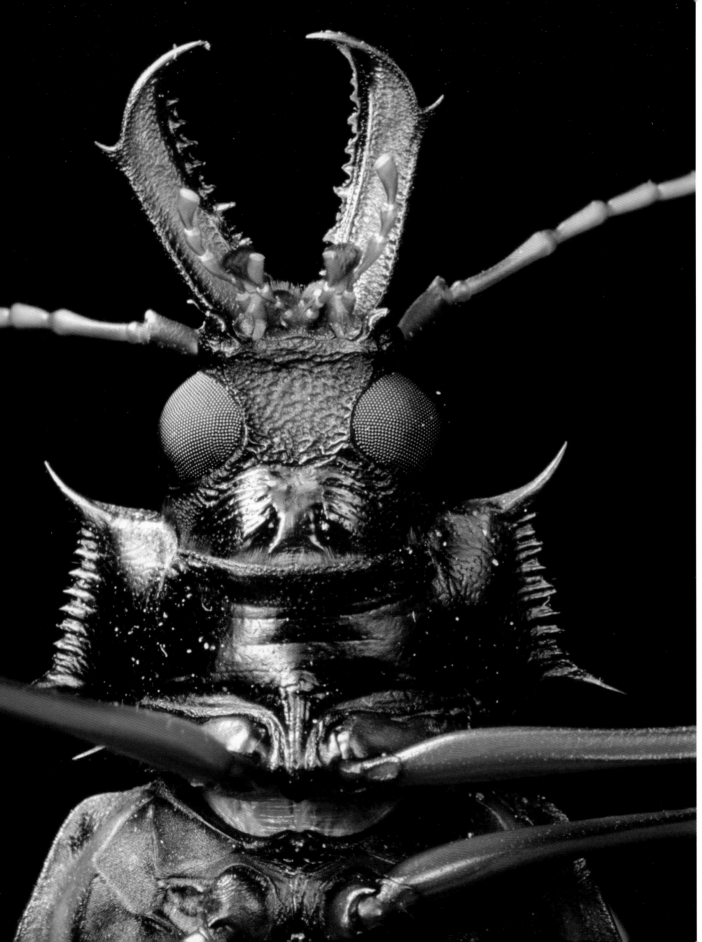

Long-horned beetle
This long-horned beetle was photographed by Mark Moffett in French Guiana using a three light set-up. The image was considered so strong that it was used on the cover of *National Geographic*. "It was quite a straightforward image," he says, "because the beetle is quite large, around four inches in length. I was so busy trying to get the best angle and getting myself co-ordinated that I reached a little too close, and it turned around and slashed my hand. The burnished look is the result of the sheen of blood on it."

Canon T-90, 55mm macro lens

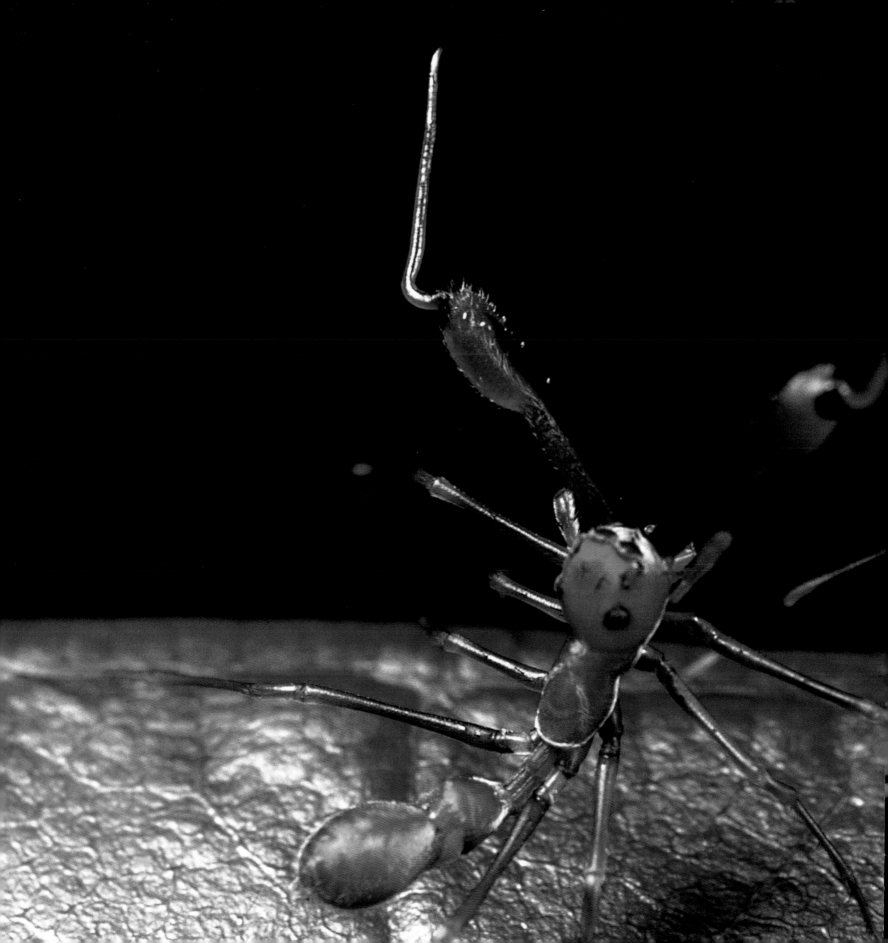

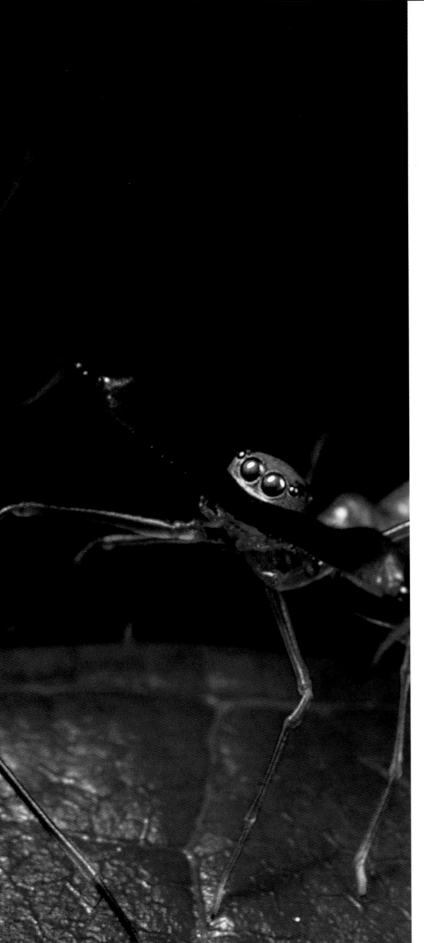

Fighting spiders

"The kind of pictures that really interest me are those that haven't been tried before," says Mark Moffett. Much of his work is undertaken in the field, because it would be almost impossible to replicate the behaviour of his subjects accurately inside. Wishing to achieve the best possible quality in his pictures, however, Moffett has perfected a way of achieving a miniature studio lighting set-up that is totally portable.

This picture of fighting spiders, taken in Queensland, Australia, shows how effective this arrangement is in action. "Basically I build a little studio into the front of the camera," he says, "and replicate studio lighting around two to ten centimetres in front of the lens." Two lights are used at 45-degree angles either side of the taking lens, while Moffett holds the third light in his hand, and manoeuvres it into the required position for extra fine control. "Multiple lighting set-ups are always more effective than a single flash or ringlight," he says. "In studio terms, I use one light as the main light, the other as a fill, and the one that I have in my hand acts as a hairlight, for that glamour look! It's important to have that backlight because if the subjects are being photographed, as here, against a black background, you need to be able to differentiate them from their surroundings. The black background is quite appropriate in dim jungle settings, but you can add background by shifting the flashes."

Moffett needed to use his natural history skills to work out where he was likely to find his subjects and when the best time would be to photograph them. This location is a fallen tree, which the male spiders fight over jealously, because it's the ideal spot for mating. "They throw themselves at their opponent like gladiators in a duel," says Moffett, "clashing fangs as if they were swords. In this frame, the one on the right is backing away to make his escape while the winner rears up like 'Rocky' in the ring. Like other favourite images, you forget how small the subjects are – these guys are about a quarter of an inch long."

Olympus OM2, Olympus 38mm macro lens

Dr Mark Moffett

Art Morris USA

Art Morris first became interested in bird watching in the mid-1970s, spurred on by a number of seemingly unrelated events. One still morning, after doing some surf fishing, he became mesmerised by a black skimmer working a tiny tidal pond. Next, the owner of the local cardboard box factory came to the school where he taught, and showed the children his home movies of tiny songbirds called warblers. His enthusiasm was contagious!

Finally, while carrying out a summer job at a local outdoor-pool club in Canarsie, Florida, he found himself staring through the chain-link fence at the long-necked white "Florida birds." (He was later to learn that they were great and snowy egrets).

In 1983, inspired by the work of two local bird photographers, Morris purchased the Canon FD 400mm f/4.5 lens. He took some pictures of small sandpipers and was immensely disappointed when the resulting images showed only tiny specks on the slides. "Since I loved shorebirds so much," he says, "I began getting on the ground with my lens and crawling through the mud so I could get closer to them and make better images."

An unpromising start it may have been, but he persisted. For seven years he worked with the limitations of his 400mm lens, with its 8x magnification, pretty much unaware that there were longer lenses available, and not knowing the huge advantages that they could provide. Yet, despite this handicap, he began to sell some images. He also started writing for some of the birding magazines, and even sold several images to the prestigious Audubon calendars.

"I had thought that doubling the focal length of a lens would double the size of the bird in the final image," he says. "As it turns out, when the focal length is doubled, the size of the bird's image is quadrupled (as the area covered by the bird is a function of the square of the focal length). When I purchased the Canon FD 800mm f/5.6 L lens and used it for the first time, I felt as if I had wasted those first seven years of my photographic life."

In 1989, he married his best friend and biggest supporter, Elaine Belsky, and in June 1992 the couple left teaching to pursue Morris' dream of becoming a full-time professional nature photographer. They bought a home in Deltona, Florida and in February 1993 Morris attended a seminar given by George Lepp.

"It was then that I learned that Canon's EOS bodies and EF lenses, with their predictive autofocus technology, would be ideal for photographing birds in flight," he says. "I immediately bought a Canon EOS A2 body and an EF 400mm f/5.6L lens, and from the very first roll began producing incredibly sharp images of birds in action."

In December 1993, Morris ran his very first Birds as Art Instructional Photo-Tour, which attracted just a single participant. Today his tour business has grown to the point where most of the tours are sold out many months in advance and have long waiting lists.

Since starting his career, more than 120 of Morris' illustrated articles have appeared in natural history, birding and photographic magazines. He is a columnist for the US magazine *Outdoor Photographer*, and a regular contributor to *Nature Photographer*, *Birders World*, *Bird Watcher's Digest* and *Wild Bird*.

Five of his images have prevailed in Wildlife Photographer of the Year Competitions. As one of the original 55 Explorers of Light, he has been a Canon contract photographer for the past six years, appearing for them on television in an EOS 1N commercial that aired worldwide, and in seven episodes of the Canon Photo Safari. A travelling exhibit of his work, sponsored by Canon USA and The Nature Conservancy, began its run at the prestigious Roger Tory Peterson Institute in Jamestown, NY in 1999. In 2001, 64 of his framed images featured in a year-long educational exhibit titled *On a Wing and a Prayer; The Migratory Birds of the Americas* at the National Zoo in Washington, D.C.

Morris has conducted more than 325 slide programs and seminars in the past 15 years. He currently travels, photographs, teaches, and speaks his way across North America while leading more than a dozen Birds as Art Instructional Photo-Tours each year.

Least tern with chick
Many species of beach-nesting birds are threatened by coastal development and human encroachment. This least tern at Lido Key, Sarasota in Florida, lost its sole chick the night after Morris made this image due to flooding caused by storm surge at high tide.

Canon EOS 1V, EF 600mm f/4.0 L image-stabilised lens, 1.4x teleconverter, 1/250sec at f/10, Fujifilm Velvia pushed one stop

Whooping crane (far right)
In the 1990s, several dozen captive-bred (endangered) whooping cranes were introduced into the wild at a number of Florida locations. Most avoided people but one pair on the shores of Lake Kissimmee was completely oblivious to fishermen, boats and photographers.

Canon EOS 1N, EF 600mm f/4.0 L lens, 25mm extension tube (to allow for close focus), 1/640sec at f/8, Fujifilm Velvia pushed one stop

Snowy egret at nest

"This was taken at the St. Augustine Alligator Farm in Florida," says Morris. "Here, protected from ground predators by large numbers of tourist-attraction alligators, several species of wading birds breed in relative security. Some of the nests are within a yard of the boardwalk, providing amazing photographic opportunities from April through July.

"I set up my Canon EF 600mm f/4.0 L image-stabilised lens with a Canon EOS 1V camera body attached. A 550 EX electronic flash was mounted on a flash bracket above the lens and powered by an external battery pack. In the soft light, I knew that the exposure suggested by the evaluative metering system would be just right. I set the flash to -1 stop so that the flash would simply restore the colour balance of the Fujifilm Velvia that I was using and to add a catchlight to the subjects' eyes.

"I focused on the eye of one of the chicks and waited for the feeding process to begin. Adult snowy egrets take turns incubating so that one parent is free to go fishing, and most adult snowy egrets feed relatively far from their rookeries. The baitfish that are captured are swallowed whole and digestion begins on the flight home. When the gone-fishing parent returns, the two mates usually perform a brief exchange ceremony. The ten-day-old chicks shown here are eager to be fed and when a parent returns to the nest they begin tugging eagerly on the parent's bill. This stimulates the adult to regurgitate the partially digested fish."

Canon EOS 1V, 600mm f/4 L image-stabilised lens, Fujifilm Velvia

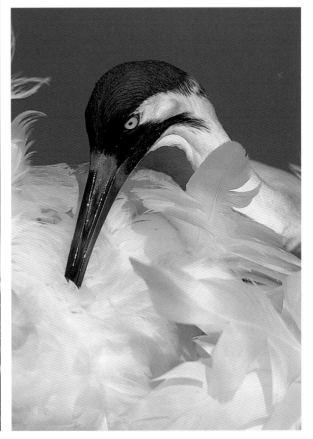

Art Morris

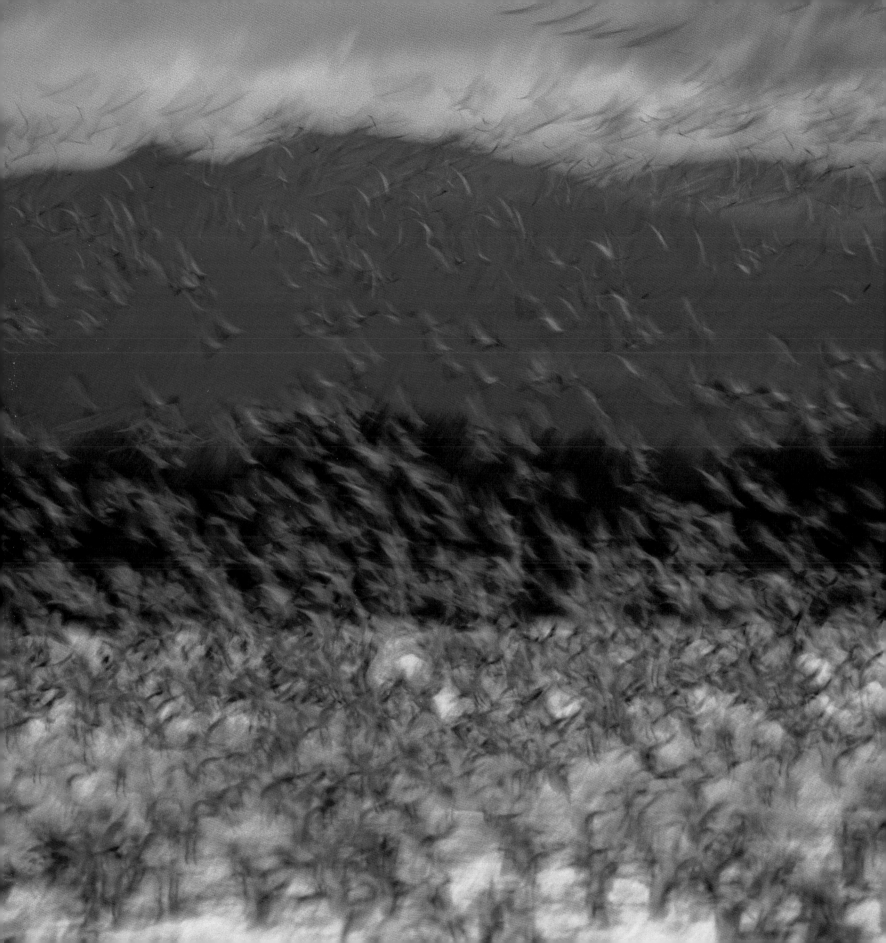

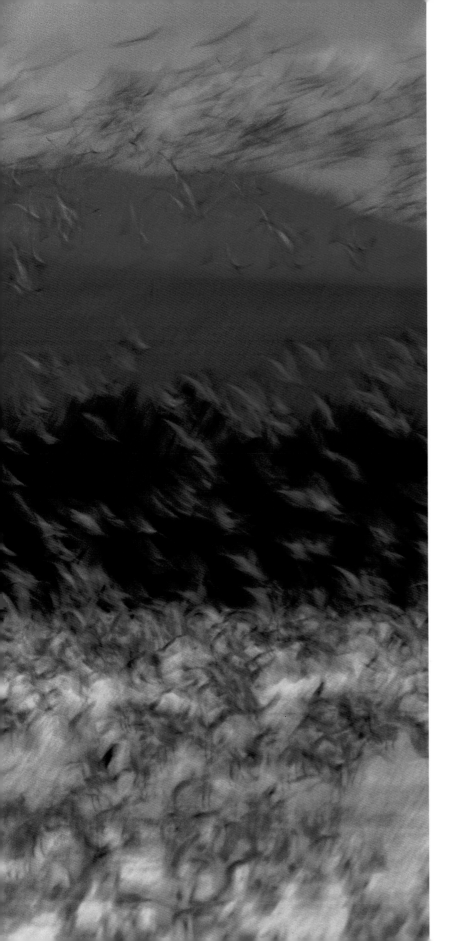

Snow geese

Morris titles this picture of snow geese at the Bosque Del Apache National Wildlife Refuge in New Mexico "Blizzard in Blue."

"It was so cold and dreary on the morning that I made this image that more than a few other photographers remained in their vehicles with the heater on," he recalls. The photograph went on to be voted runner-up in the Composition and Form category in the 1997 Wildlife Photographer of the Year Competition.

Canon EOS A2, EF 400mm f/5.6 L lens, 1/15 sec at f/5.6, Fujifilm Velvia pushed one stop.

Art Morris

Vincent Munier FRANCE

Vincent Munier grew up in Charmes in the east of France, a small town lying on the River Moselle, sandwiched between the mountains of the Vosges on one side and large areas of natural forest on the other. In such an environment it was almost inevitable that he should develop a love of nature and, as he grew older, he started to dedicate every free moment to stalking and photographing wild animals.

He acquired an Olympus OM2N, an old 400mm Novolex telephoto lens and a tripod and, with a camouflage net and a packed lunch stuffed in his rucksack, he cycled dozens of kilometres a day in search of deer, foxes and wild cats. Sometimes he even took a duvet with him, spending the night in the forest in order to capture atmospheric twilight shots.

Munier studied science at school, and then worked for a year as a gardener, saving hard to buy photographic gear. Once kitted out with Nikon camera bodies and new lenses, he began taking his photography much more seriously, setting himself professional standards. He got a job as a photographer on a daily regional newspaper, where he learned some valuable new lessons. "One of the most useful was the ability to capture good-quality pictures while working at high speed, an invaluable knack in wildlife photography," he says.

With a contract from a multimedia agency in his pocket, Munier set off abroad in search of new subjects. His first stop was Namibia, where he spent two months photographing and filming tribespeople such as the Bushmen, the Namas and the Hereros, particularly their relationship with the natural world. He worked in many stunning natural locations, including the Namibian and Kalahari deserts, Cape Cross, the Ugab Valley, Etosha and Waterberg. After this he travelled to the Canadian Rockies, to Scandinavia and to various Asian countries. He spent time in Spain and Sweden on the trail of his favourite bird, the common crane. However, the Vosges region of France remains his favourite location.

Munier has won many wildlife photography awards in his native France, and in 2000 won the Eric Hosking Award in the prestigious Wildlife Photographer of the Year Competition, also scoring a Highly Commended in the mammal behaviour section. He followed this up with a second Eric Hosking Award in 2001 and a special commendation in the landscape section of the contest. His fascination with the common crane resulted in the publication of his first book, in which he tracked the bird's annual migration route from Northern Europe to Spain, a journey of several thousand miles.

Vincent portrays his subjects in their natural environment, believing that the context is an essential part of any wildlife picture. To capture natural behaviour a hide is indispensable, but he stresses that these must be discreetly placed and carefully disguised to avoid alarming shy prey. "Bear in mind that a hide must always blend in with its surroundings," says Munier. "As far as possible you should melt into the landscape, and simply become part of it."

Munier uses Nikon gear: F801 bodies, together with an F5 and, more recently an F80, which has a particularly quiet shutter mechanism. He soundproofs his other cameras by wrapping them a fabric cover, to avoid frightening away his subjects whenever he fires the shutter. He has a number of zoom lenses together with 300mm f/2.8 and 600mm f/4 fixed telephotos. A sturdy Gitzo tripod completes the kit.

"My favourite lens is the 600mm," says Munier. "It weighs six kilograms (as much as the tripod!) and isn't easy to manoeuvre, especially in the mountains, but once I'm set up in the hide I really appreciate its quality. I like the autofocus mechanism on Nikon's long lenses but I'm waiting for them to bring out lenses with built-in image stabilisation. In the meantime, I use a tilt-and-swivel video head to hold the camera steady."

Film choice is Fujifilm Velvia, on account of its fine grain and its high contrast, although its ISO 50 rating makes for slow shutter speeds that are tricky to handle with such heavy camera equipment. When the light is particularly harsh or contrasty, Vincent uses Sensia 100, which he finds gives a more neutral effect.

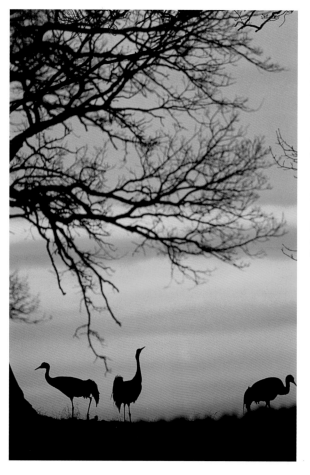

Cranes in silhouette
The Lac du Der in the east of France is a wildlife reserve that every year plays host to tens of thousands of migrating birds, particularly common cranes en route from Scandinavia to Spain. It's not unusual for upwards of 30,000 cranes to congregate here for a period of several weeks, gathering their strength for their long journey. Vincent Munier set up a number of hides in the fields around the lake. "During the day I was surrounded by thousands of cranes," he recalls. "At night they all returned to a dormitory in the middle of the lake, where they could sleep in safety. These three stragglers were silhouetted against the setting sun, and the composition was completed by the graphic shape of the old oak tree."

Nikon F5 (muffled to soundproof the shutter mechanism), Nikon 600mm f/4 lens, Fujifilm Velvia at 1/30sec, Gitzo tripod

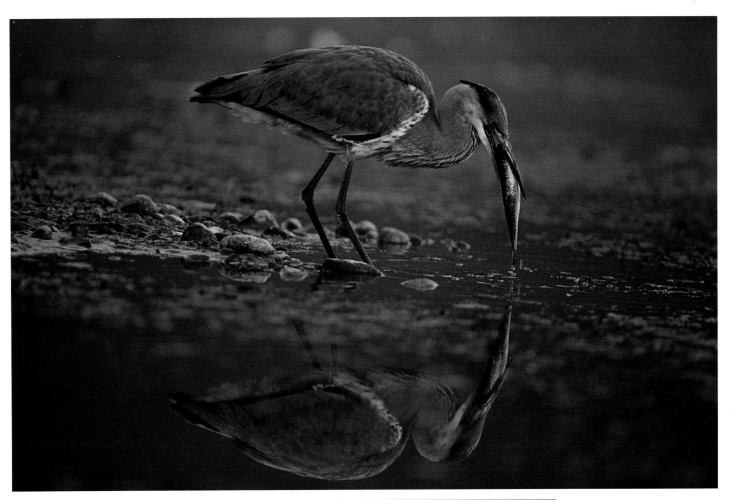

Heron feeding

Vincent Munier spent several days on the banks of the River Moselle with a pair of binoculars, establishing the exact spot where this heron and its companions came to feed in the early morning. He then built a hide out of camouflage material and disguised it with reeds and branches. "I particularly like the light that you get just before dawn," he explains. "The herons left their perches and came down to the river just before daybreak. At 4am I was in the hide, ready and waiting to photograph them catching their breakfast."

Nikon F5 (muffled to soundproof the shutter mechanism), Nikon 300mm f/2.8 lens, 1/60sec at f/2.8, Fujifilm Velvia, Gitzo tripod

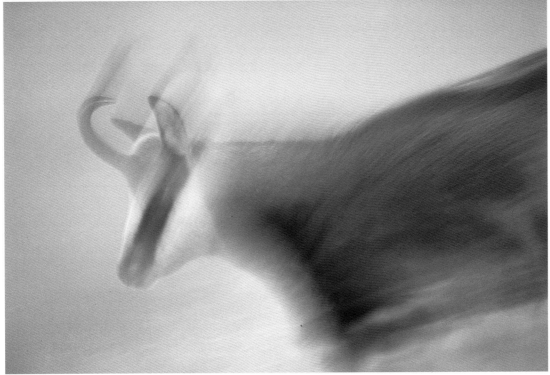

Charging chamois

Vincent Munier encountered this chamois in the Vosges mountains of eastern France, at an altitude of around 1,000 metres. It was November and the rutting season, but it was difficult to get close to the animals, as their favourite habitats are inaccessible rocks and cliff-faces. "It was very early in the morning and the sun was just rising," he says. "I was hidden under a camouflage sheet and the animal, a male, was about 100 metres away when he started to charge. He'd spotted a female right behind me and took me for a rival! However, at the last second he changed his mind and veered away."

Nikon F5 (muffled to soundproof the shutter mechanism), Nikon 300mm f/2.8 lens, Fujifilm Velvia at 1/30sec, Gitzo tripod

Vincent Munier

Backlit birds

Vincent Munier spent three consecutive days and nights in a hide, in temperatures as low as –15 degrees C, to get this shot. The location was a lake in Falköping, near Gothenburg, Sweden where every April birds such as wild swans, common cranes and numerous varieties of ducks and geese gather on their annual return to their northern breeding grounds.

"I took this shot very early in the morning. It was extremely cold but the weather was clear and sunny," explains Munier. "The wild swans are the main subjects but there were also some common cranes and mallards mixed in with them. Because the lake was frozen, the birds were restricted to a small island and I set up the hide so that when the sun first appeared over the horizon, they were backlit. Wild swans have very loud calls, like a foghorn. It was so cold that, when they opened their beaks to call to their companions flying over the lake, their breath appeared as mist on the air. The only way to capture that properly was with backlighting."

The hide was made of camouflaged canvas covered over with branches. Other essential items of kit included lithium batteries, a sleeping bag, a Thermos flask and three days' supply of food. "Each night there were 40 or so wild swans gathered around the hide," recalls Vincent. "They were constantly 'talking', as if to reassure one another. This was the last time they would be together as a flock: the nesting season was about to begin, when the birds went their separate ways. I had already seen a few mating displays and witnessed a number of fights between individuals."

To get good wildlife pictures, it's essential to have a thorough knowledge of the subject and its patterns of behaviour. "I think that a successful photo is one where the photographer has won the confidence of the subject by dint of knowledge, respect, passion and patience," says Munier. "I feel myself very privileged to be able to witness the natural world at close quarters. Through my pictures I want to share these moments and try to make people aware of the importance and the fragility of the great diversity of animal and plant life that surrounds us."

Nikon F5 (muffled to soundproof the shutter mechanism), Nikon 600mm f/4 lens, Fujifilm Velvia at 1/125sec, Gitzo tripod

Vincent Munier

Mike "Nick" Nichols USA

The photography bug bit Mike "Nick" Nichols when he was 18, starting with a Photo 101 course at school, which he undertook immediately before being drafted into the army in the early 1970s. "I had studied fine art," he says, "but the camera was more immediate, and I knew at once that was what I wanted to do."

Nichols was so sure of his career direction that, even though he didn't enjoy the idea of serving in the army, he signed on for an extra year so that he could be a photographer instead of being directed towards the infantry. "In that time I learned how to print black and white and got to use equipment that I couldn't afford," he says. "The people there never used a light meter and, as far as I could tell, they didn't care about quality, but I liked the concept of not depending on the technology so much and using your instincts."

After leaving the army he went back to school to get his photographic degree and starting sending his portfolio to *National Geographic*. His first experience was not altogether encouraging: "The magazine had (and still does have) a famous internship programme for young photographers," says Nichols. "Bob Gilka, the director of photography at the time, sent me back a letter that said 'why don't you choose another profession – have you thought about being an attorney?'"

Nichols didn't give up, however, and his perseverance eventually paid off when he started to work regularly for the European-based *Geo* magazine, which was challenging *National Geographic* at that time. "I really saw the world on their money," says Nichols, "and matured a lot and evolved to where it was right for the *Geographic*." He eventually became one of the staff photographers on the magazine in 1996.

Nichols thoroughly appreciates the working methods of the title and the faith that it shows in stories that others would simply sideline as being impossible. The title's belief in Nichols and, in particular, in a method he was working on to set up "camera traps" so that some of the world's most elusive creatures could effectively photograph themselves, has paid off spectacularly, but only after a huge financial investment and a series of early failures that almost finished the project before it had properly got started.

The idea of "trapping," which had initially been pioneered way back in the early years of the last century by English photographer F. W. Champion, was tested out by Nichols in the Congo. He quickly discovered just how frustrating it can be ironing out the bugs that are inevitably associated with such a highly sophisticated technique. "We had so many problems," he says. "Batteries blew up, flashes melted, animals ate the cords, and we got nothing on film. The device was too sensitive, so we got thousands and thousands of false hits and empty frames. We did, however, get a leopard picture and, when I took this out of its Kodachrome box, the picture didn't work because its eye wasn't visible. When I peeled back the cardboard mount, however, there it was right on the edge, and I persuaded *National Geographic* to use it right across a spread!"

All of the experimentation, however, was just a precursor for his sensational tiger shoot in Bandhavgarh National Park in India, which took him 11 months of solid work spread over two years to complete and which eventually not only appeared in *National Geographic* but provided much of the material for a book, *The Year of the Tiger*.

The project was fraught with problems from the very start. It took a full year to sort out permissions to enter the area and to set the camera traps, partly because of red tape but also because it was a dangerous assignment and the park authorities were not keen to allow walking on foot or the use of hides, both of which were forbidden. A case also had to be made for the camera traps to be use against a background of misunderstanding that they might disturb the animals. Finally, Nichols had to overcome a degree of jealousy that a stranger should be allowed special access.

Then, once everything had finally been arranged, it was a case adapting the equipment so that it would become more reliable and learning, through experience, where to set the camera traps and how best to maintain them.

"Up till then there was only one way to photograph a wild tiger," says Nichols, "and that was from the back of an elephant, because the tigers wouldn't associate the elephants with humans and woul accept you to a degree. The camera traps offered me the chance of different way of working, and I wanted to see what could be achieved"

The cameras selected for the camera traps were Nikon N90s, combined with SB26 strobes. *National Geographic* technicians worked out a way to send the cameras to "sleep" so that battery lif could be conserved, and they also treated the strobes so that they reacted in the same way – waking up every hour, however, so that they were charged and ready to fire the moment they were require Prolonging battery life was essential because, to avoid disturbing th creatures he wanted to photograph and to keep human scent to a minimum, Nichols was changing films only around once a week.

The set-up was fired by an infrared beam linked to an infrared trigger called a Trailmaster (www.trailmaster.com) that fired the camera. Its sensitivity was adjustable to suit different circumstance

For a set-up such as this, the camera needs to be protected and different methods have to be used to suit the conditions. In the Congo, to prevent the film from rotting in the humidity, the camera was encased in a waterproof box packed with silicon gel and fronte with a sheet of optical glass. In India, however, this was adapted, so that the camera was covered with a camouflaged waterproof hood with the camera itself and the tripod protected by a plastic bag.

"As a photographer I don't recommend that people try to photograph tigers in the wild," says Nichols. "It's very intrusive to them, and I had extraordinary permissions for my work. Tigers are very different to lions and cheetahs out in the Serengeti who don't mind being seen and whose hunting ability, and therefore survival, isn't so affected. But you can get great photographs of tigers in captivity – and there are more tigers in captivity than in the wild."

Tiger time

"This tiger is a rival of the dominant male Charger," says Nichols, who got this picture at Bandhavgarh National Park in India using one of his camera traps, with which the animal unwittingly photographs itself. "The waterhole was a very important spot for them both and marked an uneasy overlap in their territories. On this night we knew from the Trailmaster computer that Charger had drunk from the waterhole an hour earlier. We think it was that night that they got into a fight and Charger was badly injured. The male was not seen again for several months."

Nikon N90, 24mm lens, Kodachrome 64, Trailmaster trigger

Sita bathing her cubs

This shot was taken at Bandhavgarh from the back of an elephant. "We arrived before Sita had returned from her night of hunting," says Nichols. "The cubs were hiding in a small cave and only came out when they heard their mother approach. Here she is cleaning them and transferring her scent, and then she will let them drink." The picture was taken using a 500mm lens, steadied on a monopod resting on the elephant's back. A touch of fill-in flash helped with the darkness and lifted the highlights a little.

Canon EOS 1, 500mm lens, Kodachrome 200 uprated to ISO 500, monopod

Mike "Nick" Nichols

Charger

This picture was taken in the Bandhavgarh National Park in 1997. Nichols considers it to be the best of all his tiger frames, and it was effectively taken by the tiger himself!

"From an elephant's back I had seen this tiger that we called Charger and another called Bacchi jump across a small gap to reach a waterhole," he says, "and, with great effort, we put a camera trap at that spot. The gap that the tigers were jumping across was just a few feet, but the drop was more like 30 feet, and we had to make sure that no-one fell down it.

"In the three months that we left this trap in position we got pictures of monkeys, pictures of bats and several pictures of Charger's tail as he headed in the opposite direction. This was the only image that caught him face on, however, in all that time."

A selection of SB26 strobes were set up around the scene to create lighting that was as natural as possible – "I like to take care over the lighting so that it looks as though I was there taking the picture," says Nichols – and these were set to manual so that they weren't confused by a creature being lighter or darker than average. The camera was set to its aperture priority metering mode and the shutter speed was allowed to float.

Nikon N90, 20mm lens, Kodachrome 64, Trailmaster trigger

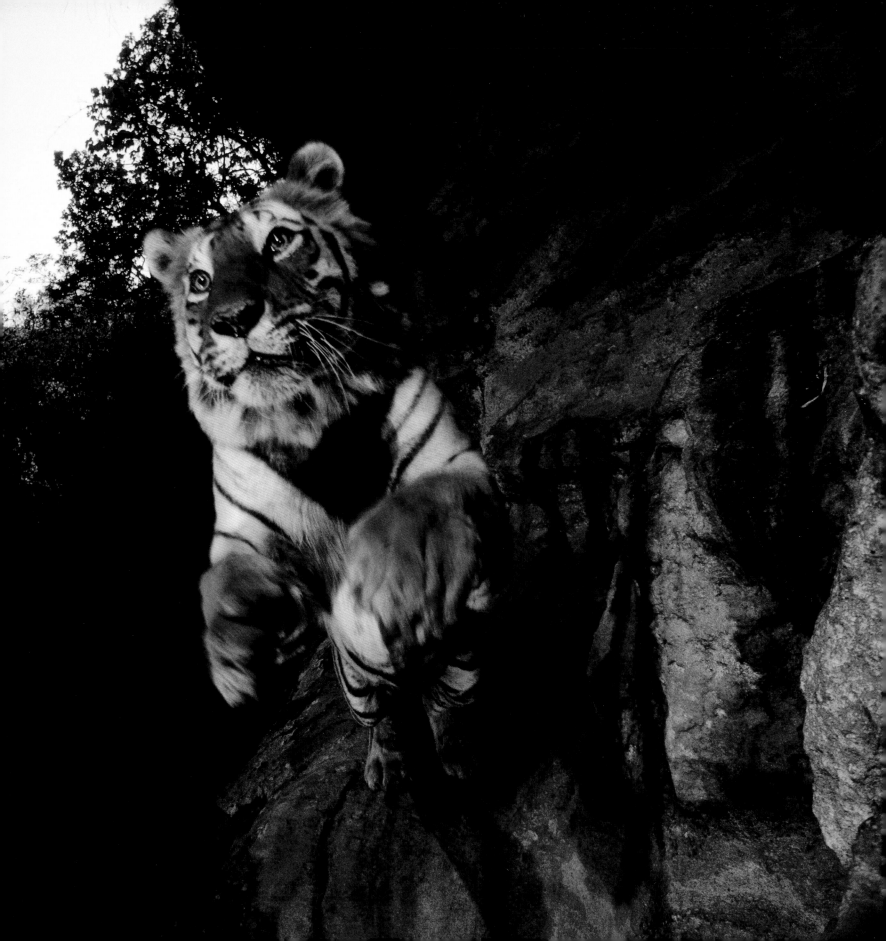

Flip
Nicklin USA

The relationship between Flip Nicklin and the ocean goes right back to his childhood, when his family ran a dive shop selling speciality gear for spear fishing. There was also a tradition of photography in the family: "My father shot a lot of stills," says Nicklin, "and he was also a cinematographer, who worked on some of the James Bond films. We also had a connection with *National Geographic*, because my grandfather had worked with Bates Littlehales, who was the underwater photographer for the magazine, and he had become a great family friend."

While Nicklin had the credentials to be an underwater photographer himself, he didn't really get involved until he suffered a bike accident in 1978, and he used the insurance money that he received to invest in a Nikon underwater housing. He then landed a three-month job as a diving and camping companion for a *National Geographic* team led by Jonathan Blair that was undertaking an assignment on a desert island in the Pacific chain.

"I was there just to help out, not to use a camera at all," says Nicklin, "but the guys on the trip were very generous and let me take some pictures, and subsequently I showed these to Dave Arnold, who was *National Geographic*'s picture editor at the time, and also to Gilbert Grosvenor, who was the editor. Looking back, it was pretty ordinary work, but they both took time and encouraged me, which I really appreciated."

The next break came for Nicklin when he landed the job of shooting the production stills for a team that was working on a new IMAX film about humpback whales, *Nomads of the Deep*, in Hawaii. It introduced him to a team of researchers led by James Darling, who were to go on to become key people in the study of marine life in the area and, once again, there was a *National Geographic* connection, with the magazine becoming a sponsor to the group.

The magazine paid Nicklin's expenses to allow him to dive for three seasons, one while the film was being produced in 1979 and then two years on his own. His work during this time earned him a reputation as the "whale guy," which subsequently led to him being offered another assignment, this time to photograph killer whales. From this point on he worked regularly for the magazine.

"From photographing these enormous subjects, I was then given an assignment by *National Geographic* to photograph krill, which are around one quarter inch in size," he says. "It was typical of the magazine's attitude: it was prepared to invest in stories that it didn't even know would be possible, and it would provide the time and the resources to allow you to try your best to come up with the results.

"One of my jobs for *National Geographic* was to photograph sperm whales in Sri Lanka, for example, and it was so difficult that in the six months I was working on it I only had four days of decent photography. At another time I was covering narwhals off Baffin Island, and I went three and a half months before I got a single decent image. Most magazines would pull you off the story if you didn't produce the goods in two weeks, and I'm very lucky that *National Geographic* has a different way of looking at things."

The kind of assignments that Nicklin tackles calls for him to travel light. Originally he used Nikonos cameras extensively, but after ten years, and with assignments to photograph rare species increasing, he decided to move exclusively to Nikon SLRs and to use housings. "It was the development of really good autobracketing and autofocus that decided me," he says. "With a Nikon F4 I can lock on to a subject and follow focus automatically, and I know that if I shoot three frames all of those pictures will be okay. With the Nikonos, I would probably only achieve the results that I wanted two-thirds of the time, which meant that I would miss one pass out of three. When you consider that you might only get one four-second pass to work with in a whole shoot, it was obvious that I couldn't take the risk of losing these opportunities."

Nicklin will also try to ensure that he shoots at least one roll of colour negative film per situation on an assignment. "Most of the requirement from *National Geographic* is for transparency film," he says, "but colour negative film is much more forgiving, and if I get the opportunity to use it I know that it will give me something that I can use."

Humpback eye
This humpback whale was located off Maui in Hawaii and Nicklin, who has a special permit allowing him to photograph what is an endangered species, dived to take some underwater pictures as it swam next to his boat.
"It was really enormous," he says. "I decided to take some detail shots of rather than try to show the whole whale, because that's what a diver is most likely to see. When the light caught his eye I decided that this was the moment I had been waiting for."

Nikon F4, Nexus underwater housing, 55mm Micro-Nikkor lens, Fujifilm Provia 100

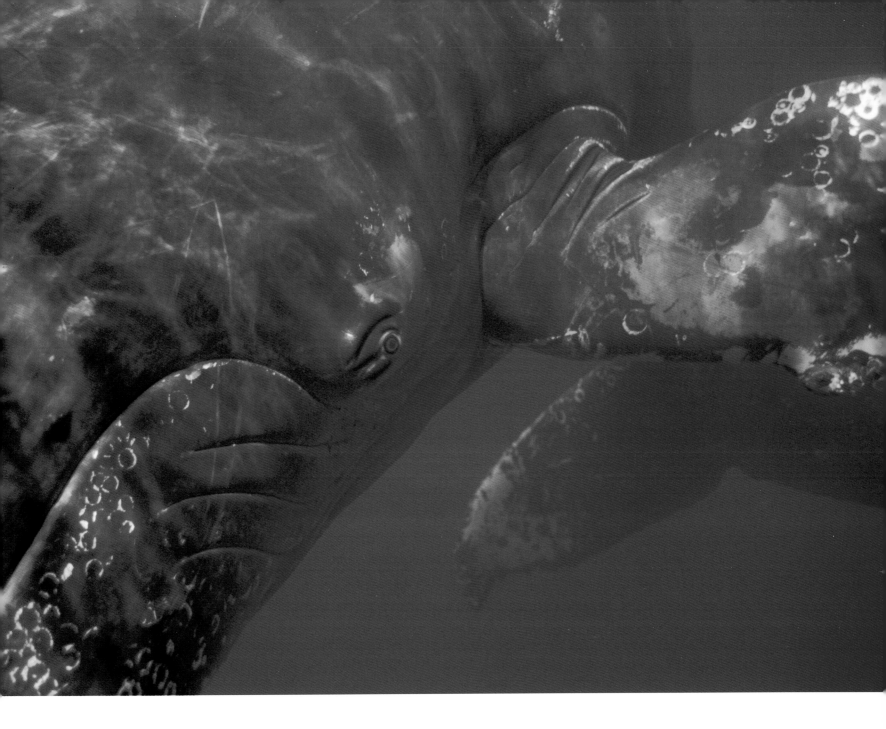

Flip Nicklin

Speedy dolphins

One of the hotels in Hawaii has a huge man-made lagoon next to it, and most days it's used as an exercise area for a team of 11 captive dolphins. Flip Nicklin had been visiting on a regular basis in order to photograph the dolphins in this environment, but had decided that it wasn't really worth entering the water before around 7.30am because the sun wasn't high enough in the sky before that time to provide the necessary quantity of natural light that he required.

"My assistant Maria Bunai suggested that there was an opportunity to do something a little different here that might work out really well," says Nicklin. "So, every morning for the first half-hour, while there were still shadows in the lagoon, I went in with the dolphins and took pictures that were a deliberate mix of flash and slow shutter speed. I use two Sea & Sea 300 strobes either side of my camera, about 18 to 24 inches from the nodal point, which are just aimed straight out there so that they come together at a point around 30 inches in front of me. I combined this arrangement with a shutter speed of around one eighth to one quarter of a second, and this is the result that I got.

"It was something of a revelation to me. I had spent the previous ten years working hard to get a really hard edge into my pictures and, if they were pin sharp, to my way of thinking that was a good picture.

"The result I achieved here, however, was less about what the dolphins themselves looked like, and more about what it actually felt like to be there and, for me, that was a very different way of working, and one that I found really rewarding."

Nikon F4, Nexus underwater housing, 20-35mm zoom, Fujifilm Provia 100, two Sea & Sea 300 strobes

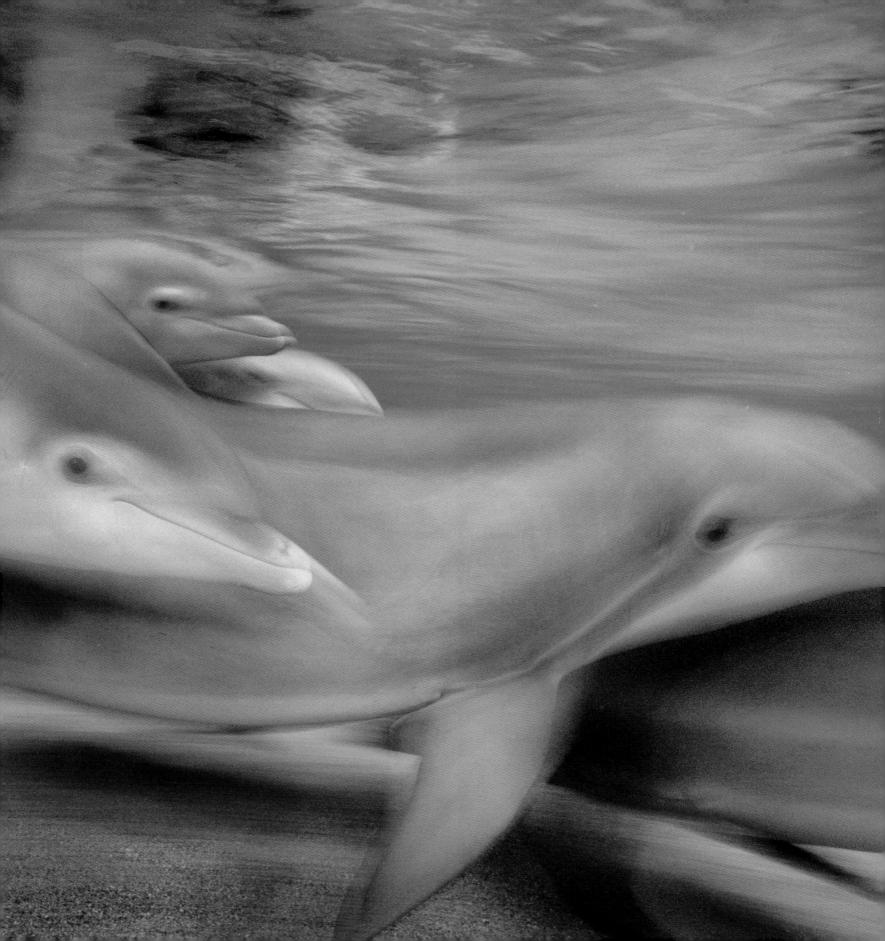

Chris Packham UK

While passionate about wildlife from a very early age, Chris Packham found himself growing up in a suburban area of southern England that appeared to offer little encouragement to someone who wanted to hone photographic skills. Faced with the fact that he was unlikely to be able to turn his camera on the more dramatic species, he decided instead to make the most of the opportunities that he did have, and to look at subjects, such as garden birds and urban foxes, that might have been considered more mundane and less challenging by some.

"I wanted to produce wildlife photographs that were very different to most of those that I was seeing at that time in the early 1980s in any case," he says. "In my opinion there was, and still is, a lot of very dull wildlife photography being produced, because people aren't looking beyond the obvious images. I didn't want to take pictures that were just repeats of things that had already been done many times before. Instead I wanted to see if it might be possible to develop a style of my own that was very art-based."

Setting himself a series of personal projects, Packham slowly started to put together a portfolio of images that he felt expressed what he felt about wildlife, and he worked close to his home, often in his back garden or driveway. "I produced a whole series of pictures where the theme was simply reflections," he says, "and I also put together a set of photographs using just the local park as a location."

He also started entering competitions and sending his work to photographic magazines in the hope of achieving some recognition. His success rate began to increase as he became more confident in his style.

"It's not the subject that's important, it's the image," believes Packham. "For years, photographs of lions and tigers won competitions because they were photographs of lions and tigers — not because they were any good.

"I started taking pictures in my backyard to prove it's the image and not the subject that counts. I did well in competitions with foxes on my driveway and dead fish on the garage floor. They beat shots of cheetahs pulling down gazelles in Kenya. You should be able to take a prize-winning picture of a grey squirrel if you come up with the right idea."

Packham's obvious enthusiasm for his subject, his distinctive style and the fact that he was in the right place at the right time – he was working as a film cameraman's assistant – all conspired to engineer him a break into television, and over the past decade or so he's built up a high profile in Britain, fronting a whole series of television programmes with wildlife themes.

It's still the photographic work that gives him the greatest pleasure and sense of fulfilment, however. "The thing that I've had to learn to live with as far as TV is concerned is that it's all about compromise," he says. "At the moment I'm working in a very close team and, as the executive producer, I have quite a lot of editorial control. However, there is still a cameraman, a director and an editor involved, and so no matter how focused my idea is, it will always be compromised to some extent.

"With photography, however, the moment you press the shutter it's all about you. Or rather it's you, the place, the time and the subject. There's no compromise. To me, that makes it a much purer form of expression."

Koi carp
"I'd travelled to Hawaii for the World Surfing Championships and to photograph honeycreepers, which are endemic to the island," says Packham. "The weather was atrocious and I didn't get any pictures at all. On the last morning, out of desperation, I went to a hotel lobby where I knew they kept a pond full of koi carp. I shot a set of pictures of them using a slow shutter speed, and this was the result. I think it says pretty much all you need to know about these fish and their beautiful colours."

Canon EOS 1, 80-200mm f/2.8 zoom, Kodak Ektachrome 100, 81B filter, shutter speed two seconds

Young tawny owl
"I had been told about this young tawny owl, which had died in a cement silo in Southampton Docks, by a friend of mine who recognised that it might be suitable as a subject for my style of working. It was autumn, and it had probably starved to death because this is the time of year that a large number of young birds are driven out of their territory by adults, and this is the fate that often befalls them. I wanted to photograph the bird in such a way that the cement powder that had worked its way into its feathers would almost make it appear like a fossil. With the bird positioned against a plain background in an area that was right on the edge of where the natural light was falling, I balanced things out with a section of highly polished aluminium sheeting that reflected light in much the same way that a mirror would. Then I set my tripod as high as it would go so that its feet wouldn't intrude into the picture and looked down directly on the bird. The light was poor and consequently it was a long exposure: for this image it was around four seconds, although I did try some 30-second exposures later on as well."

Canon F1, 50mm lens, Kodachrome 64

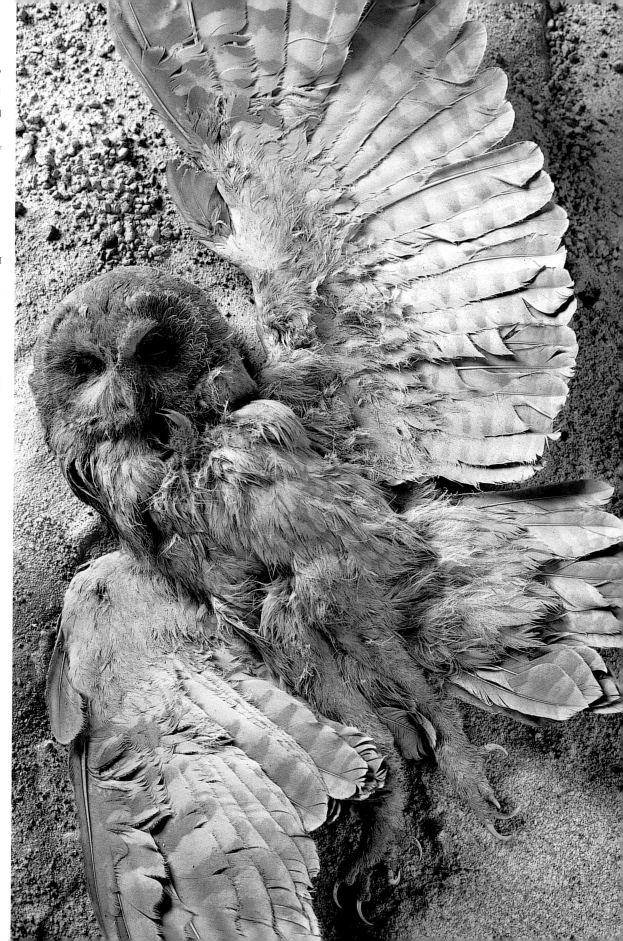

Fulmar over the sea

Chris Packham was travelling across the North Sea on the Oriana cruise liner on his way to head up a bird expedition, when his attention was attracted by the distinctive patterns being created by the ship's wake. "Initially I thought that I would just photograph the wake itself," he says, "but then I noticed that there were individual fulmars using the lift provided by the wake to move along, and they were shooting past the side of the ship at enormous speed.

"I quickly realised that this was the picture I should be trying to take, and so I set myself the task of achieving an image where the fulmar was an important element. Because of the speed that they were moving this wasn't easy: I couldn't rest the camera on the ship's rail because the ship itself was moving and the picture would have been blurred, so I had to hand hold my camera, fitted with a 400mm lens, and then I followed the fulmars through the viewfinder as each one passed by me."

Ever the perfectionist, Packham was disappointed that this method of working made it virtually impossible to react in time for the fulmar to be anywhere but the centre of the frame. "For me it's detracted from the picture," he says, "because I think from a composition point of view it would have been a stronger image if the fulmar had been over to the left flying into the picture." Even so, the image was strongly rated by his peers: it won a Highly Commended in the prestigious Wildlife Photographer of the Year Competition.

Canon EOS 1, 400mm f/5.6, 1/250sec at f/5.6, Kodak Ektachrome 100, 81B filter

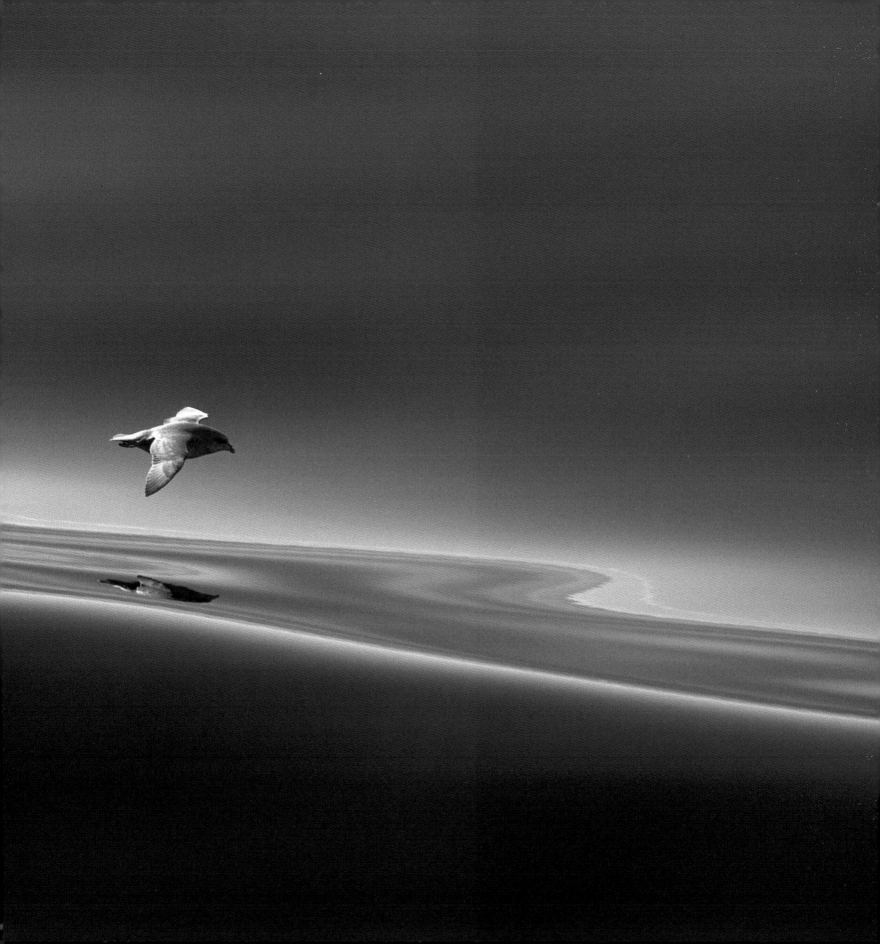

Fritz Pölking GERMANY

Born in 1936, Fritz Pölking grew up photographing the songbirds that nested around his family home in Krefeld, Germany. "I saw a starling that came to get the ripe cherries under the tree in the garden," he says, "and I thought, you have to take a picture of this, that looks really wonderful, a green lawn and a black bird with red berries in its beak. So I took a picture of it. After that I saw a peewit and I wanted to take pictures of it too. And that was how it all started."

After initially specialising in European wildlife, during which time he built up a remarkable collection of pictures of the osprey, Pölking extended his range further afield, and started to travel extensively. He has now amassed a huge library of images taken throughout Africa, America, Asia, Europe and Antarctica. His versatility and appetite for taking on new challenges has seen him scoop a number of international awards – including being named as the outright winner of the Wildlife Photographer of the Year Competition in 1977 – while building a massive worldwide reputation.

He's also become known for being a methodical and patient photographer who will return to a story over and over again over a matter of years to ensure that he tells the full story and doesn't just come away with a pretty picture. One of his projects, for example, saw him undertake to document the entire life of a single leopard, Paradise (Half-Tail) in the Masai Mara of Kenya, and he's still photographing her children and grandchildren several years later.

He's just as enthusiastic about wildlife photography, if not more so, than he was in his youth, and is excited about the technology that those working today have at their disposal. "The quality of the lenses," he says, "the use of autofocus, cameras that can take six to eight pictures a second, film materials such as Fujifilm's Sensia 100 and Velvia 50, these are all fantastic tools. They are all things that have moved up the level of wildlife photography with incredible speed in

the last few years. You only have to look at the ten years of books that document the results of the Wildlife Photographer of the Year Competitions to realise that the pictures have become more interesting and appealing each year."

He also is becoming increasingly interested in digital cameras, and is contemplating switching to one himself. "Digital photography has many advantages," he says. "If I take a trip to Africa today, I have to take 300 rolls of film with me, which I must carry in my hand luggage, for safety. Then, I won't see any of the results until I have been home for days, which means that, after a four-week trip, I have another four weeks of work cataloguing the pictures.

"When I take digital photographs, however, I don't need to carry film with me. I can shoot 50 pictures during a day, view them in the evening, send 45 pictures to my agencies and keep five. If I get something sensational on the second day, for example, I can send it by satellite telephone to my office at home and when I get back four weeks later it may have been published 27 times over.

"It's also very useful for me to be able to make digital duplicates of my pictures when they are required by publishers or agencies. Whereas once a dupe would have suffered an obvious drop in quality, now they are 100 per cent as good as the original."

Black darter
This black darter, with its wings covered in dew, was photographed by Pölking in a swamp in Germany.

Canon EOS 1V, 24-85mm f/3.5-4.5 zoom, Fujifilm Sensia 100, tripod

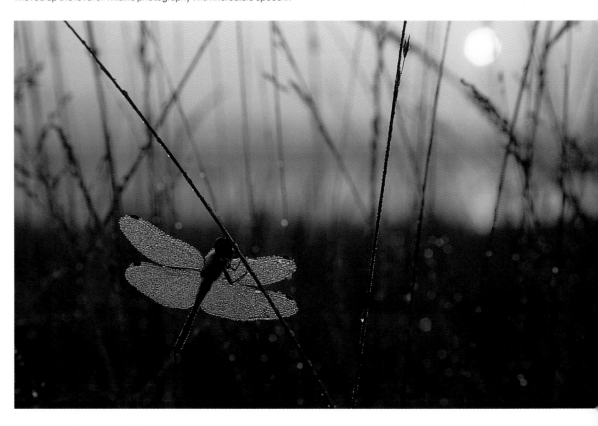

Butterfly and caiman, Brazil
This highly unusual act of a butterfly perching on the nose of a caiman was something that Pölking had noticed, and he then spent five days pursuing the image until he caught it on film.

Nikon F5, 500mm f/4 lens with 1.4 converter, Fujifilm Sensia 100, tripod

Fritz Pölking

Tussac bird and sea elephant

"There are times when everything just fits together ideally during an action photograph," says Pölking, "and you take that magical moment where everything is perfect, the composition, action, emotion and the special situation, which all together make that one moment in nature unique and unrepeatable.

"This happened to me when I was at the Falkland Islands, on Sea Lion Island. I saw this little tussac bird running among the sea elephants that were there and searching their bodies for parasites. Suddenly the bird was standing right in front of one of these great giants and quite obviously was waiting to pick the parasites from his nose. It was one of these rare moments that nature photographers wait and look for throughout their career — an incident that is full of magical qualities.

"It was perfectly clear – this was David and Goliath, compressed in one visual statement. There was nothing missing nor too much that would serve to distract and make the picture too loud. Five seconds passed and then it was all over, as the little bird continued on to other parts of the body and never came back. But I had been able to capture that wonderful moment for photographic eternity."

Nikon F4, 300mm f/4 lens, Kodachrome 64, tripod

Norbert Rosing GERMANY

Born in 1953 in northern Germany, Norbert Rosing has always had an interest in nature and wildlife photography, first as a keen amateur and then later as a highly regarded professional working regularly for magazines such as *National Geographic*, *Geo*, *Terre Savage*, *BBC Wildlife Magazine*, *Sinra*, *Terra*, *Naturfoto* and *PhotoTechnik International*.

"I was largely self-educated," he says, "through books and magazines and by picking the brains of those who were already established photographers. I had been taking pictures since childhood, starting off with a Kodak Instamatic and then graduating to a Praktica SLR and then, until 1988, the Canon System. Since 1989 I have used the Leica R System.

"My first published picture appeared in a German photographic magazine in 1980 and it was taken in Kuopio in central Finland from the top of a huge tower and showed the view looking out over thousands of lakes that were reflecting the golden glow of the sun.

"Shortly afterwards a publishing house approached me and asked me if I would take the pictures for a book they wanted to produce called *The Night is Like a Silent Ocean*, which involved photographs taken by moonlight and in the middle of the night. In 1988 I started with the story *The World of the Polar Bear*, which brought me many times to the Canadian Hudson Bay and the Arctic to cover the lives and the habitat of these amazing creatures. My work on the story still continues today."

In 1992, while working with photographer Fritz Pölking on a book about cheetahs, Rosing made the decision to become a professional and has never looked back. Since then, he has travelled extensively to photograph wildlife, to the Canadian Arctic, the landscapes of the US southwest, the national parks of his own homeland and the African savannas. In 1999 he visited China for the first time.

Throughout his career, Rosing has considered books to be one of his most important outlets and, to date, he has published six, taking enormous care and effort over each to ensure that the quality of content and reproduction is as good as possible. "I try to do justice to the subject," he says, "and perhaps help to raise awareness of the habitat of the subject which the book features.

"In financial terms my books are difficult to justify, but I consider them, essentially, to be beautifully produced business cards. They have become an extremely important way for me to show my work and I like to take the necessary time to ensure that they are as good as they could possibly be. The book I did on polar bears, for example, took me six years to complete, and I was involved in every stage, from the selection of images down to the design of the book and the making of colour separations, even though the publishing house was located over 700 kilometres from my house."

Rosing has worked with Leica cameras for 12 years, starting with the R6 then moving to the R7 and now the R8. He works with a full range of lenses covering focal lengths from 15mm up to 800mm. The majority of these are fixed lenses, Rosing owning just one zoom, a 70-180mm. "The prime lenses are heavier to carry," he says, "but I still think they give me better quality. I'm fascinated by the so-called 'Leica Myth,' meaning the handling of solid built metal and glass equipment – something very different from the 'high-tech' world.

"I don't use autofocus or image stabilisers, so I suppose you could say that the way that I work is low-tech, but that's the way I like to operate." His favourite lenses are part of the Apo-Telyt Module System (he describes them as his "bread and butter" lenses) and are the Apo-Summicron 180mm f/2 and the Super Elmar 15mm f/3.5.

Much of the time Rosing uses a tripod, a heavy-duty Manfrotto 350 MVB fitted with a Linhof levelling head, and this gives him the stability that he considers so essential for work in what are often less than ideal conditions. His regular films are Fujifilm Velvia and Provia F.

Rosing also uses a Ken-lap gyro-stabiliser for times when a tripod is unfeasible, such as those occasions when he's shooting from a helicopter or a boat. The camera is attached directly to the device, which weighs around four kilograms complete with battery, and is held steady even under extreme conditions.

Walrus
Rosing came across this atlantic walrus bull while on an expedition to Igloolik, which is located on the Foxe Basin in the Central Canadian Arctic. The walrus allowed Rosing to approach within a few yards to shoot this portrait, using a 280mm f/4 lens.

Lecia R8, 280mm f/4 lens, Fujifilm Velvia

Polar bear and dog
Rosing first observed the playful relationship that can develop between dogs and polar bears during a 1989 winter expedition to Hudson Bay, but he had to wait until 1992 before he was able to produce pictures of the event, when this bear approached a tethered dog and nuzzled it.

Leica R8, 180mm f/2 lens, Fujifilm Velvia

Buffalo
Taken in Yellowstone National Park, the bison here were looking for heat on what was an extremely cold February morning, by standing over some fumaroles that were emitting warm steam and gases. Using a 180mm f/2 lens, Rosing had to wait for periods when the breeze cleared the steam for a moment to get his pictures.

Leica R8, 180mm f/2 lens, Fujifilm Velvia

Norbert Rosing

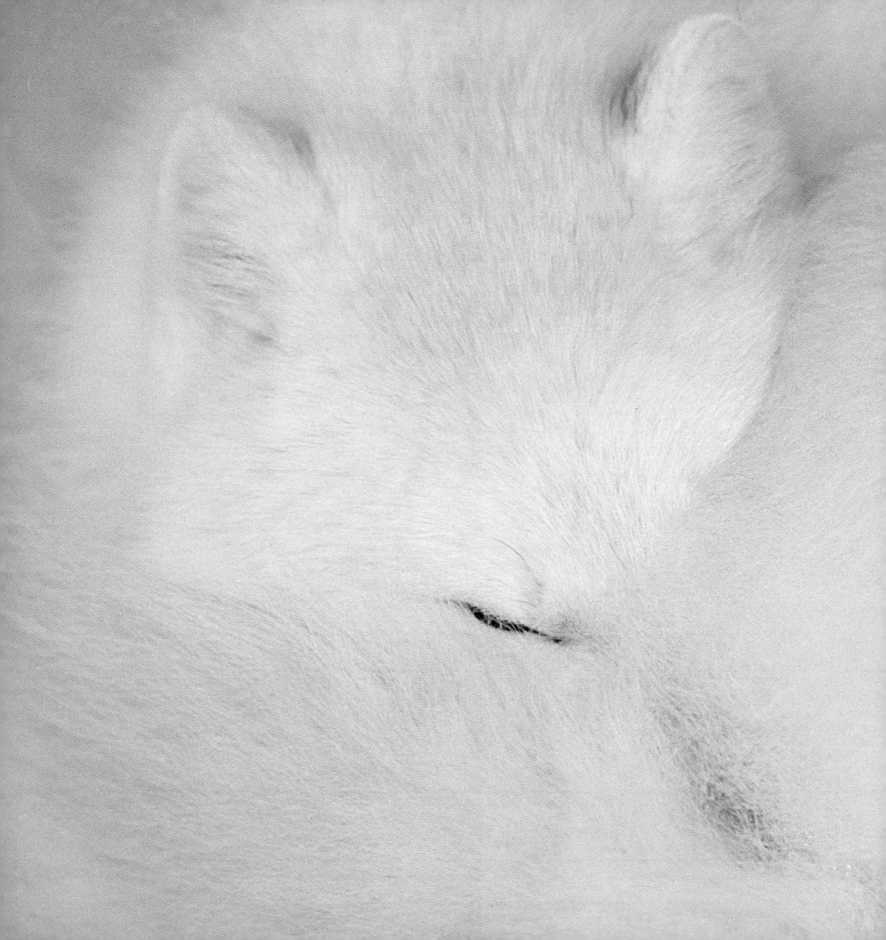

Arctic fox, Hudson Bay

"I was undertaking a two-month photographic expedition to the Hudson Bay coast in November, which was at the height of the polar bear season, and I didn't have to go looking for this arctic fox, because she attached herself to our camp. I would never feed a wild animal, but I think the scraps of food that she could scavenge in the area where our dogs were being fed probably attracted her. She was in beautiful condition although, at this time of year, her coat had still not quite turned 100 per cent white.

"Giving some idea of just how relaxed she was about human company, I took this picture of her with my Apo-Makro-Elmarit 100mm f/2.8, approaching her very slowly over a period of around 20 minutes and positioning my tripod so that I was looking directly down on her. I shot with Fujifilm Velvia rated at ISO 40, using a Bosch Ultrablitz 38 Logic flash fitted with a light softener to add a little bit of light to her fur. It was an old model and, instead of a display, it featured a symbol of a sun, then half sun and quarter sun. I set it to the quarter-sun setting to cut the light down as much as I could, because I didn't want the effect to look obvious. I filled the frame with her, and just about the only area of tone in the whole picture is provided by the eye.

"There was a sad conclusion to this story because we found her two to three days later, killed in one of the many traps that are set by the sides of the roads in this area by local people. It was a sobering reminder of just how vulnerable wild creatures are, even in this remote part of the world."

Nikon F4, 300mm f/2.8 lens, Fujifilm Velvia, fill-in flash

Norbert Rosing

Andy Rouse UK

After completing a degree in Electronic Engineering, Andy Rouse became a computer consultant, with wildlife photography very much tackled as a hobby, albeit one that consumed all his spare time. As an amateur he tasted early success, winning a category of the Wildlife Photographer of the Year Competition with a quirky image of a fox chewing a garden gnome. In many ways, it was an image that typified Rouse's determination to present an alternative and highly individual view of wildlife subjects.

Instead of being the start of something, however, the award marked a period in Rouse's life when he was so overwhelmed by the demands of a busy career that he scarcely took any wildlife pictures at all. "I was just too busy for around five or six years," he recalls, "but eventually I just had to make time for photography again because it was the only way that I could relieve the stress of my job.

"Then my career started to involve travel to various locations around the world and I began to add on extra days so that I could take advantage of the place I happened to be in and could take some pictures there before I headed home. Eventually it reached the point where the extra time was starting to overwhelm the time spent on my job and I knew that I had to go where my heart was and to try to make a go of wildlife photography full time."

It was a huge leap of faith on Rouse's behalf, and he admits that the early years were really tough financially. "I survived by tackling UK wildlife that hadn't been covered in any great depth," he says. "I started to get known for my coverage of animals such as foxes and badgers and eventually I was making enough money to think about travelling, but I made sure that I went to places that were less obvious and therefore less likely to have been covered by everyone else."

Since that time Rouse has built up a portfolio full of international subjects, and his media profile has also risen thanks to appearances in a series of television "fly-on-the-wall" nature documentaries. He now works closely in the field with his partner, zoologist Dr Tracey Jane Rich. "It's great to have someone around who understands what I'm doing and who will handle the video diary I produce for TV and can also act as a photographic assistant while I'm shooting pictures," he says.

Rouse has built himself a reputation for working with larger animals and for taking the odd risk to get close enough for the viewpoint that he likes to present. His approach, however, has changed considerably in recent times with his adoption of medium format as his preferred way of working. "In some ways 35mm was becoming less challenging," he says. "With medium format you get just 16 pictures to shoot before the film requires changing and it makes you think a little more about what you do.

"I find that, because its balance is so good, I can hand hold my Pentax 645 NII almost as easily as I can my 35mm models, and the quality of the results that it achieves are superb. The kind of pictures that I like to do now are very graphic and feature the animal as part of a landscape. These invariably need to be used big, and it just doesn't work if you're starting with a 35mm original.

"That's not to say that I've abandoned 35mm altogether, because it is still the only way to tackle those subjects where fast reactions are required. I've simply come to realise that there's a time and a market for both formats, and each of them offers me something that the other cannot."

Lioness stalking prey, Botswana
"Perhaps the most dangerous escapade that I have ever undertaken is to stalk a lion through the grass," says Andy Rouse. "In the end she stalked me while I tried to take pictures that I was convinced would be published posthumously! I got away with it, I'm glad to say, but at the time it was a very frightening experience."

Canon EOS 5, 70-200mm f/2.8 lens, Fujifilm Velvia pushed to ISO 100 at f/2.8

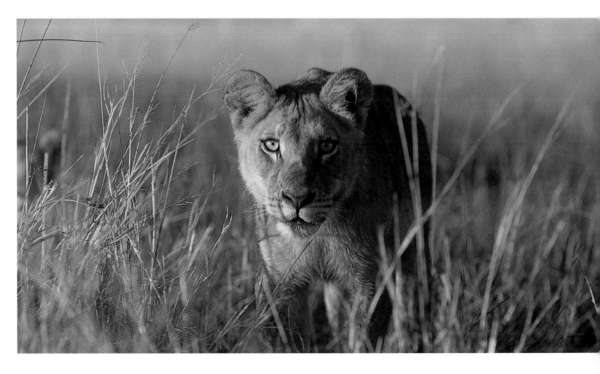

...hino, South Africa
This is the first picture that I ever
...ok on medium format, and I used
...Pentax 645NII," says Andy
...ouse. "I really love working with
...inos, because of their size and
...eir unpredictability. I was lying
...wn just a few feet away from this
...e when he decided to come
...wards me for a closer look, and
...eeded to crawl under my Land
...over in order to get away from
...m. He stood there blowing dust
...o the lens of the camera and I had
... change my film while he was
...ving to reach me with his horn."

...ntax 645NII, 45-85mm f/4 lens,
...jifilm Velvia at f/8

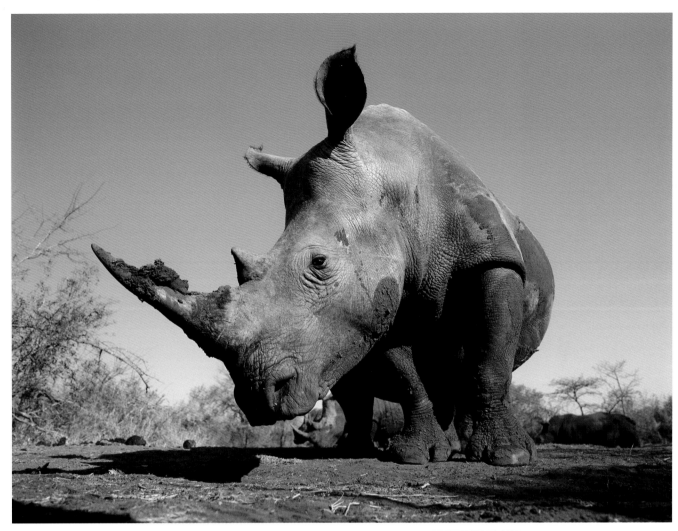

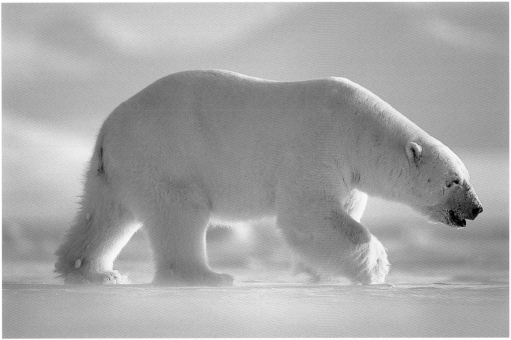

Male polar bear
"I love working with polar bears,"
says Andy Rouse, "but they've
certainly given me some hairy
moments. This big male, which
I estimated had to be around 600
kilograms in weight, came striding up
to us on the sea ice off Svalbard. We let
him get to within 30 feet or so of us so
that I could take this picture, and then
we had to sit and rev our snowmobiles
to convince him to stay away.
Fortunately he got the message."

Canon EOS 1N HS, 70-200mm f/2.8
lens, Fujifilm Velvia at f/5.6

Andy Rouse

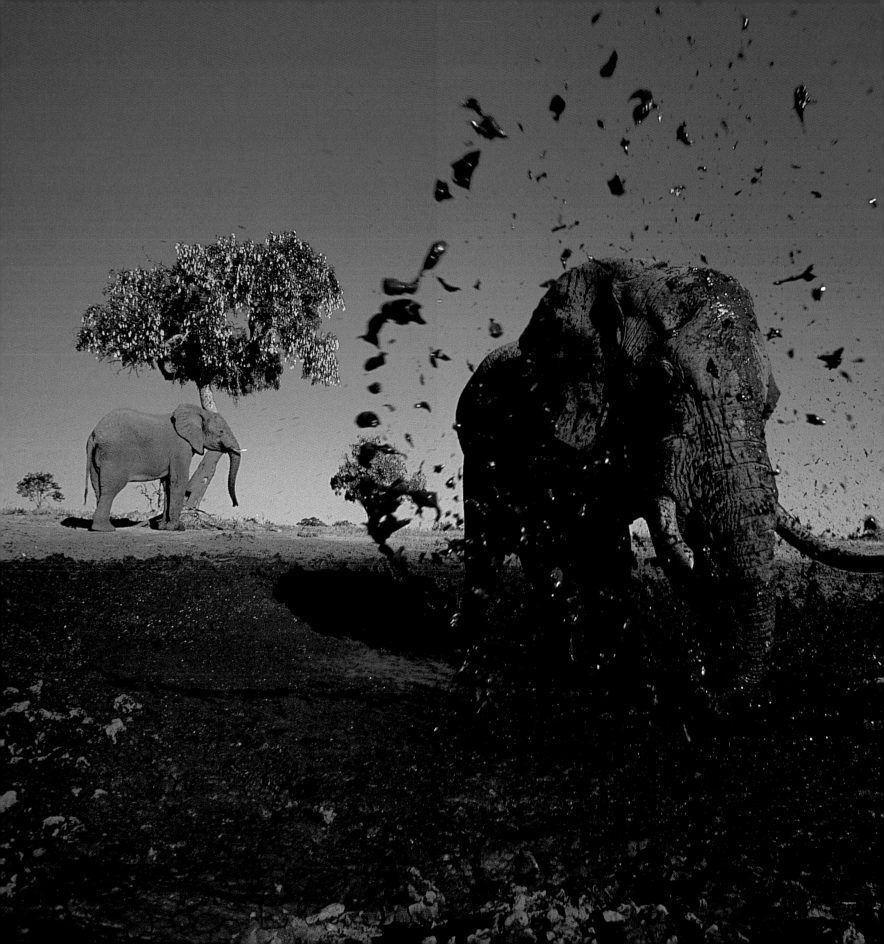

Elephant spraying mud

"Elephants are very reluctant subjects when taking a mud bath," says Andy Rouse, "and so I had to resort to downright sneakiness to get this unusual shot, which I took in Botswana. Whilst the mud wallow was unoccupied I fitted a 17mm lens to my quietest camera, a Canon EOS 5, and set it up so that it was covering the whole scene, stopping it down to f/11 to ensure that the depth of field was such that, wherever the elephant moved, it was likely to be in focus. Then I attached a Canon remote transmitter and retired to a safe distance.

"After an hour or so an elephant lumbered slowly up to the wallow and, without even a second glance, started chucking mud over itself. I triggered the camera several times and, on one occasion, the elephant must have heard the camera's motordrive because it stopped and stared at the camera for a second, reached its trunk towards it and appeared to be about to send it sailing through the air.

"Fortunately it thought better of it and it withdrew its trunk, but then scooped up some fresh mud and hurled it at the camera. Just as it hit I pressed the shutter, and the result you see here. The camera and lens were completely covered in mud, but it was worth it to get such an unusual and fun shot of an elephant. It won me the Animal Behaviour section of the Wildlife Photographer of the Year Competition, and helped to establish me in Europe as a serious wildlife photographer."

Canon EOS 5, 17mm lens, Fujifilm Velvia at f/11

Andy Rouse

Jonathan & Angie Scott UK/KENYA

Brought up on a farm in Berkshire, England, Jonathan Scott yearned to see for himself the creatures of Africa that he'd read about in his magazines and books. He finally got his chance in 1974, when a visit to the Serengeti was planned as part of a much larger adventure that was scheduled to take him around the world. He arrived in the region one February, the time of the great migration journey to the southern plains when more than a million wildebeest and zebras reclaim the vastness of the Serengeti's short-grass plains. He was captivated: "It was every bit as wonderful as I'd imagined," he says. "I can still remember the vivid mix of colours, the intensity of the light and clarity of the air, the sounds and smells of the great herds.

"I decided that I had to stay for longer, and I cancelled the ticket for Australia that I had booked for the next leg of my journey, and set about trying to find a way to earn a living.

"My great love had always been art, particularly natural history subjects, so my main interest in taking photographs was to provide reference materials for my pen and ink drawings. At that time I had a Canon SLR and just one poor-quality lens to go with it, and I was using black and white film, which couldn't really do justice to the sights that I was seeing. So, as I slowly started to build up my income by selling limited edition prints of my drawings, I upgraded my gear and made the switch to Kodachrome 64 film, and slowly but surely my results started to improve."

His first book, *The Marsh Lions*, appeared in 1982 and Scott began to build his reputation and to hone already impressive, though entirely self-taught, photographic skills. He had managed to scrape together enough money to buy a Toyota four-wheel drive Land Cruiser that, for weeks at a time, effectively became his home as well as a mobile hide, and that allowed him to live in the same environment as the subjects he photographed and to study them at close quarters. It gave him the chance to observe scenes that the casual visitor would simply never see, and it provided the platform for his Wildlife Photographer of the Year Award in 1987 and his Cherry Kearton Award and Medal given by the Royal Geographical Society seven years later.

"After a while I became known as a person that film crews who were visiting the area could come to, because I would be able to use my local knowledge to help them find subjects such as lions and cheetahs. After being used as a facilitator for some time, eventually someone suggested that I should be used in front of the camera, and I made my first TV broadcast as a presenter on UK television in 1989."

Things have mushroomed since then and Scott the adventurer, who has become acknowledged as one of the most knowledgeable guides to the area, is now in huge demand from a variety of quarters. His is a familiar face on both British and American television, co-presenting *Africa Watch* and the hugely popular *Big Cat Diary* for the BBC and Animal Planet. He also leads expeditions to the area for those who long to experience a brief taste of his unique lifestyle. He is also a successful author, penning 13 books to date.

He now works closely with his wife Angie, also an accomplished wildlife photographer. Angie was born and raised in Africa and is a kindred spirit in terms of her love for the people and wildlife of Africa. The couple recently collaborated on the book *Mara-Serengeti: A Photographer's Paradise*. As its name implies, it places a heavy emphasis on the photographic skills that have been honed during a career dedicated to documenting the wildlife of this special area.

"We wanted the book to celebrate the beauty of Mara-Serengeti and to stimulate public interest in wildlife photography," says Scott. "I wish when I had been starting out that someone could have pointed out a few of the basic do's and don'ts of photography to me. It took me some time, for example, to realise that photography is not so much about the camera that you use, but the piece of glass that you attach to it. Good lenses are absolutely vital, and the best of them can help you to improve the quality of your photography no end. You should go for the best optics that you can afford."

Scott also feels that the aspirational wildlife photographer should take inspiration from all sources, and cites his personal influences as wildlife artists Sir Peter Scott and photographers Robert Bateman, Sebastiao Salgado, Frans Lanting and movie cameraman Alan Root, who made a series of ground-breaking wildlife films, including *The Year of the Wildebeest*, between the sixties and the eighties.

"I've also learned a lot from the Japanese wildlife photographer Mitsuaki Iwago," he says. "While many people in this field have come to it from a zoological background, Iwago is a pure photographer, and as such he's not distracted by trying to capture a particular type of behaviour. He just wants to become the animal: that's what he's after – the essence of his subject."

To date it's been a hugely exciting and satisfying career, but Scott is not convinced that others will have the opportunity to follow in his footsteps unless they are willing to make considerable sacrifices. "I would caution anyone these days about wanting to be a professional wildlife photographer," he says bluntly. "It might be better to try to break into wildlife cinematography than stills. Everywhere is so much more accessible these days, and it's increasingly difficult to come up with something new and different that the picture libraries will want because they already probably have it on file.

"I love the challenge of trying to get great wildlife shots in natural settings, but it is not always very cost effective. It's expensive on safari, and there's also the logistics to consider. It's very difficult for someone starting out these days to get a work permit for a country such as Kenya. With such high unemployment Kenya is obviously keen to encourage of its own photographers.

"Having said all that, however, I'm an optimist at heart and I say that if someone is keen enough then they should follow their dream. It's all a question of plugging away and, with luck, you could get the break that you need."

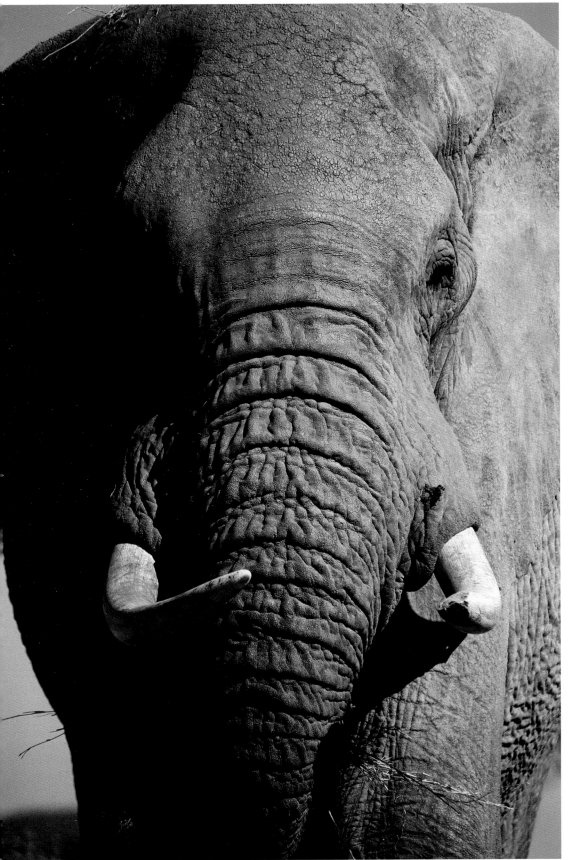

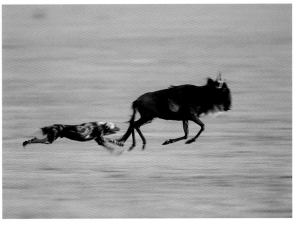

Wild dog chasing wildebeest, Kenya
One of Jonathan Scott's favourite images, this was produced as part of his project on a pack of wild dogs. It was taken from a moving vehicle, with Scott steering with his knees while trying to compose his picture with his two free hands. "It was a bit of a gamble," he says, "because there were termite mounds and burrows all across the plain and, had I hit one of these, the car might have smashed a spring or broken an axle. But I was completely absorbed in keeping up with the chase and photographing it, and the adrenaline was flowing." He took this picture using a 200mm lens and a shutter speed of 1/60sec, and focused on the dog, waiting until it had moved to just behind his quarry yet had still to grab it. "I could have used a 1/1000sec shutter speed to have stopped the action, but I wanted to achieve a sense of movement," says Scott, "and that's exactly what this picture is all about."

Elephant close-up
For this striking portrait of an elephant in the Samburu Game Reserve in Kenya, Angie Scott shot from inside a vehicle, achieving as low an angle as possible, and then framed tightly with a 500mm lens to remove all the distracting and unnecessary detail from around the animal.

Canon EOS 1N, EF 500mm f/4.5L lens, 1/250sec at f/8, Fujichrome RDP 100

Canon F1, FD 200mm f/2.8L lens, 1/60sec at f/2.8, Kodachrome 64

Jonathan and Angie Scott

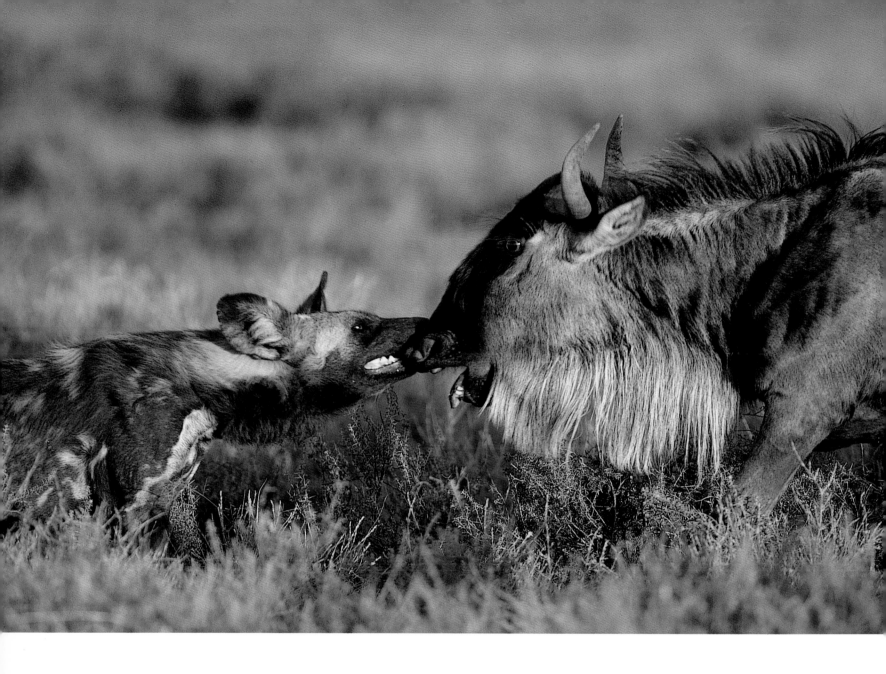

Wild dog and wildebeest, Kenya

Wild dogs are one of the most endangered of Africa's creatures, mainly because of persecution by humans, and diseases that they pick up from their domesticated equivalent. Their numbers are now down to around 5,000 in the whole of Africa, so Jonathan Scott decided that he would document their lives in detail before this figure shrank still further.

"I've always been fascinated by pack animals," he says, "and I decided to virtually live with the wild dogs for a time so that I could really get to understand them and study their behaviour at close quarters. I stayed in my car next to the dogs, got up when they got up and when they hunted I followed. This picture was taken at the end of a hunt. Because I knew the animals that I was photographing, I was aware of how they were likely to tackle big prey, such as a wildebeest. One dog will usually grab the leg or tail of the wildebeest and try to pull it to a halt while another will fasten its jaws around its nose and upper lip. This causes the wildebeest to freeze, making it easier for the pack to tear it apart.

"I visualised this picture months before I pressed the shutter. It was the end of the day and the light was fading fast. I didn't want to get too close, so I used my 500mm at around 1/60sec, and rested the camera on a beanbag. I couldn't afford a fluid head in those days."

The picture went on to win Scott the coveted title of Wildlife Photographer of the Year in 1987.

Canon F1, FD 200mm f/2.8L lens, 1/60sec at f/2.8, Kodachrome 64

Lioness and her young

Angie Scott photographed this lioness and her young very early one morning while she and Jonathan were on a prolonged expedition to shoot pictures for stock purposes and for their Mara-Serengeti book.

Because of their extensive experience with African wildlife, the couple recognised that this lioness was nervous about the presence of two male lions, both interlopers, that were patrolling close to her area. One of the two resident pride males had been killed by Masai tribesmen after killing a cow, making her pride vulnerable to a takeover.

If that was to happen then Angie and Jonathan knew that the lionesses' cubs would almost certainly be killed by these new males, prompting her to come into season and to breed with them. It was a reflection of the harsh face of nature, and the expression on the face of the lioness showed that she was aware of the danger. She froze completely so as not to arouse the attention of the males and never took her eyes off them for an instant.

Because the picture was taken so early in the morning, the light was still low, and Angie was operating with a shutter speed of 1/60sec, using a 500mm and 1.4 converter to achieve a tight crop on her subjects. This was not fast enough to freeze the cubs, but the impact of the photograph is achieved through the stare of the mother, which is steady enough to have registered pin sharp.

Although on this occasion the lioness managed to move her cubs to safety, the story ultimately was one that was sadly predictable. One cub died after it was tossed by a buffalo, while the other four simply disappeared, victims of a new regime that had no interest in acting as surrogate fathers.

Canon EOS 1V, EF 500mm f/4L IS lens, 1/60sec at f/4, Fujifilm Provia 100F

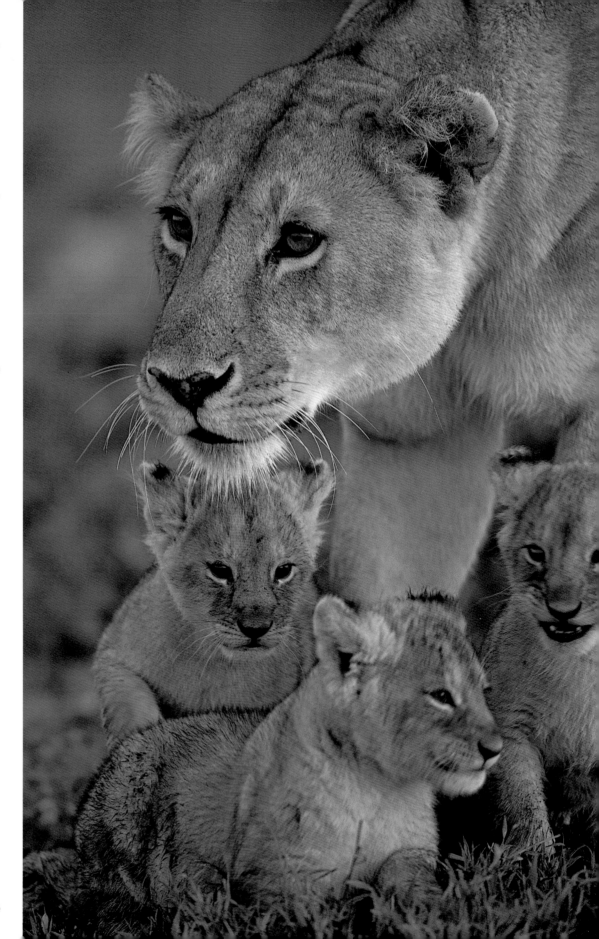

Anup Shah KENYA

"My path to becoming a wildlife photographer was marked out by a series of turning points," says Anup Shah. "When I was still a kid in shorts I was taken to Nairobi National Park close to our home, and there I saw lions and other mammals. By the time of my next visit there I had been given a camera and I was anxious to see what I could achieve with this. The black and white prints that resulted showed no promise whatsoever, and yet it was a very intense experience: repeat visits merely increased the pleasure of taking pictures of wild animals."

By chance Shah met someone who had a Mamiya RB67 kit for sale, and he was soon convinced about the quality that medium format cameras might offer. Taking his new acquisition on a trip to Tanzania's National Parks, however, he found that it was too slow to capture action and animal behaviour, but, still convinced about the value of medium format, he traded the RB67 for a 645 model.

Then he discovered one more limitation: even a smaller camera like the 645 was not flexible enough to allow pictures to be taken of creatures that were shy of human contact, and this finally persuaded him to look at a 35mm SLR system. By chance he met the Canon agent in Nairobi, who convinced him to invest in that company's top of the range F1 model with its myriad of accessories.

"An important turning point came for me when I submitted some images to a library and had them rejected, not because of the content but because they weren't technically good enough," says Shah. "I knew the camera was not at fault and I was at a loss to know what to do until I came across some work that had been produced with Canon 'L' series lenses. These pictures were razor sharp and I could suddenly see how my own work paled next to work that had been taken with better quality, low dispersion glass optics. Since that time I've never forgotten how dependent wildlife photography is on technology.

"Although lagging behind other photographers I did manage to save up for a 500mm 'L' series lens and finally had my pictures accepted by a small picture library. Then I began a long process of acquiring a range of high-quality lenses and accessories.

I stayed with the Canon system and, consequently, was able to tap into the extensive range of products that the company offered. However, despite this additional equipment I was reminded of the limitations still inherent in my work when I encountered a portfolio of photographs taken by a Japanese photographer in, of all places, a forest in India. I realised that I still had a long way to go."

Shah learned slowly and painfully. He had no training in photography and taught himself through experience and by making mistakes. "My fundamental mentor has been the larger National Parks of East Africa," he says. "They opened my eyes. The vast vistas – their atmosphere, the scale of space, the breathtaking animals – seeped into my marrow. Wild mammals in their original, natural habitat became my teachers in the sense that they affected my mood and emotions. I am still learning."

The first few days of a field trip are, for Shah, an investment required to get the feel of a place and the animals that can be found there. An enormous amount of time is spent watching and waiting. "It is a good idea to tune into the habits of the animals," he says, "because such knowledge can be put to good use when predicting behaviour. The actual picture-taking time can be counted in minutes since I am looking for something special.

"I like to tell a story and am always working on projects, most of which are self-set assignments that involve either an interesting mammal or habitat. After taking the images I try to put words to them to flesh out the story. This way of working carries the bonus that it allows you to really get to know your subject."

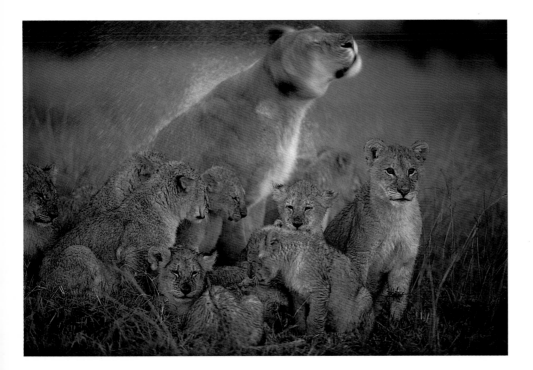

Lioness shaking its head
"After sitting out a downpour in Masai Mara, Kenya, a lioness left in charge of her pride's cubs shakes off water while the cubs awaken from naps."

Canon EOS 1N, 300mm lens, 1/250sec at f/2.8, Fujifilm Sensia

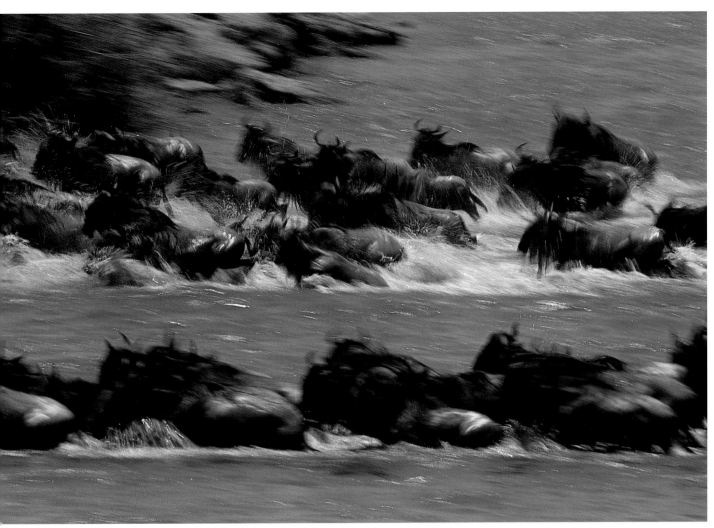

Wildebeest crossing

The great migration of wildebeest, zebra and gazelles across the Serengeti-Mara ecosystem is one of the great sights of the natural world. A high point is when the herds heading south have to ford the Mara river flowing west.

"I chose a high viewpoint that gave me broad coverage of the expanse of the river's waters,' says Shah.

"Then I positioned myself so that, from where I was sitting, the wildebeest were likely to enter the river and cross it on a sideways plane in front of me. Then it was simply a matter of waiting.

"It took a long while for things to happen. Either the animals were crossing elsewhere or were crossing when conditions were all wrong. However, after waiting ten days, a line of wildebeest appeared and hesitantly made for the crossing point. They hung around for a while, before one of them took the plunge, giving the others the confidence to follow. The crossing had begun.

"I used a medium telephoto lens and panned using a slow shutter speed. After only a few minutes, however, the crossing stopped abruptly: one smart wildebeest had spotted a lioness lurking in a thicket and had given the alarm."

Canon F1, 500mm lens, 1/30sec, Fujifilm Velvia

Common langur, India

In India's Ranthambhore National Park, I came across a troop of monkeys by a huge banyan tree. While the adults rested on the branches, the youngsters, with energy to spend, played acrobatically. The light was lovely, the setting excellent, the action truly amusing. I just held the camera ready and squeezed the trigger."

Canon F1, 200mm lens, 1/1000sec at f2.8, Kodachrome 64

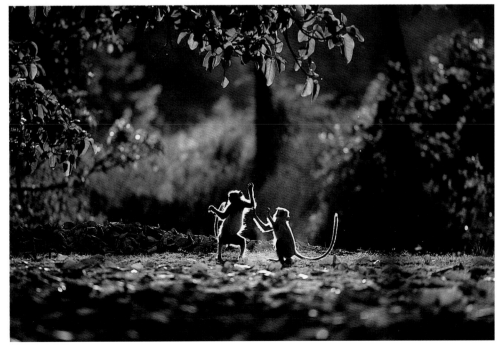

Anup Shah

Zebra rolling on its back in the dust

"Coming across an inviting dusty spot in Amboseli National Park, Kenya, a short line of zebras stopped and began to dust bathe, quite unconcerned about my presence. I captured the moment using the 500mm lens on my F1."

Canon F1, 500mm lens, 1/500sec at f/5.6, Kodachrome 64

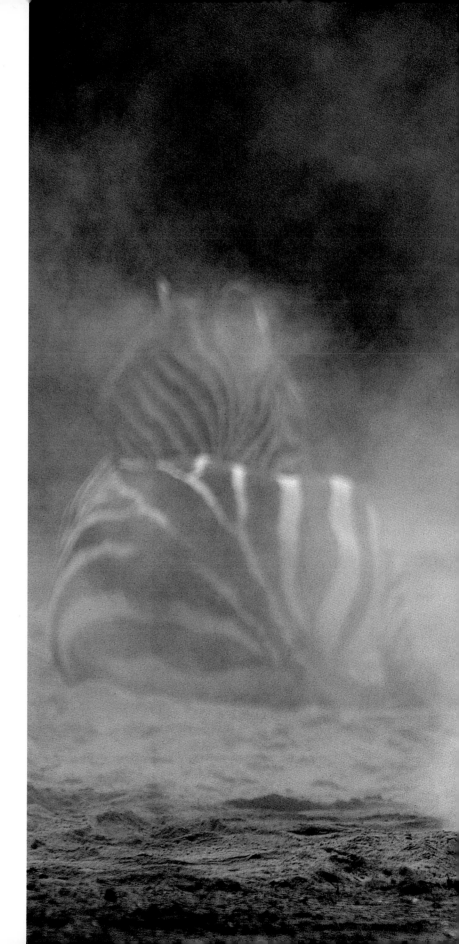

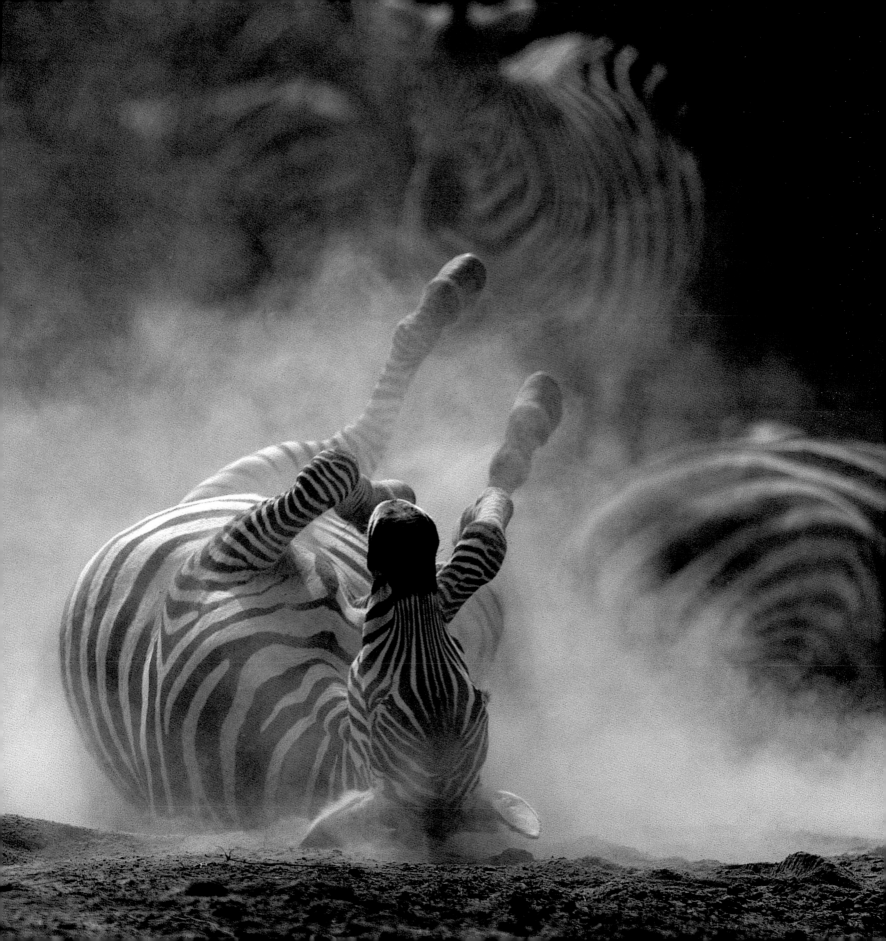

Manoj Shah KENYA

"It all began with feral cats," says Manoj Shah, brother of Anup. "There were several of them living in and around the roof of our huge house in Nairobi, and I was fascinated by them. I would stalk them to get near and watch. Then I began photographing them, and the satisfaction of getting a decent shot after hours of trying was immense. My enthusiasm for taking pictures grew, and soon I was taking pictures of the big cats in national parks." Shah has remained fascinated by mammal behaviour ever since, and it's become the focus of his wildlife photography. "Although a good grasp of technology and a certain amount of technical expertise is essential for the kind of behavioural pictures that I take," he says, "that's by no means the only requirement. A vital ingredient is quite simply luck, and the realisation of that fact was quite humbling.

"Because it's impossible to predict exactly what a creature might do in the wild, I don't pre-visualise an image. I don't want the world to fit to my preconceptions in any case, and so I clear my mind and make myself ready for the unexpected. For me, it's better to let the images come in whatever style and manner they choose to arrive.

"I try to pare everything down and to allow my photography to be a response that is instinctive, sometimes even irrational. My challenge is to be in the right place at the right time with the equipment that will do the job, and then I make sure that my visual sense is on full alert. The increasing automation of cameras has really helped in terms of honing my instinctive responses to a situation, and through experience I just know the right time to press the shutter."

On average it takes Shah several days to get the shots that he's after. The kind of pictures that he's interested in, where wild animals are captured in their most natural state, calls for extreme patience and an ability to be responsive to the subject. "Unlike weddings where you can set up some of the key moments, or sports events where there is a certain amount of predictability involved, with wildlife you have absolutely no idea of where the action is going to happen," says Shah. "There is a lot of guessing involved, and that makes it all the more fascinating for me."

Equipment-wise Shah has always preferred the versatility and ease of use associated with 35mm. "When I was starting out I came across a heap of camera brochures while messing around in a friend's shop," he says, "and soon I was saving up for a secondhand Konica Autoreflex T with an 80-200mm zoom. This kit gave me a big boost, because technically my photography improved immediately as soon as I started using it.

"Later on I switched to Canon equipment and I've stuck with that ever since and now am working with a Canon EOS 1V. I use a wide variety of lenses from 24mm through to 600mm and I also use an extender on occasions if I need to work a long way from my subject. If there is time I might use a warming filter (81 A) to lift a scene and, if the image includes a large area of sky, the polarising filter might be fitted. I also carry a 100mm f/2.8 macro lens for occasions when I'm photographing insects or amphibians."

Shah works off a Gitzo tripod whenever practical and shoots mainly on Fujifilm Provia F, switching to Velvia if the light is strong enough. Photography is usually carried out from a hide: "Stalking on foot is fun," he says, "but it can be very difficult because animals will normally be smart enough to know that you're around, and they will stay well out of range."

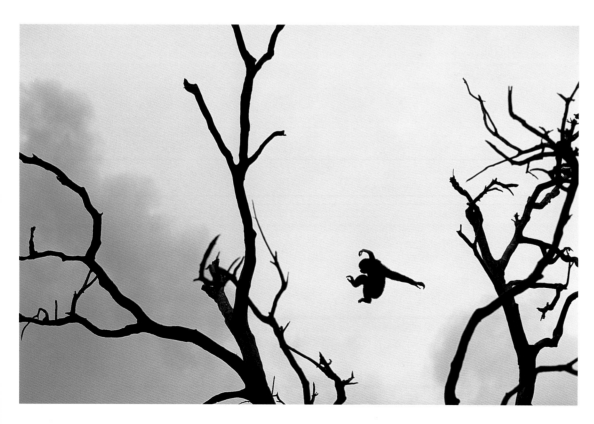

Monkey between trees, Kenya
"While photographing deep in the forest, I witnessed this juvenile gibbon hurrying to catch up with its mother. Anticipating its path and hoping it would come to this leafless tree, I prepared for this shot. As the youngster leaped from one branch to another, high above the forest floor I caught it silhouetted against the sky.

Canon EOS 1N, 200mm lens, 1/1000sec at f/5.6, Fujifilm Velvia

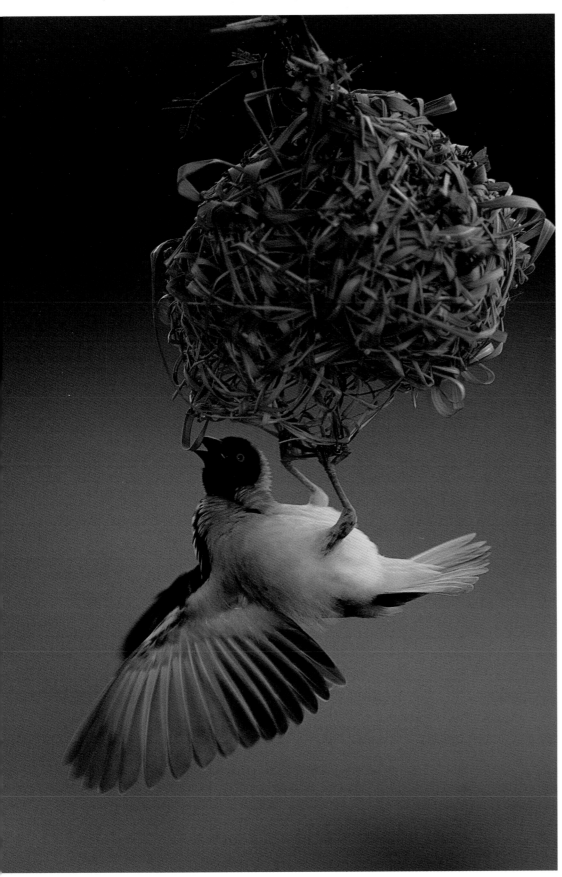

Weaver bird hanging upside down from nest
"Male weaver birds construct their intricate nests to impress and attract mates. This male, in the Masai Mara National Reserve, Kenya, was making the final touches to his loosely constructed nest before trying to attract a female by hanging upside down at the entrance, fluttering his wings."

Canon EOS 1N, 300mm, 1/125sec at f/5.6, Fujifilm Sensia

Lioness with cub in its mouth
"This lioness decided that it was time to move her litter to a different site in the Masai Mara. Though a lion's jaws are powerful enough to crush ribs and pierce elephant hide, she carried the delicate cub without a scratch."

Nikon F4, 600mm lens with 2x converter, Fujifilm Velvia

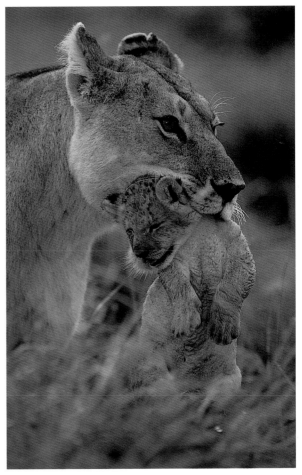

Manoj Shah

Nile crocodile fishing

"I was camping near a river in the Serengeti," says Manoj Shah, "and, late one afternoon, when I was driving along I came across an unusual sight. In the section of the river where the water was flowing the quickest, there was a crocodile, apparently stationary but with its mouth open. Sometimes crocodiles have been known to catch fish that swim down river, but normally they would put in the effort to snap at the passing fish. This character seemed to be waiting for the fish to swim into its mouth!

"The first problem I faced was getting close enough to the crocodile to get the picture that I wanted, without disturbing the scene. First of all I let the creature have a good view of my car from a distance then, over the course of the next hour, I drove slowly towards it in a zig-zag course, stopping every 20 metres or so. In the meantime I had everything ready for the one special shot that I was hoping for.

"I finally got myself into a position where I could use the longest telephoto that I had with me, a 300mm f/2.8. The sun was about to go down so I quickly shot a few frames, using a beanbag to hold the camera steady and stopping down to f/8 to achieve a reasonable depth of field. Fortunately the co-operative giant did not even blink.

"Because the light had been fading so fast I was prepared for a disappointment when I examined the results at home, but I needn't have worried because this picture was absolutely spot-on."

Canon EOS 1V, 300mm lens, Fujifilm Velvia

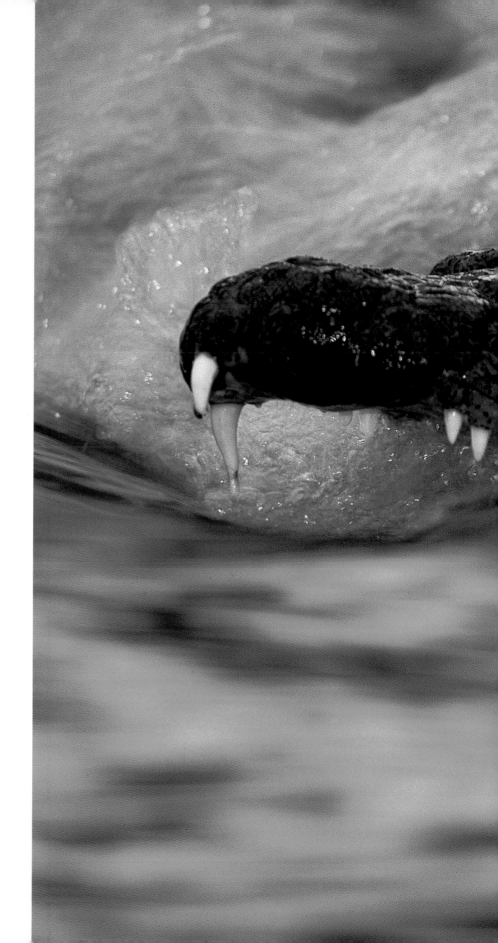

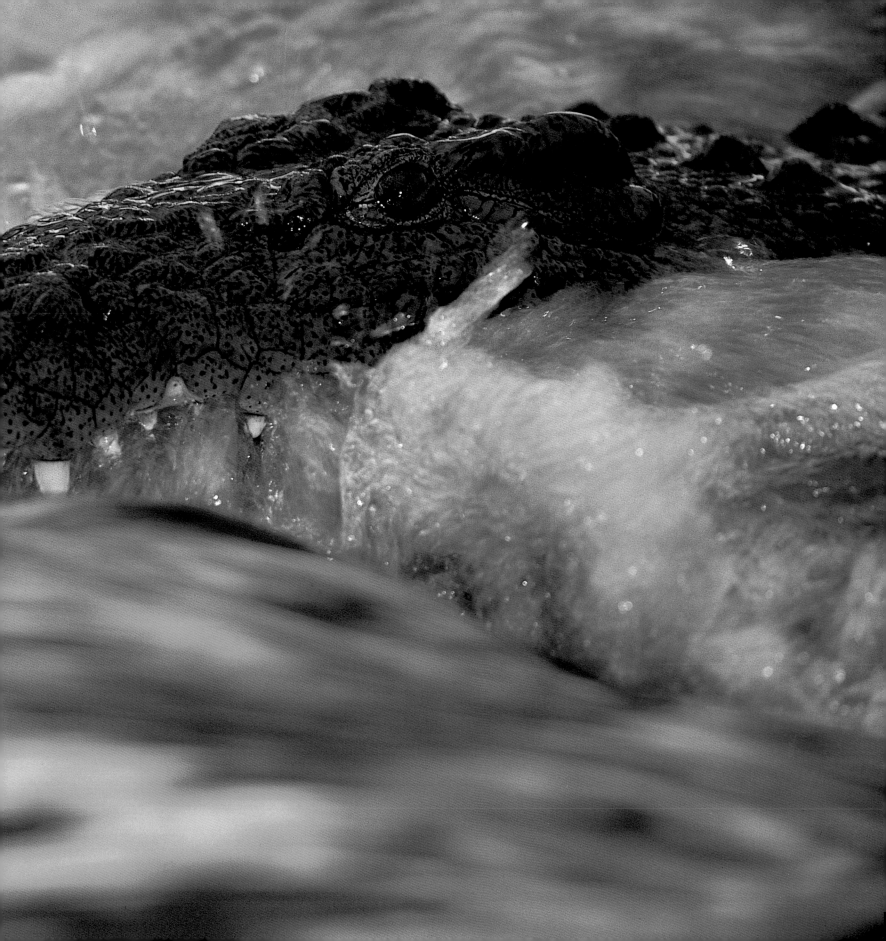

Nicole Viloteau FRANCE

Nicole Viloteau was born in Burgundy, France just after the Second World War. Her twin careers of herpetology and photography have evolved side by side, but it was the love of animals that came first. When she was a small child, her mother told her a fairy tale about a princess who rescues a wounded lizard that turns out to be the most powerful wizard in the world, and who later saves the princess's life. After hearing this Viloteau would bring wounded animals back to her family home, much to the annoyance and dismay of her father.

Her interest in photography started at the age of 19 while at a school for fine arts, and she bought into the manual Nikon system , which she still uses today. She has travelled all over the world over the last 35 years, spending up to a year researching her destination and then up to two years when actually there.

Her total immersion in nature is not without its risks, though. Viloteau was recently gored by a buffalo that badly injured her, and whose particular attention to her hand meant she feared (wrongly) that she would never hold a camera again. When she first set out on location she was bitten in the face by a rattlesnake and had to spend three months recovering in hospital. She has since been bitten in the thigh by another venomous snake, and treated herself in-situ. In addition to these injuries, she has caught and recovered from most of the known tropical diseases.

Animals are often less dangerous than people, though, and in addition to her animal injuries she has also been wounded by poachers. Despite this, she is never happier than when out in the jungle: "I like to be in a bubble of nature – when I'm not, I'm like a fish out of water."

In order to get the co-operation of her animal subjects, Viloteau will go to almost any lengths. She has cuddled Komodo dragons and even wrestled crocodiles in order to get them how she wants them. When out photographing her specialist subject of snakes and reptiles, she has spent a good deal of time tickling snakes to calm them down before photographing them, and can even calm grasshoppers by stroking them gently on the eyes and thorax.

Her photographic approach is to get close to her subjects, and then get closer still. In terms of technique, the huge majority of her photos rely on the same simple set-up. She uses manual focus, manual exposure with off-camera flash, generally held above and to the left of the subject, and shooting with a polarising filter to stop the flash from overwhelming the reflective scales of her reptilian subjects and the tough exoskeletons of the insects she captures on film.

The result of her efforts is an enviable and unique domestic reputation as a herpetologist, photographer and anthropologist, although due to the anglophilic nature of globalisation she has remained, up to now, relatively unknown outside the scientific world and the francophone countries.

Chameleon on orchid
Madagascar is an ideal stamping ground for photographing chameleons as there are upwards of 80 types there. This chameleon is waiting patiently on an *Angræcum eburneum* orchid whose smell attracts insects for the chameleon to eat. With their four colour-forming layers, chameleons can blend in with their background to avoid detection, but their emotions sometimes get the better of them. They will turn black if annoyed, will puff their cheeks up if irritated and should they fall from their perch, they have inflatable air sacs with which to break their fall. This picture was taken after a rainstorm at midday in the Madagascan region of Pangalane with powerful off-camera flash used to overpower the background so as to isolate the chameleon from its surroundings.

Nikon FM2, 18mm f/8 lens, off-camera flash with small daylight exposure

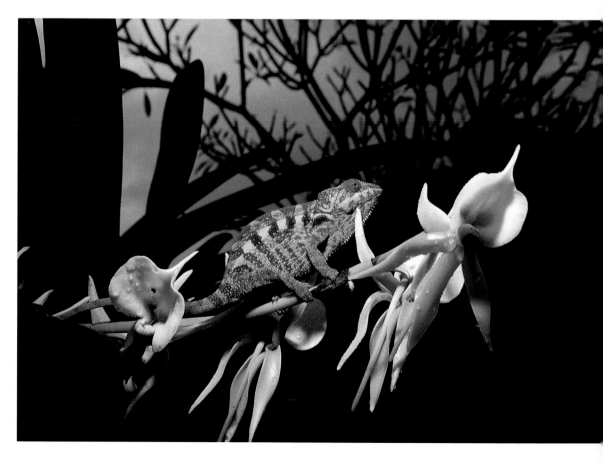

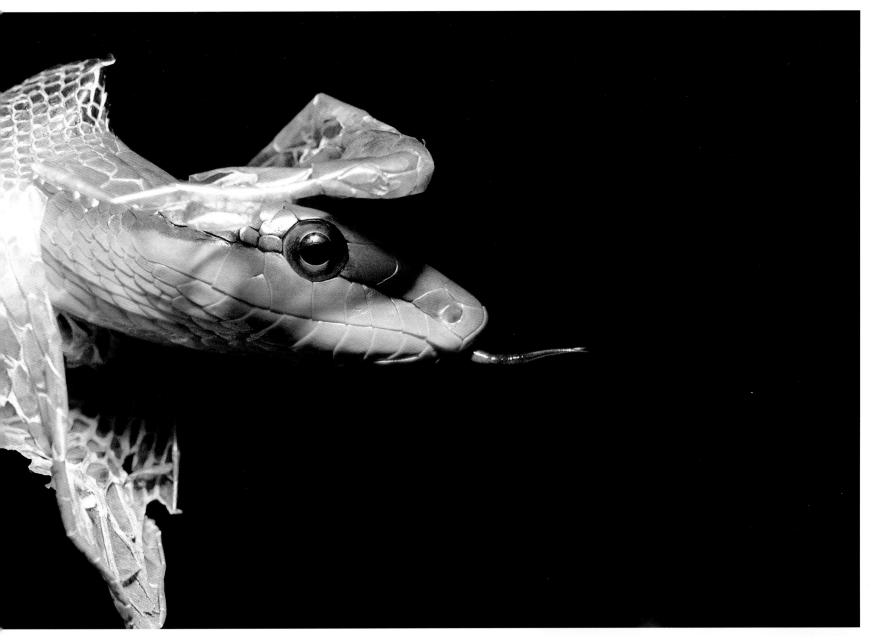

Gonyosoma oxycephala
This Indonesian tree snake is sloughing off its skin (it starts by rubbing its muzzle on a tree to form a hole through which to push the rest of its body). Its most striking feature is its blue tongue (which indicates it is not a venomous snake) and its turquoise eyes. Eye size, like scale size and position, are all indicators of what kind of snake you are dealing with, and a snake's sloughed-off skin will also reveal the state of health of the creature.

Nikon FM2, 55mm macro lens, flash

Cercopithecus mona
Gabonese monkeys live in large social groups. They are very curious and this one radiates a near-monastic state of calm. When you are lost in the jungle, and have nothing to eat, it is worth following the monkeys and (with the exception of leaves, which can be poisonous) you can eat what they eat. Viloteau shot this one with a 135mm lens with a fresnel lens on her flash to concentrate the beam more. Although it appears placid, you wouldn't want to get much closer than this to any wild monkey.

Nikon FM2, 135mm lens, flash

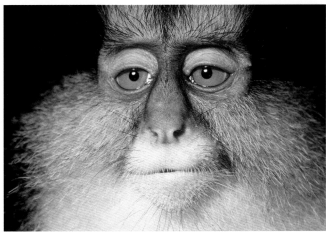

Nicole Viloteau

Gastropixix smaragdina

Viloteau hitch-hiked with a group of Gabonese soldiers near Libreville and had been walking along a forest trail when she saw this eye-catching tiny green snake. As she knew it wasn't venomous, she grabbed it, and after calming it with her body warmth, placed it in a canvas bag until she found an appropriate background for it.

Once on the raffia leaves, the snake began an arabesque and Viloteau was able to take well over a hundred shots (including this one) of the striking snake. The local tribespeople (the Fang) christened Viloteau Smaragdina (emerald) after she took the snake into a meeting with the local medicine woman and the village elders. During their meeting, a huge millipede walked into the hut where they all were, and Viloteau's animal-charming credentials were cemented by picking up the insect and giving it a quick kiss and cuddle – much to the astonishment of the locals.

Nikkormat, 55mm Micro-Nikkor, 1/60sec at f/8, off-camera flash at 1/2 power

Nicole Viloteau

Kennan Ward USA

Born in Chicago, Illinois in 1954, Kennan Ward never made a conscious decision to take up photography. Rather, wildlife and natural history was, and still is, his prime passion in life, and it was a logical step for him to join the National Park Service in 1973 as a search and rescue ranger. While pursuing this outdoor career he took a Natural History/Environmental Studies degree at the University of California in Santa Cruz, graduating in 1979. After further studies, Ward obtained a joint degree in Wildlife Biology.

"Photography was just one of those things that I always enjoyed doing," he says. "I was the unofficial documenter of my family simply because I was the only one who didn't seem to crop everyone's head off, and when my job as a park ranger took me out to the west and Alaska the scenery that I found there was so beautiful compared to the surroundings I'd grown up with in the mid-west that I felt obliged to record it on film to show the people back home what it looked like."

In 1980, aged 26, Ward was taking time off from his duties as a ranger in Yosemite National Park when he produced two of his most iconic landscape photographs, "Half Dome Lightning Strike" and "Double Rainbow." Such was their popularity that it gave him the opportunity to consider turning professional, and he decided to make photography his career, using his pictures as the illustrations for a series of high-quality postcards, notelets, calendars and postcards.

Ward works in the field with his wife Karen who, since 1986, has contributed to the image library as a photographer in her own right, while also assisting in the research and business management of the couple's successful publishing company, Wildlight Press Inc.

Assignments have taken the pair all around the world, to some of its remotest regions – Alaska remains a favourite location, while Ward has also travelled to the Arctic, Newfoundland and Midway Atoll – through to many wilderness regions throughout the US. "Despite making my living as a photographer," says Ward, "I still consider that I'm a naturalist, first and foremost, and photography was simply something that I happened to be able to teach myself.

"I think that, providing you love the subject that you're taking pictures of, your relationship with that area will help you to deliver something that is insightful and special. When I'm taking workshops this is one of the points that I emphasise all the time: photograph what you know, and this is likely to be what you are best at."

Family portrait
This polar bear group portrait is one of Kennan Ward's favourite wildlife pictures It was taken on the sea ice at Cape Churchill, the location being reached by a half track vehicle. "I actually took this picture with a 20mm lens," says Ward, "and the only reason that I knew I was safe to venture this close was because I had spent three years photographing polar bears in the mid-1990s for my book *Journeys with the Ice Bear*. They had recently finished sparring with each other and I knew that, when this happened, they would need to spread themselves on the ice as much as they could to cool off, and this meant that they couldn't get up too quickly. When I first came across the scene the bears were all passive and lying down on the ice. After I had taken a few pictures this particular bear sat up as part of the process of getting up, and as I took my picture I was going through my preparations of getting out of there!"

Pentax 35mm, 20-35mm zoom at 20mm setting, Fujifilm Provia, tripod

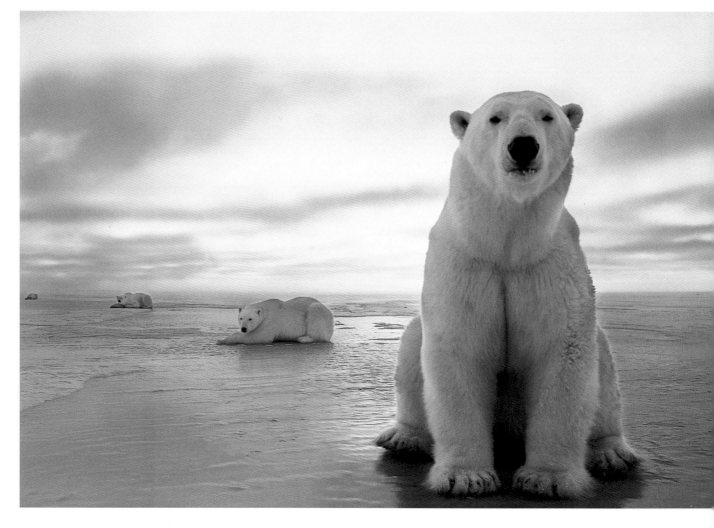

Frog and heliconia
Kennan Ward was on a visit to Costa Rica, and was being given a guided tour of the island's botany by a friend. "He was busy showing me this heliconia plant," he says, "when I noticed that there was a tiny ruby-eyed tree frog making its way to the top. I held my breath hoping that he would make it and, when he did, I shot off a whole roll of film."

Pentax 35mm, 60mm macro lens, 1:1 image, Fujifilm RD 100, tripod

Moose in Denali National Park
Having worked there as a park ranger, Kennan Ward knows the Denali National Park in Alaska really well, and it's one of his favourite places to photograph. "This particular location, the view across Wonder Lake to the mountain range beyond, is a beautiful landscape," he says, "but I always thought that it was waiting for something to complete it, and it took 15 years for this picture to finally come together. "During summer the sun never sets in this part of the world. This photograph was taken at around 4am. I was camping at the other end of the lake and had hiked to this point to be in position in case there was anything worth photographing. The water is very shallow here, and I knew that there was a chance that moose would be attracted by the aquatic plants that they love. Once I saw the moose I had to be very careful not to scare it away. There's a saying that if something happens in the forest, the eagle will see it, the bear will smell it and the moose will hear it. They can see pretty well too, and hear even better, and I had to know what I was doing to be able to take the picture that I wanted."

Mamiya 645, 55mm lens, Fujifilm Velvia, tripod

Kennan Ward

Son of bear

This image, taken in the Katmai National Park in Alaska, is named "Son of Bear" by Kennan Ward because the subject's characteristics are so similar to that of another bear that he's photographed that he's sure the two must be related.

"I was doing some quite unusual underwater work in this lake," he says, "photographing a fish graveyard. While I was there, this coastal brown bear, a close relative of the grizzly, swam downstream beside me, stopped, and then, with his hind feet, caught a fish. I was so mesmerised that I missed it. It was such a great picture, however, that I knew I had to come back to try to capture it on film and, after a month, I achieved my goal. It was another of these occasions when the landscape was absolutely beautiful and it was just a question of putting the creature within that: I finally got my chance one day when the bear came back for more fish and positioned itself in exactly the right place for me. At this point he had caught the fish with his hind legs and was in the process of transferring it to his paws, and the next frame I have shows him with it in his mouth. I have worked with bears many times during my period as a park ranger and so I knew I was fairly safe, even though I was so close to the bear, since they are at a disadvantage in the water. I wouldn't, however, recommend that anyone else should go to these lengths to get a picture!"

Pentax 35mm, 80-200mm zoom on 80mm setting, Kodachrome 200

154

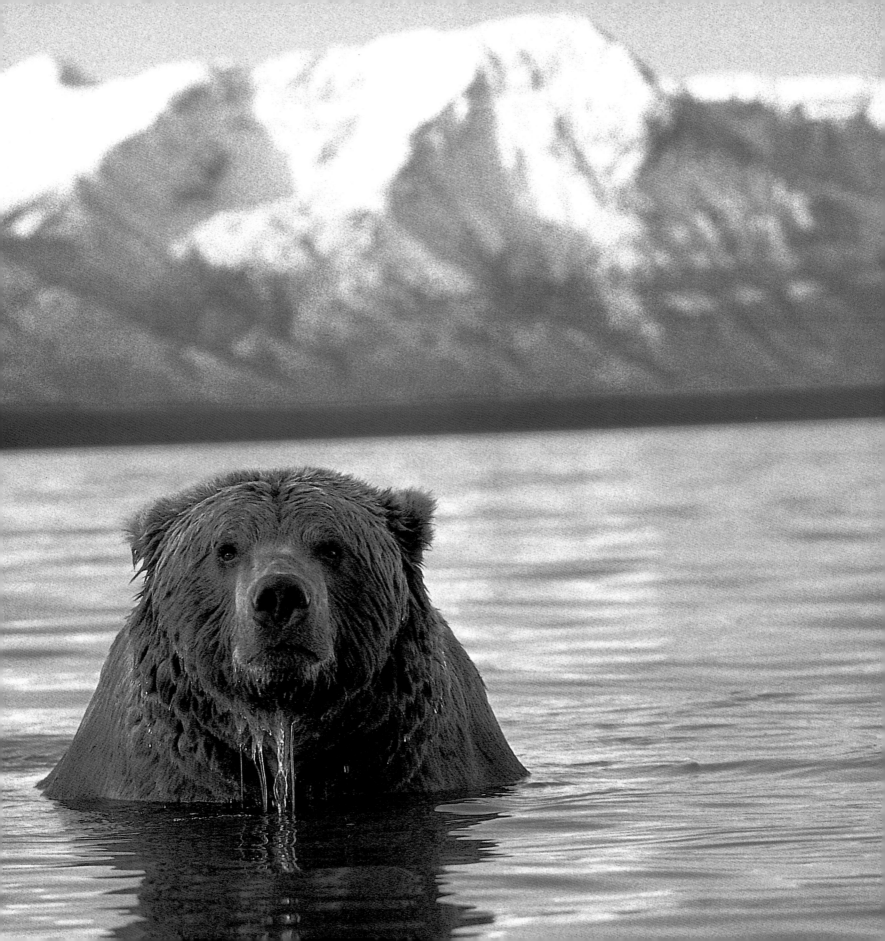

Art Wolfe USA

A multi-faceted photographer, who is every bit as well regarded for his landscape photographs and pictures of indigenous people as he is for his wildlife and natural history work, Art Wolfe grew up with a natural affinity with the great outdoors. "I was one of those kids that you see around with a plastic pair of binoculars, the type that's always out there chasing birds and investigating the woodland around where he lives," he says.

"I was also the school artist, because my mother was a commercial artist and it just kind of rubbed off on me. So, basically I had these two early influences and, 25 years later, they combined to produce a nature photographer."

Wolfe graduated from the University of Washington in Seattle with bachelor's degrees in Fine Art and Art Education. "While at university I was studying art during the week and then climbing at weekends and taking pictures, and so I was applying a lot of the art training that I was being given to my photographic compositions," he says. "Eventually my allegiance shifted from painting to photography because it was much easier for me to generate original compositions with a camera than with a brush."

He was completely self-taught as a photographer. "It's not something that I say so much with pride as something that just happens to be reality," he says. "When I went to art school there was no equivalent programme available for those who wanted to be photographers. Maybe if I had wanted to be a photojournalist that would have been different, but certainly there was nothing available at that time for those wanting to go into nature photography."

As his career began to build, he found himself on the road more than he was at home and, over the course of his 25-year career, he has worked on every continent and in hundreds of locations. He now spends over nine months of the year travelling, giving lectures all over the world and shooting for new book projects. He burns more than 2,000 rolls of film annually, has taken an estimated one million images in his lifetime, and has released more than 45 books to date.

His work has earned him a multitude of awards, including being named Outstanding Nature Photographer of the Year by the North American Nature Photography Association in 1998 and being awarded a coveted Alfred Eisenstaedt Magazine Photography Award in 2000.

The philosophy behind his photography is simple and to the point. "Whatever subject I happen to be shooting," he says, "I make clean, clear records conveying the emotion of the moment when I took the picture. I try to keep my composition simple, even when I'm working with a wide-angle lens, because I believe that this creates a purer form of communication."

Wolfe is similarly pragmatic about the equipment that he uses. "To me a camera is simply a tool," he says, "and I will use different ones to tackle different assignments. My approach has always been to use whatever camera and lens that I consider will get me the best shot in a given situation, and I see no reason to change that approach."

Wolf
"This was photographed in Montana, near Glacier National Park," says Wolfe. "The picture was taken in the winter and there was a kill nearby, and wolf tracks were going in and coming away from that and so I knew that there were definitely wolves in the area. This is a member of a pack that lives on the western side of Glacier National Park, and this is as close as I got to this particular individual."

Canon EOS RS, 600mm lens

Polar bear and mother
"This was taken in Manitoba," says Wolfe, "and it's one of my all-time favourite shots because the complementary colours of orange and blue in the scene are really effective and I also love the way that the image highlights the tenderness between this mother, an animal that is the largest land carnivore on earth and its tiny innocent baby. There's a lot of metaphors here, all about power and grace and innocence, and you can virtually read into the picture what you want."

Canon EOS 1N, 600mm with a 1.4 converter

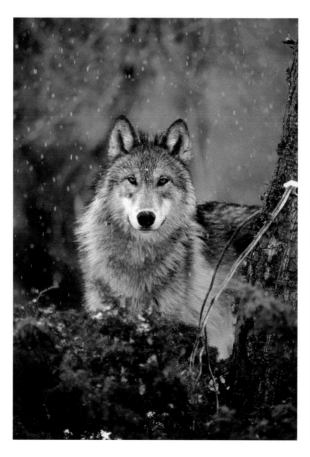

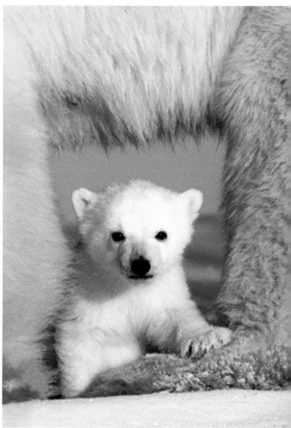

ee eaters

These bee eaters were photographed along the Okavango river during the night," says Wolfe, and I lit the scene with three ashes, one either side of the amera and a third behind the birds o illuminate the background a ttle. At night time bee eaters group p like that for safety and sit on eds that overlap the river, so that ny ground predators cannot get to em. Once they have tucked emselves down and it's pitch lack, they are not going to fly. I as able to get just a foot or two way from them, so close in fact at I was able to take this picture ith the standard lens."

kon N90, 50mm lens, three flash eads

Gazelle mid-flight

"This was shot in the Masai Mara National Park in Kenya," says Wolfe, "It was very early in the morning and the light was very rich and saturated, and the moment before I took this picture I was taking still portraits of members of the herd. Suddenly there was a little bit of a noise behind them and they instinctively started bounding across the landscape. The harder they ran, the more they started leaping off the ground."

Canon EOS RS, 600mm lens, 1/500sec at f/8, Fujifilm Velvia pushed one stop to ISO 100

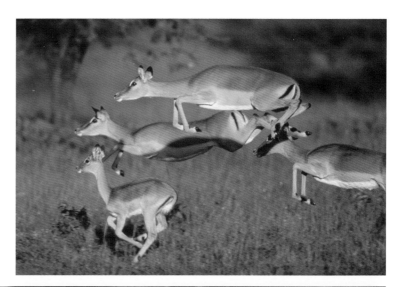

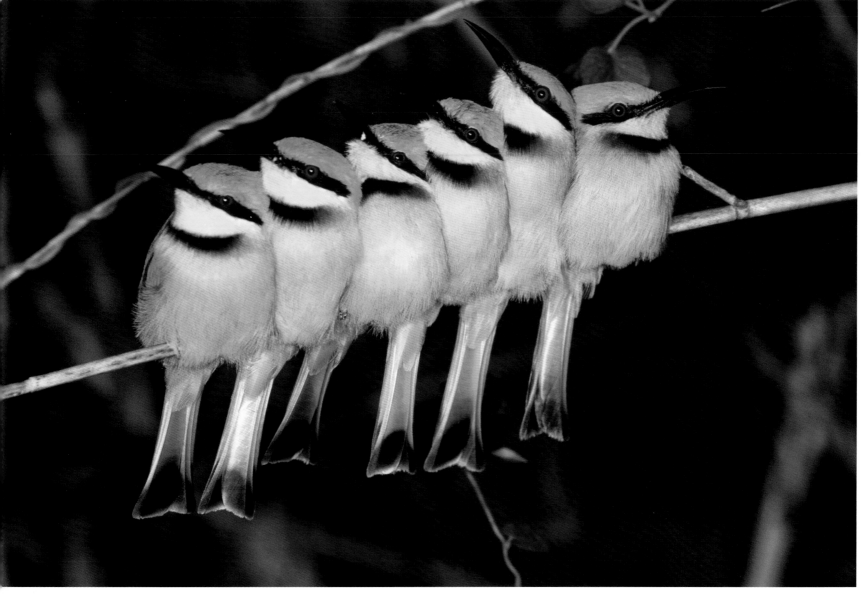

Art Wolfe

Caimans in Brazil

"I was on a photographic expedition to the Pantanel Marsh in Brazil," says Wolfe, "and I had a guide with me who asked me at one point if I would like to see the caimans. Naturally I said yes, and he led me to a river bank and then took out a large stick and started to club the earth along the edge of the bank.

"This was obviously a signal to the caimans, because as the vibration went out into the water they started emerging from the river. I found out later that the ranchers in the area had started this habit and had taken to feeding the caimans scraps such as chicken bones, and all they were doing was responding to what they took to be a sign that there was some food around.

"Because I didn't know that, I was suddenly confronted by all these caimans coming towards me and, armed with just a 17mm lens, I was literally hiding behind my tripod just a few inches away.

"Historically these animals are not aggressive towards humans, not like a crocodile for instance, and I knew that. I was also sure that the guide wouldn't put me in harm's way, but caimans are capable of snapping and biting at you if you start to tease them, and that was certainly farthest from my mind at this point! They are about five to six feet long at the most, so they are certainly big enough to render a pretty sizeable bite out of you if they so choose, but they just didn't exhibit any aggression whatsoever. They were almost like dogs waiting to be fed.

"I took up a very low angle with this picture to make it even more effective, and I used a neutral density filter to try to keep the sky from washing out because I was exposing from the backs of the caimans to make sure that I retained detail there."

Canon EOS 1N, 17-35mm zoom, available light

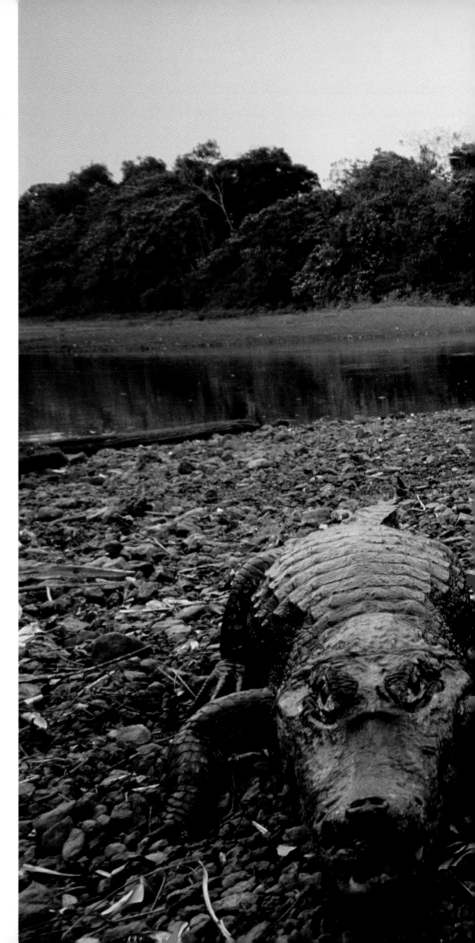

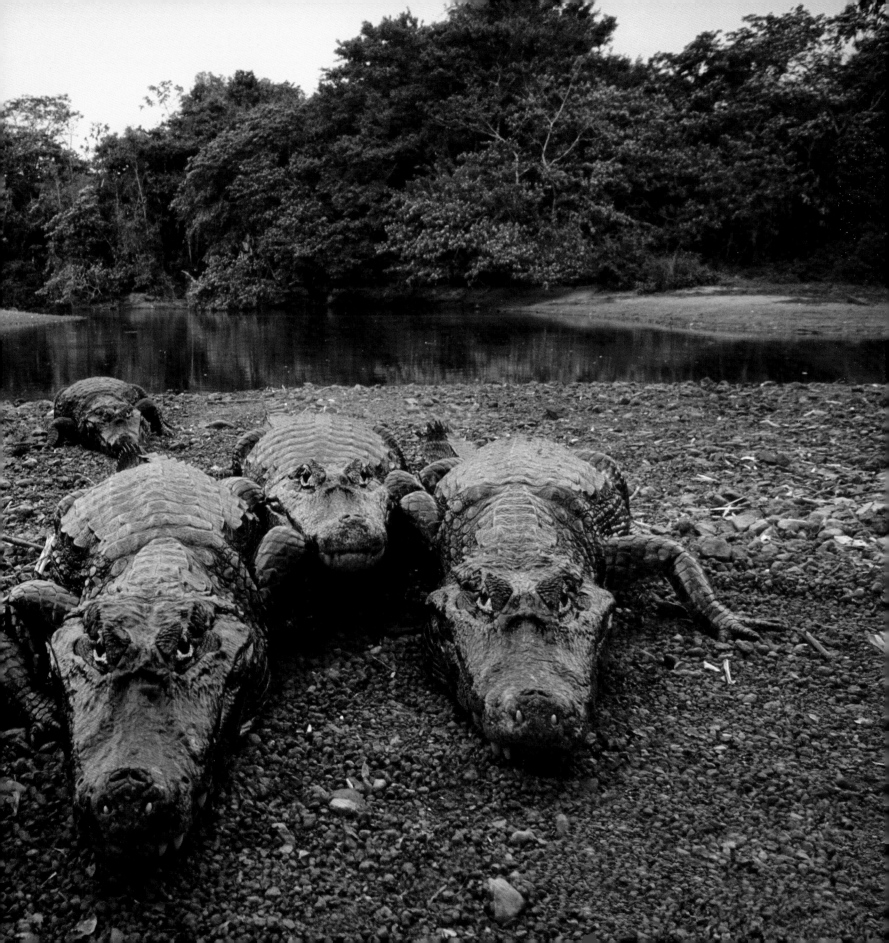

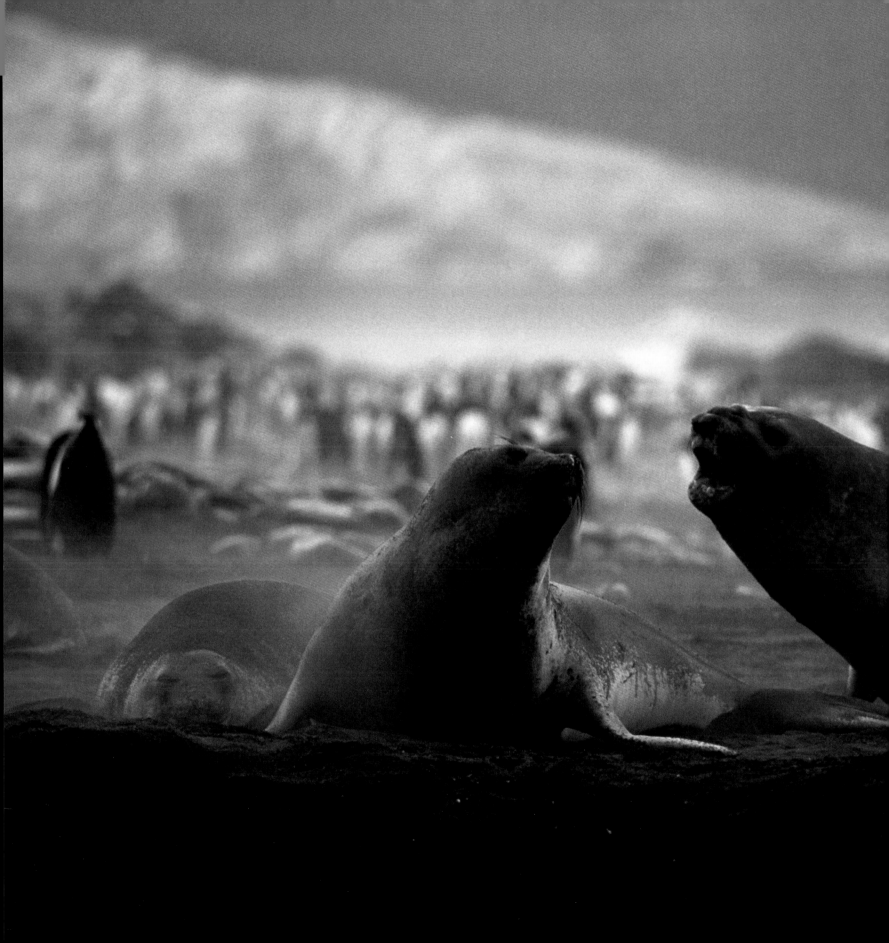

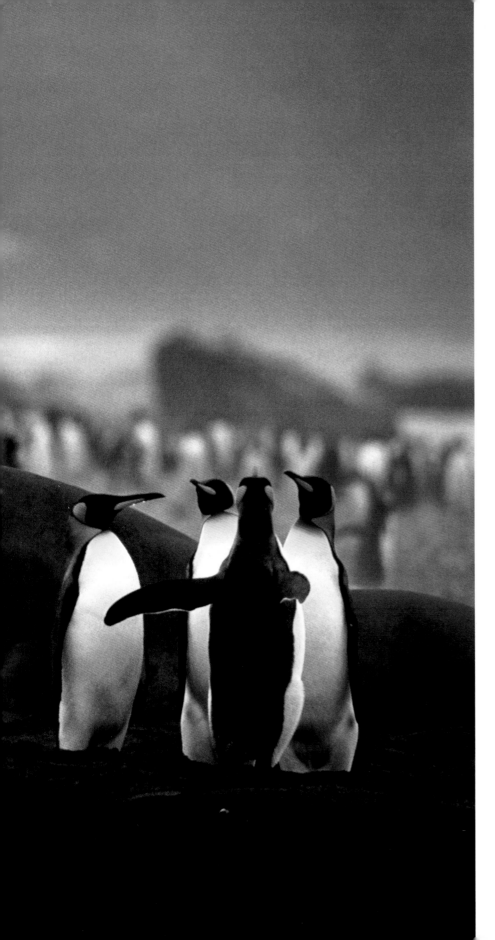

Penguins and seals

"This was a picture that I took on South Georgia Island one December," says Wolfe, "while I was engaged in putting together the images for a book on penguins. What I like about the image are the atmospheric conditions, created by the mist blowing in from the nearby ocean. I'm also very taken with the positions of the creatures within the frame: it almost looks like four penguins engaged in a discussion while the animals around them are just totally ignoring their presence, and are secondary to the composition.

"I took the picture on the long end of an 80-200mm zoom, and used a 1.4 converter to get closer still to these subjects to concentrate attention on this area of the scene."

Canon EOS 1N, 80-200mm zoom, 1.4 converter

Art Wolfe

Konrad Wothe GERMANY

As a child Konrad Wothe never enjoyed playing with toys such as train sets, preferring instead to make toys with his own hands or to be outside in his parent's garden. "I loved nature and animals from the very beginning," he says. "When I was eight years old I started taking pictures with a very basic camera, and my first subjects were the kittens we had at home. Soon I tried to build simple wooden cameras on my own and an enlarger for my black and white lab in the basement.

"While I was at grammar school I won a major prize in a competition with a genuine working model of a medium-format reflex camera with interchangeable lenses, all made out of wood, and in another year I took the first prize with the construction of a 360-degree panoramic camera."

After graduating from school, Wothe worked as a cameraman for the German wildlife filmmaker Heinz Sielmann, and soon decided that he too wanted to become a wildlife filmmaker and nature photographer. Before launching his career in photography, however, he studied Biology and Animal Behaviour at the University of Munich, and this proved to be a good foundation for his work today.

"I had never stopped taking photos," he says, "and in 1978 I had my first pictures published in the book *Save the Birds* by Horst Stern and others. They were taken with my Pentax Spotmatic and motordrive, equipment that I paid for with the money won in my school competition. I partnered this with a self-made 600mm f/5.6 telephoto lens. I also made myself a 400mm f/5.6. Later I built a kind of a lightweight telephoto-module system; one fast-focusing unit with three lens-heads: 500mm f/4.5, 600mm f/5 and 800mm f/5.

"Then I started travelling: East Africa, India, and Sri Lanka were my first faraway destinations. Two bird books for Gräfe und Unzer followed in 1982 and 1984."

Between 1984 and 1992, Wothe, alongside Dr Michael Herzog concentrated on filmmaking, as a producer and as a cameraman. He worked with a lightweight Beaulieu 16mm camera, which allowed him to develop quick reactions in the field and to document wildlife as authentically as possible. Several wildlife films made in India, Costa Rica, Madagascar and Europe were screened on television Germany (ZDF) and abroad.

In 1995 Wothe decided to stop filmmaking and to concentrate completely on photography, which he had realised was his true passion. "Since then, many photo trips and expeditions have led m around the globe from the Arctic to the Antarctic," he says. His wor is sold mainly through picture libraries, and has appeared in books, magazines, advertisements, posters and calendars worldwide. "Rainforests have always had a special fascination for me: after th TV films made in the rainforests of India and Costa Rica, I twice travelled to the rainforests of Borneo and Sumatra working on my book *Orang-utans*, which was published in 1996 in Germany.

"I then made three expeditions to the rainforests of Irian Jaya t photograph birds of paradise and bowerbirds. I hope my pictures help to increase public awareness about the ecological importance of this wonderful biosphere for the world climate and mankind.

"With my pictures I try to transmit the character of an animal, plant or landscape. I want the viewer to get the same feelings that had during my encounter with that animal, plant or other wonder c nature. My photographs hopefully will bring more people to love nature, because I believe that only those who love nature are also willing to preserve it and to treat it with the respect it deserves.

"My earliest influences were Heinz Sielmann, who definitely brought me into filming and professional photography and the wor of Günther Ziesler, Frans Lanting and Art Wolfe, but there were ma other good photographers that gave me motivation and ideas."

When the first fluorite lenses became available, Wothe switched the Canon EOS AF system, with lenses ranging from 14mm to 600mm. "I very much appreciate the new image stabilisers, which give me the freedom to work more spontaneously handheld, without a tripod or monopod. When using tripods, I prefer the lightweight and very stable ones made of carbon fibre. I work mos with Fujifilm Sensia and Velvia films, but, depending on the situatio I also use Kodak materials."

Wothe has won many accolades, including four section wins, fi runner-up awards and 22 Specially or Highly Commended Awards the Wildlife Photographer of the Year Competition. He was the GD Nature Photographer of the Year in 1999 and was overall winner of the Nature category in the Austrian Super Circuit international competition with six gold medals. In 1992, his film *Jungle Spirits o Madagascar* was awarded the URTNA (Union of National Radio an Television Organisations of Africa) first prize.

Siberian tiger
This shot was taken in a German zoo during heavy snowfall. The species is at the edge of extinction, with fewer than 500 animals living in the wild.

Canon EOS 1N, 600mm f/4 lens, Fujifilm Sensia

Tengmalm's owl

This Tengmalm's owl was spotted looking out of its nesthole in a forest in Sweden. These little owls are active mostly at night, and it's rare to see them during the daytime.

Canon EOS 1V, EF 4,0/600mm lens, Fujifilm Velvia

Spotted cuscus

Wothe photographed this animal in the rainforest on Yapen Island, Irian Jaya, Indonesia. Cuscuses are phalangers, and feed mainly on the leaves of rainforest trees. Their strong tails help them to climb trees and branches.

Canon EOS 1N, 300mm f/2.8 lens, Fujifilm Sensia

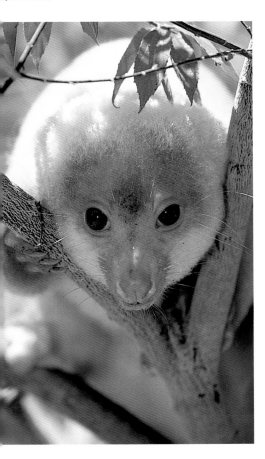

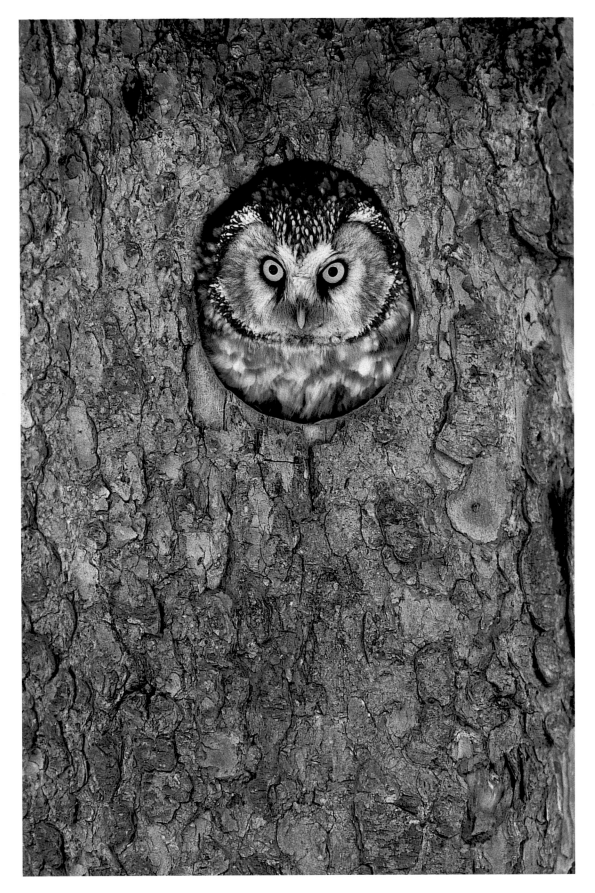

163

Konrad Wothe

Macaques in the snow

Japanese macaques (snow monkeys) are among the most photographed of all wild creatures, much of their fame stemming from their love of taking a bath in hot springs during the middle of the coldest winters.

"I had always wanted to see this with my own eyes," says Wothe, "and so I spent a week one January at Jigokudani, Hell's Canyon in the Japanese Alps, where the snow monkeys traditionally carry out their bathing. The best pictures occur when there is a lot of snow around, but when I arrived, there was very little to be seen. Then my luck changed and a heavy snowfall started and, at last, the conditions were perfect for getting the pictures of snow monkeys I had drawn in my imagination.

"The little pool at the hot spring was steaming and, through the mist, I could see the snow-capped heads of the macaques as they relaxed, groomed and just warmed up. However, after a while, all the monkeys left the pool dripping wet as another group approached. They seemed to have some kind of schedule for sharing the pool that I still cannot understand, and nor do I know why the monkeys don't suffer from pneumonia once they reach the chilly air with their soaking wet fur!"

Canon EOS 1N, EF 28-70mm f/2.8 and 70-200mm f/2.8 lenses, Fujifilm Sensia and Velvia

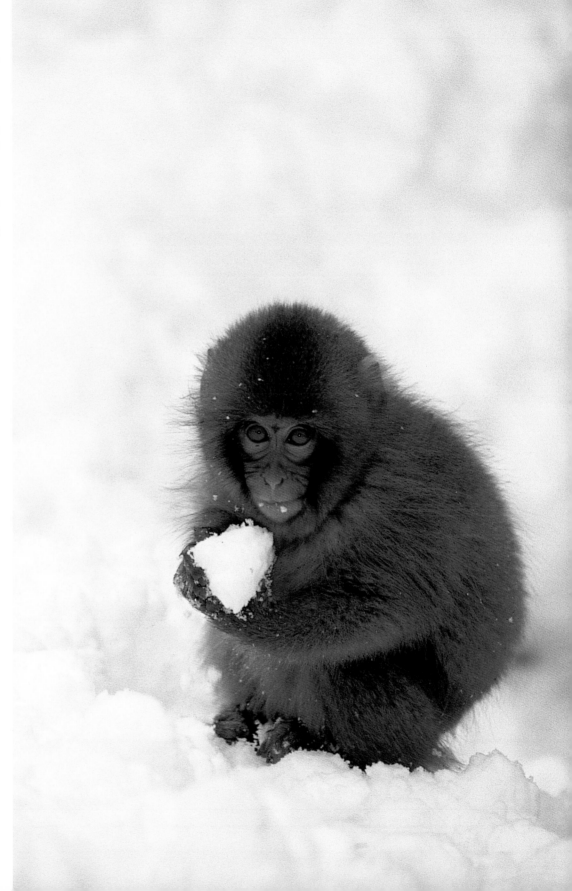

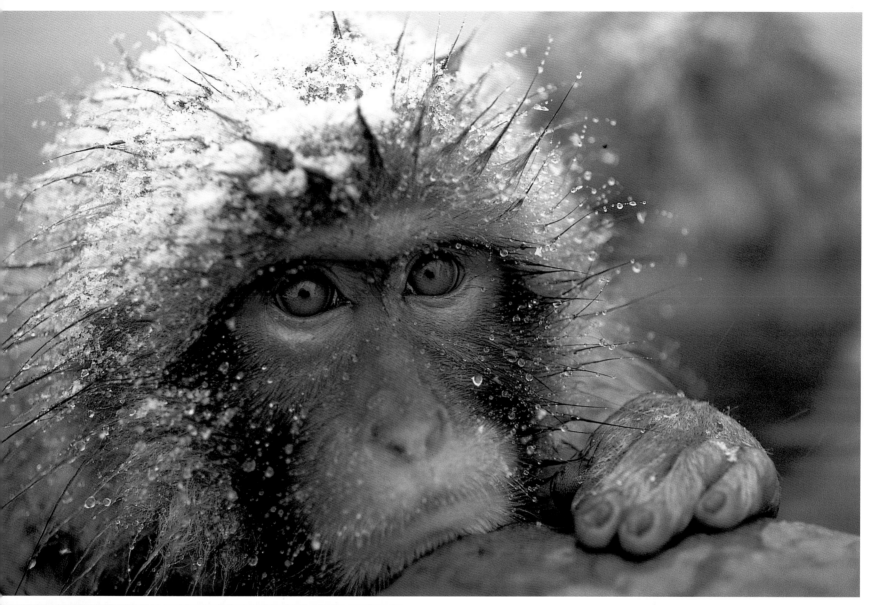

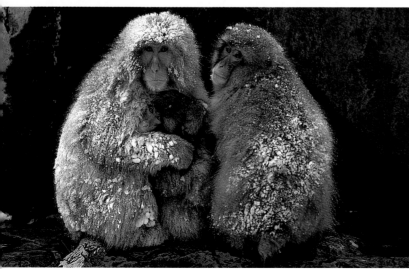

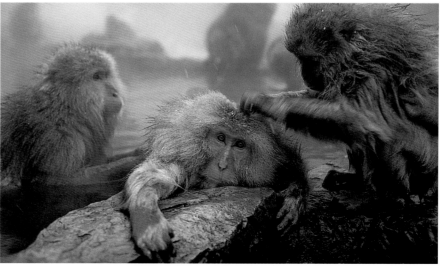

Konrad Wothe

Norbert Wu USA

In the course of his career, celebrated marine photographer, cinematographer and writer Norbert Wu has been bitten by sharks, run over by an iceberg, stung nearly to death by sea wasps and trapped in an underwater cave. He has photographed in virtually every conceivable locale, ranging from the freezing waters of the Arctic and Antarctic to the coral reefs and jungles of the tropics. He has also worked as chief still photographer for Jacques Cousteau's Calypso; as research diver for the Smithsonian Tropical Research Institute; and as the cinematographer for numerous television productions.

"At the age of six I wanted to become a marine biologist," he says. "And, as a teenager growing up in Atlanta, I spent summers snorkelling in Florida and became fascinated with wildlife. When the time came to go to college, I chose California because I thought that meant beaches, sun and warm water. Then, deluged with advice from friends, professors and parents, I embarked on a degree in Electrical Engineering rather than my lifelong interest, Marine Biology."

Wu kept up his diving, however, and explored what were, in reality, the "bone-chilling" waters of Monterey Bay after investing in a wetsuit and basic diving gear. He obtained a master's degree in Engineering and got a job as a computer engineer in Silicon Valley. "The job paid well, my boss was easygoing and the work was routine and unstressful," he recalls. "Of course, I was bored. My thoughts kept wandering to tropical beaches and coral reefs."

After months as a corporate player, Wu took an extremely poorly paid job as a research diver with the Smithsonian Tropical Research Institute on one of the San Blas islands of Panama. "The island I was on was about 100 square feet of sand and the researchers lived in bamboo and plywood huts right above the water. Most importantly the water was warm, and I had all the time in the world to dive.

"Prior to this trip I never had the slightest interest in photography. Before heading south, however, I had bought some books on the subject, as well as an underwater flash and a Nikonos camera system."

In the four months that he was in the San Blas, Wu shot only around ten rolls of film, but the pictures from that trip have been published over and over again. "Because I was diving the reefs every day I knew their inhabitants intimately," he says. "I was able to return to subjects again and again over the course of my four-month stay."

Following his San Blas experience, Wu took courses in Marine Biology and spent two years as a doctoral student at Scripps Institution of Oceanography. Photography took up more and more of his time, and he convinced his friend Spencer Yeh to spend two months with him, diving every day in the cold but rich waters of Monterey Bay. Eventually photography became his way of life, and it offered him the chance of a career that he loved plus the opportunity to see the world.

His photographic philosophy and technique has been developed and refined through experience. "Three things happen when light goes underwater," he says. "Light rays are bent or refracted, colours are absorbed, and light is scattered by particles in the water. This leads to the cardinal rule of underwater photography – get close, and then get even closer. This rule makes the choice of equipment relatively simple. Nearly all photographs are taken with wide-angle lenses or close-up macro lenses, and nearly all subjects are lit with underwater flash as fill or as key light. Water absorbs warm colours very quickly,

so flash photos of colourful subjects are rarely taken more than six feet from the subject. Since scatter significantly degrades an image, wide-angle lenses are used to get close to the subject, and flash is used to bring out the colours.

"The choice of cameras is also simple. Most pro underwater photographers use 35mm, and the Nikonos amphibious camera and an SLR land camera in a plastic or aluminium housing are the only practical choices. I choose a specific camera depending on what subject I plan to encounter during my dive. For fish portraits and close-up work, I use a housed Nikon system with 60mm and 100mm macro lenses. The Nikonos with a wide-angle underwater lens is perfect for large animals, underwater panoramas, and fast action involving larger subjects such as sharks, divers and marine mammals.

"For underwater scenics requiring careful composition, I use the housing with wide-angle lenses ranging from 16mm fisheye to 24mm. The TTL flash control in underwater systems works well, especially with close-ups. Autofocus cameras work as well as they do on land.

"Before going underwater, the cameras, lenses and film must be set up and sealed. I sometimes carry a Nikonos with wide-angle lens as well as a housed camera with macro lens together on one dive. I'm limited to one roll of film for each camera and, if a subject doesn't fit within the capabilities of one of those systems, then I am out of luck. If I'm diving in strong currents, I'm limited to just one camera.

"Since light underwater is so diffuse and blue in colour, the sharpness, contrast and colour bias of Kodachrome transparency film works well, and I use it almost exclusively for underwater work. Since I almost always use flash, I'm limited to the flash sync speed of my cameras. The majority of my photographs are taken using a sync speed of 1/60 or 1/90 of a second. This relatively slow speed is sufficient in most situations, since animals don't move as fast under water and low light levels need slow shutter speeds in order to register an image on film. In the darker waters off the California coast, I'll often use Fujichrome 100 film, which responds better to low light levels and makes the muddier, greener waters look more pleasingly blue."

In addition to the technical challenges, underwater photographers have the added issue of personal safety to consider, and must keep an eye on currents, bottom time, and remaining air supply.

"My dive computer is essential for allowing me to concentrate on photography. It gives me my time remaining and keeps me from getting into trouble with decompression or air supply. Though I have taken my camera as deep as 240 feet, I get much more time underwater if I stay in shallower waters, sixty feet deep or less. At sixty feet I can generally stay in the water for an hour or so at a time."

As an independent photographer and filmmaker, Wu's projects support his commitment to exploration, research and conservation. He co-authored the feature on marine biodiversity in Encyclopaedia Britannica's 1996 Yearbook of Science and the Future, and he was awarded National Science Foundation (NSF) Artists and Writers Grants to document wildlife and research in Antarctica in 1997, 1999 and 2000. His recent films include a high-definition television film on Antarctica's underwater world for PBS Nature. In 2000, he was also awarded the Antarctica Service Medal of the USA, for his contribution to exploration and science in the US Antarctic Programme.

Hammerhead sharks, Costa Rica
"Off islands and undersea
pinnacles, schools of scalloped
hammerhead sharks can often be
encountered," says Norbert Wu.
"Swimming in the midst of a school
of hundreds of sharks is exciting,
but fortunately not dangerous.
The sharks are timid when gathered
in great groups like this, and they
flee at the sound of a diver's
bubbles." The picture was taken
off Cocos Island, Pacific Ocean.

Nikonos V, UW-Nikkor 15mm lens,
1/60sec at f/8, Kodak Elite Ektachrome

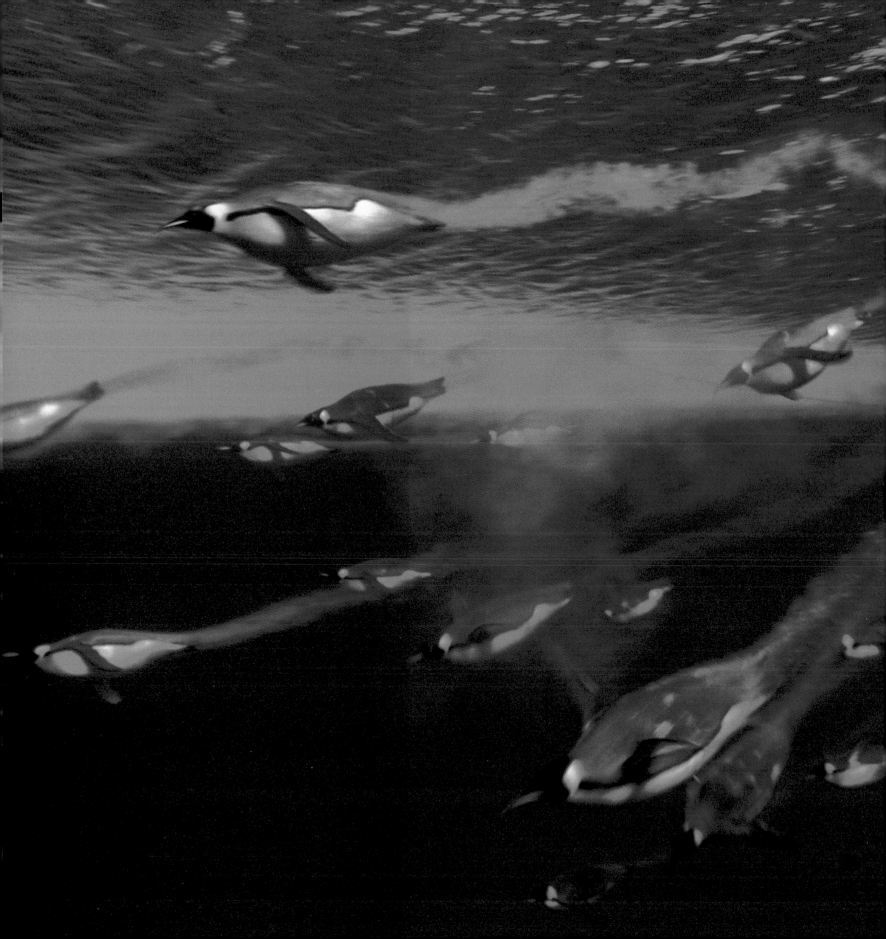

Emperor penguins underwater

"I worked out of the McMurdo Station in Antarctica in 1997 and then again in 1999-2000 under the National Science Foundation's Antarctic Artists and Writers Programme," says Norbert Wu. "We began in October 1997, early in the Antarctic summer, when the sun has been largely absent for six months and the water is virtually free of phytoplankton and so strikingly clear. Our visibility was limited not by particles in the seawater, as is usual when diving, but by the availability of light filtering through the sea ice. In three months we made 68 scuba dives, typically lasting an hour, sometimes longer if our hands could stand the cold. We also undertook various field trips, during which I shot 500 rolls of film.

"Diving from the sea ice of McMurdo Sound was heaven for me, since I detest boats. Doing a dive was as simple as loading one of our tracked vehicles, driving to a heated hut over a hole in the ice and jumping in the water. Not all dives were comfortable: we spent cold days at the ice edge, where the saliva in my mask immediately turned to ice (you spit in the mask before diving to prevent fogging during the dive) and then I would have to put on my gear without seeing, clearing the mask in the water. If I lifted my head above the water for more than a few seconds the water would again freeze until I put my head back in the water."

This image of diving emperor penguins was taken during this trip, and the sight astounded Wu. "Emperor penguins are the champions of diving birds," he says. "They are able to hold their breath for 22 minutes and to dive to depths of 1,760 feet as they forage for fish and squid. The contrails seen here are streams of bubbles. The emperor penguin's thick feathers insulate it by trapping a layer of air next to the skin, but often some of that air streams out when the bird swims."

Nikonos V, UW-Nikkor 15mm lens, 1/30sec at f/8, Fujifilm Velvia

Norbert Wu

Directory

Cherry Alexander
All pics © B & C Alexander
Email: alexander@arcticphoto.co.uk
Website: www.arcticphoto.co.uk

Bibliography (With Bryan Alexander)
— Eskimo Boy, A&C Black, 1977
— Hunters of the Polar North, Time Life Books,1980
— The Inuit, Wayland Books, 1988
— What Do We Know About the Inuit?, MacDonald Young Books, 1995
— Vanishing Arctic, Cassell, 1996

Heather Angel
All pics © Heather Angel/Natural Visions
Email: hangel@naturalvisions.co.uk
Fax: +44 (0) 1252 727464
Website: www.naturalvisions.co.uk

Selected Bibliography
— Nature Photography: Its Art and Techniques, Fountain Press/Argus, 1972
— Photographing Nature Series, Argus Books, 1975
— Wild Animals in the Garden, Jarrold, 1976
— Fungi, Angus & Robertson, 1979
— The Guinness Book of Seashore Life, Guinness Superlatives, 1981
— The Book of Nature Photography, Dorling Kindersley/Ebury Press, 1982
— Nature in Focus, Octopus Books, 1989
— Photographing the Natural World, Collins & Brown/Sterling, 1994
— How to Photograph Flowers, Stackpole Books, 1998
— Pandas, Voyageur Press, 1998
— How to Photograph Water, Stackpole Books, 1999
— Natural Visions, Collins & Brown/Amphoto, 2000

Fred Bavendam
All pics © Fred Bavendam/Minden Pictures (Portrait by Patricia Danna)
P.O. Box 494, Wenham, MA, USA 01984
Tel: +1 (978) 468-2354
Fax: +1 (978) 468-2365
Email: fabavendam@mac.com
Agent: Minden Pictures (www.mindenpictures.com/+1 831-685-1911)

Selected Bibliography
— Beneath Cold Waters, 1980, Down East Books

Niall Benvie
All pics © Niall Benvie
Tel/Fax +44 (01356 626 128/ 0780 1067 160
Email: niall@niallbenvie.com
Website: www.niallbenvie.com

Bibliography
— The Art of Nature Photography, David & Charles, 1999
— Creative Landscape Photography, David & Charles, 2001

Steve Bloom
All pics © Steve Bloom
Email: info@stevebloom.com
Website: www.stevebloom.com

Bibliography
— In Praise of Primates, Konemann

Dr John Brackenbury
All pics © John Brackenbury
Woodfall Wild Images, 17 Bull Lane, Denbigh, LL16 3SN.
Tel: +44 (0)1745 814581

Bibliography
— Insects in Flight. Castle Publications
— Insects and Flowers: A Biological Relationship. Castle Publications
— Insects and the Seasons. Castle Publications

Jim Brandenburg
All pics © Jim Brandenburg
Ravenwood Studios, 14568 Moose Lake Road,
Ely, Minnesota 55731
Tel: +1 218-365-5105
Email: brandenburg@2z.net
Website: www.jimbrandenburg.com
Agent: Minden Pictures (www.mindenpictures.com/+1 831-685-1911)

Bibliography
— White Wolf – Living with an Arctic Legend, Northword Press, 1988
— Minnesota – Images of Home, Blandin Foundation, Grand Rapids, 1990
— Brother Wolf – A Forgotten Promise, Northword Press, 1993
— To the Top of the World – Aventures with Arctic Wolves, Walker and
 Company, 1993
— Sand and Fog – Adventures in Southern Africa, Walker and Company,
 1994
— An American Safari – Adventures on the North American Prairie,
 Walker and Company, 1995
— Scruffy – A Young Wolf Finds his Place in the Pack, Walker and
 Company, 1995
— Chased by the Light – A 90 Day Journey, Northword Press, 1998
— Looking for the Summer, Northword Press, 2002

Laurie Campbell
All pics © Laurie Campbell
Email: laurie@lauriecampbell.com
Website: www.lauriecambell.com

Bibilography
— Wildlife Photographs of Laurie Campbell, Colin Baxter, 1986
— RSPB Guide to Bird and Nature Photography, David & Charles, 1990
— The Great Wood of Caledon, Colin Baxter, 1991
— Golden Eagles, Colin Baxter, 1996
— Wild Scotland, Luath Press, 1998
— Badgers, Colin Baxter, 1999
— Highlanders, Castor and Pollux, 2000

Stephen Dalton
All pics © Stephen Dalton/NHPA
Email: stephen@nhpa.co.uk
Agent: NHPA (www.nhpa.co.uk/+44 (0)1444-892514)

Selected Bibliography
— Ants From Close-Up, Thomas Crowell, 1967
— Caught in Motion, Weidenfelt & Nicolson London, Van Nostrand NY,
 1982
— The Secret Life of an Oakwood, Century Hutchinson, 1986
— Secret Lives, Century Hutchinson, 1988
— At the Water's Edge, Century Hutchinson, 1989
— Vanishing Paradise, Century Hutchinson, 1990
— The Secret Life of a Garden, Ebury Press, 1992
— The Miracle of Flight, Firefly Books, Canada. Merril Publishing
 UK and Europe, 1999
— Secret Worlds, Firefly Books, Canada, 1999

Manfred Danegger
All pics © Manfred Danegger
Hasenbühlweg 6, Germany, 88696 Owingen-Billafingen,
Tel: +49 7557 8765

David Doubilet
All pics © Doubilet Photography Inc.
Tel: +1 212-348-5011 (library)

Bibliography
— Water Light Time, Phaidon Press, 1999

Richard du Toit
All pics © Richard du Toit
Box 547, Witkoppen, 2068, South Africa
Tel/Fax: +27-11- 465 9919
Email: rdutoit@iafrica.com

Bibliography
— Creatures of Habit, Struik Publishers, 2000
— Images From a Timeless Wilderness, Struik Publishers, 2000
— Catching the Moment, Struik Publishers, 2001
— African Wildlife Themes, Struik Publishers, 2001

Tim Fitzharris
All pics © www.TimFitzharris.com
Fitzharris Stock Nature Photography: +1 505-988-5530
Email: fitzharris@earthlink.net
Website: www.timfitzharris.com
Agent: Minden Pictures (www.mindenpictures.com/+1 831-685-1911)

Bibliography
— Rocky Mountains: Wilderness Reflections, Firefly Books
— The Sierra Club Guide to Close-Up Photography in Nature, Sierra Club Books
— Virtual Wilderness: The Nature Photographer's Guide to Computer
 Imaging, Amphoto
— The Sierra Club Guide to 35mm Landscape Photography, Sierra Club Books
— The Audubon Society Guide to Nature Photography, Firefly Books

Anders Geidemark
All pics © Anders Geidemark
Säterhagen 10A, Berg, 734 91 Hallstahammar, Sweden
Tel/Fax +46 220 202 40/070-769 41 77
Email: anders.geidemark@telia.com
Website: www.andersgeidemark.se

Hannu Hautala
All pics © Hannu Hautala
Kiestingintie 12, 93600 Kuusamo, Finland
Tel: +358 8 8511 056
Fax: +358 8 8523 031/+358 400 101 278
Email: hannu.hautala@koillismaa.fi

Bibliography
— The Play of Light, Otava Book Printing Ltd, 2001

Mitsuhiko Imamori
All pics © Mitsuhiko Imamori/Nature Production
c/o Nature Production, TIZ Bldg. 3F, 39-6 Udagawa-cho,
Shibuya-ku, Tokyo, 50-0042 JAPAN
Fax: +81-3-3461-7279
Email: mail@nature-pro.co.jp

Selected Bibliography
— Scarab, Heibonsha Publishers, 1991
— Mitsuhiko Imamori's Days of Insects, Fukuinkan-Shoten Publishers,
 1998
— Mitsuhiko Imamori's Insects on Earth, Fukuinkan-Shoten Publishers,
 1994
— Satoyama: In Harmony with Neighbouring Nature, Shinchosa
 Publishers, 1995
— The Museum of Stag Beetles, Alice-Kan Publishers, 2000
— Satoyama, Shinchosa Publishers, 2001

Mitsuaki Iwago
All pics © Mitsuaki Iwago/Minden Pictures
3F Edelhof Dai-ichi Bldg., 8 Honshio-Cho,
Shinjuku-ku, Tokyo, 160-0003, Japan
Tel: +81 3 3359 8641
Fax: +81 3 3359 9503
Email: Iwago.of@poem.ocn.ne.jp
Agent: Minden Pictures (www.mindenpictures.com/+1 831-685-1911)

Selected Bibliography
— Serengeti, Chronicle Books
— In the Lion's Den, Chronicle Books
— Mitsuaki Iwago's Whales, Chronicle Books
— Mitsuaki Iwago's Kangaroos, Chronicle Books
— Mitsuaki Iwago's Penguins, Chronicle Books
— Wildlife, Chronicle Books

Frans Lanting
All pics © Frans Lanting Inc.
Frans Lanting Photography, 1985 Smith Grade,
Santa Cruz, CA 95060
Tel: +1 831-429-1331
Fax: +1 831-423-8324
Email: info@lanting.com
Website: www.lanting.com

Bibliography
— Forgotten Edens, National Geographic Society, 1993
— Okavango: Africa's Last Eden, Chronicle Books, 1993
— Bonobo: The Forgotten Ape, University of California Press, 1997
— Eye to Eye, Taschen Verlag, 1997
— Living Planet, Crown Publishing, 1999
— Jungles, Taschen Verlag, 2000

Tom Mangelsen
All pics © Thomas D. Mangelsen/Images of Nature
Email: info@mangelsen.com
Website: www.mangelsen.com
Agent: Images of Nature Stock Agency (www.imagesofnaturestock.com)

Bibliography
— Images of Nature: The Photographs of Thomas D Mangelsen
— Spirit of the Rockies: The Mountain Lions of Jackson Hole
— Polar Dance: Born of the North Wind

Francisco Márquez
All pics © Francisco Márquez
c/o Prado, 11 - 9° E, 45600 Talavera de la Reina (Toledo), Spain
Telfax +34 925 82 41 22
Email: fmarquez@teleline.es

Joe and Mary Ann McDonald
All pics © Joe McDonald/Mary Ann McDonald
Tel: +1 717 543-6423
Email: hoothollow@acsworld.net
Website: www.hoothollow.com

Bibliography
— The Wildlife Photographer's Field Manual, Amherst Media, 1992
— The Complete Guide to Wildlife Photography, Amphoto, 1992
— Photographing on Safari, Amphoto, 1996
— The New Complete Guide to Wildlife Photography, Amphoto, 1998

Dr Mark Moffett
All pics © Mark Moffett/Minden Pictures
Agent: Minden Pictures (www.mindenpictures.com/+1 831-685-1911)

Bibliography
— The High Frontier, Harvard University Press, 1994

Art Morris
All pics © Arthur Morris/Birds as Art
PO Box 7245, Indian Lake Estates, Fl 33855
Tel: +1 863-692-0906
Email: birdsasart@att.net
Website: www.birdsasart.com

Bibliography
— Shorebirds: Beautiful Beachcombers, North Word Press, 1996
— Bird Photography Pure and Simple, Birds as Art, 1997
— The Art of Bird Photography, Amphoto, 1998
— Pocket Field Guide to Evaluative Metering Systems, Birds as Art, 2002

Vincent Munier
All pics © Vincent Munier
36 rue Etienne Simard, F-88130 Charmes, France
Tel: +33(0)6 07 12 00 97
Fax: +33(0)3 29 38 00 88
Email: vincent.munier@wanadoo.fr

Bibliography
— Le Ballet des Grues (Ballet of the Cranes), Editions de Terran

Mike "Nick" Nichols
All pics © Michael Nichols/National Geographic Image Collection
Website: www.michaelnicknichols.com (with link to agent)
Agent: National Geographic Image Collection (+1 202 857 7537)

Bibliography
— Brutal Kinship
— Keepers of the Kingdom – The New American Zoo
— The Year of the Tiger
— Gorilla: Struggle for Survival in the Virungas
— The Great Apes: Between Two Worlds

Flip Nicklin
All pics © Flip Nicklin/Minden Pictures
Agent: Minden Pictures (www.mindenpictures.com/+1 831-685-1911)

Chris Packham
All pics © Chris Packham/Nature Picture Library
Tel: +44 2380 454538
Email: sexbeatles@aol.com

Bibliography
— Chris Packham's Back Garden Nature Reserve, New Holland, 2001
— Chris Packham's Wild Side of Town, New Holland, 2003

Fritz Pölking
All pics © Fritz Pölking
Munsterstr. 71, D-48268, Greven, Germany
Fax +49 2571 953269
Email: fritz@poelking.com
Website: www.poelking.com

Bibliography
— Fritz Pölking's Image Collection, Kilda Publishing, 1999
— The Art of Wildlife Photography, Fountain Press
— Planete Sauvage, Editions Proxima (Nature), 2001

Norbert Rosing
All pics © Norbert Rosing
Email: rosingbear@aol.com
Website: www.rosing.de

Bibliography
— Polarbaren (German Edition), Tecklenborg Verlag, 1994, 2000
— The World of the Polar Bear, Firefly Books, Toronto, 1996
— Yellowstone (English Softcover Edition), Firefly Books, Toronto

— Unbekanntes Deutschland (Unknown Germany), Tomus Verlag, 1992
— Geparde (Cheetahs), with photographer Fritz Poelking, Tecklenborg Verlag Steinfurt, 1993
— Deutsche Nationalparks, (German National Parks), Tecklenborg Verlag, Steinfurt, 1996
— Yellowstone – Land aus Feuer und Eis (Yellowstone – Land of Fire and Ice), Tecklenborg Verlag Steinfurt, 1999
— Daybreak 2000 (a celebration of the Millennium Change with more than 100 other photographers), Northword Press, 2000

Andy Rouse
All pics © Andy Rouse
Studio 444, 80 High Street, Winchester, SO23 9AT, UK
Telephone +44 (0)7768-586288
Email: andy@andyrouse.co.uk
Website: www.andyrouse.co.uk

Jonathan and Angela Scott
All pics © Jonathan & Angela Scott
Website: www.jonathanangelascott.com
Agents:
Pictor (www.pictor.com)
Email: feedback@pictor.com
Tel: +44 (0)20-7482-0478
Fax: +44 (0)20-7267-1991

NHPA (www.nhpa.co.uk)
Email: nhpa@nhpa.co.uk
Tel: +44 (0)1444-892514
Fax: +44 (0)1444-892168

Getty (Image Bank collection) (www.gettyimages.com)
Email: sales@gettyimages.co.uk
Tel: +44 (0)20-7267-8988
Fax: +44 (0)20-7579-5797

Bibliography
— The Leopard's Tail, Elm Tree Books, 1985
— The Great Migration, Elm Tree Books, 1988
— Painted Wolves: Wild Dogs of the Serengeti-Mara, 1989
— The Leopard Family Book, Picture Book Studio, 1991
— Kingdom of Lions, Kyle Cathie Ltd, 1992
— Jonathan Scott's Guide to East African Animals, Kensta: Nairobi, 1997
— Jonathan Scott's Guide to East African Birds, Kensta: Nairobi, 1997
— Mara-Serengeti – A Photographer's Paradise, Fountain Press, 2001
— Big Cat Diary: Leopards (Autumn 2003)
— Big Cat Diary: Cheetahs (Autumn 2004)

Anup Shah
All pics © Anup Shah
Email: sneh_shah_uk@yahoo.com
Agency: BBC Natural History Unit Picture Library (www.bbcwild.com)

Bibliography (with Manoj Shah)
— Wild Rhythms of African Wildlife, Panthra Ltd, Nairobi, 1993
— A Tiger's Tale, Fountain Press, London, 1996
— Serengeti, Lubbe, Germany, 1999
— Afrique Sauvage, Selection du Readers Digest, Paris, 2000

Manoj Shah
All pics © Manoj Shah
Email: sneh_shah_uk@yahoo.com

Agenct: Getty Images (www.gettyimages.com)

Bibliography (with Anup Shah)
— Wild Rhythms of African Wildlife, Panthra Ltd, Nairobi, 1993
— A Tiger's Tale, Fountain Press, London, 1996
— Serengeti, Lubbe, Germany, 1999
— Afrique Sauvage, Selection du Readers Digest, Paris, 2000

Nicole Viloteau
All pics © Nicole Viloteau
Ed Arthaud,
26 Rue Racine,
75006 Paris
Tel: +33 1 4544 8528

Bibliography
— Secret Jungle, Flammarion, 2001
— Madagascar : L'île aux sorciers, 2001
— Bivouacs, 2000
— Les Dragons de Komodo, 1992
— Les Sorciers de la pleine lune, 1990
— Des Jungles plein la tête, 1988
— La Femme aux serpents, 1985

Kennan Ward
All pics © Kennan Ward
P.O.Box 42, Santa Cruz, CA 95060
Tel: +1 800-729-5302
Website: www.grizzlyden.com

Bibliography
— Born to be Wild (Bears)
— Denali: Reflections of a Naturalist
— Grizzlies in the Wild
— Journeys with the Icebear

Art Wolfe
All pics © Art Wolfe
Tel: +1 206 332 0993
Fax +1 206 332 0990
Email: info@artwolfe.com
Website: www.artwolfe.com

Selected Bibliography
— The Art of Photographing Nature
— Penguins, Puffins and Auks
— Wild Cats of the World
— Photography Outdoors
— Rhythms of the Wild
— Journey Through the Northern Rainforest
— The Living Wild
— Africa
— The Nature of Lions

Konrad Wothe
All pics © Konrad Wothe
Tel: +49 089 717453
Email: k.wothe@t-online.de
Website: www.konrad-wothe.de

Bibliography
— Fotoatlas der Vogel, Grafe und Unzer Verlag Munich, 1982
— Naturfuhrer Vogel, Grafe und Unzer Verlag Munich, 1984
— Orang-Utans, Tecklenborg Verlag Steinfurt, 1996

Norbert Wu
All pics © Norbert Wu/www.norbertwu.com
Website: www.norbertwu.com

Bibliography
— Splendours of the Sea, Hugh Lauter Levin Associates
— Beneath the Waves, Chronicle Books
— How to Photograph Underwater, Stackpole Books
— Selling Nature Photographs, Stackpole Books
— A City Under the Sea, Atheneum/MacMillan
— Fish Faces, Henry Holt
— Creeps from the Deep, Chronicle Books
— Scholastic Encyclopedia of Animals, Scholastic Reference

Many thanks to all those who have contributed so very much to this book. To Nigel Atherton, whose concept this was, and who has overseen and edited the whole project; to David Wilson and Joël Lacey for contributing text; and to all the photographers who have contributed their work, and their expertise, so willingly. And, of course, continuing thanks to Sarah, Emilia and Charlie, who have supported me throughout the entire project, as always.

Terry Hope